THE HDR BOOK

UNLOCKING THE PROS' HOTTEST POST-PROCESSING TECHNIQUES

D0565690

Rafael "RC" Concepcion

The HDR Book Team

CREATIVE DIRECTOR
Felix Nelson

ASSOCIATE ART DIRECTOR
Jessica Maldonado

TECHNICAL EDITORS
Kim Doty
Cindy Snyder

TRAFFIC DIRECTOR
Kim Gabriel

PRODUCTION MANAGER
Dave Damstra

PHOTOGRAPHY BY
Rafael "RC" Concepcion

PUBLISHED BY
Peachpit Press

Composed in Ronnia and Rockwell by Kelby Media Group, Inc.

Trademarks
All terms mentioned in this book that are known to be trademarks or service marks have been appropriately capitalized. Peachpit Press cannot attest to the accuracy of this information. Use of a term in the book should not be regarded as affecting the validity of any trademark or service mark.

Photoshop is a registered trademark of Adobe Systems Incorporated.
Photoshop Lightroom is a registered trademark of Adobe Systems Incorporated.
HDR Efex Pro is a registered trademark of Nik Software, Inc.
Windows is a registered trademark of Microsoft Corporation.

Warning and Disclaimer
This book is designed to provide information about high dynamic range photography and photo-processing techniques. Every effort has been made to make this book as complete and as accurate as possible, but no warranty of fitness is implied.

The information is provided on an as-is basis. The author and Peachpit Press shall have neither the liability nor responsibility to any person or entity with respect to any loss or damages arising from the information contained in this book or from the use of the discs or programs that may accompany it.

ISBN 10: 0-321-77689-5
ISBN 13: 978-0-321-77689-1

9 8 7 6 5 4 3 2

Printed and bound in the United States of America

www.peachpit.com
www.kelbytraining.com

To my mother, Cristela Concepcion.
I love all of the moments that you and I spend
together for one very selfish reason: when
I step on a stage and shine as bright as you
say I do, I get to tell the whole world
that I am your son. I love you.

Para mi madre, Cristela Concepcion.
Me encanta todos los momentos que usted
y yo pasamos juntos, por una razón egoista:
cuando yo me presento a cualiquer sitio y hago
éxito, me da el orgullo de decir que soy
hijo suyo. La quiero mucho, mama.

ACKNOWLEDGMENTS

This book was written on the shoulders of so many incredible people. While the list of people that I'd want to thank specifically would be a book in and of itself, I'm going to try to do the best that I can to keep it as short as possible.

To my father, Rafael Concepcion, who has since passed on. I'm sure he's looking down, smiling at what he was able to create, and I'm grateful to him for raising me with a sense of right and wrong, and giving me the intelligence to choose.

To my brothers, Victor, Everardo, Jesus, and "baby bro" Tito, for being there when I've needed them. A special thanks goes out to my brother Carlos and his wife Vicky. One conversation with Carlos changed the course of what I've done, and I'm grateful for that. Last, but not least, to my brother Dave: you've been a sounding board and confidant for so long, it is hard to imagine a time when I wasn't with you.

To my uncle Rene, who is always a trusted advisor in my life. To my sister Daisy Concepcion and Norman Wechsler, who always believed I would be able to achieve great things. To Jim and Danielle Bontempi, the best in-laws one could ever ask for. To Merredith Bontempi and Tim Ruymen for being so supportive. Erin and Bill Irvine round out a great family that I'm thankful for.

I've been blessed with great friends. Jennifer Vacca and Lucy Cascio at Zoot Shoot Photographers gave me my start in a studio. Charlie Enxuto and Steve Zimic taught me so much at Split Image Photo. Annie Gambina of New Horizons let me wreak havoc in her classrooms. Matt Davis has always been a great cheerleader and sounding board. I've received inspiration and sage advice from Brigitte and Debbie Calisti. I've spent days on end laughing with Kyle Robinson and his wife Teresa. Bruce "Disco" McQuiston and I shared many a tender moment listening to Enigma. Mike McCarthy will forever be one of the funniest guys I know. Jane Caracciolo has been the person whom I'd call in the middle of the night to answer the most complex of problems. Her mother Jane Caracciolo, Sr., will forever be known as my second mother—one whom I love immensely. To Andrea Barrett: I miss you! Matt Wanner's a heck of a firefighter, and an even better writer and friend. Then there's Jeremy Sulzmann and Mohammed al Mossawi, two of my mates while living in Germany. Here are two friends I can call on to fly around the world (or share a tube ride) to meet me in London for just one night.

To my Tampa crew: Alan and Nicolle Brusky, Kathy Porupski, Jim Sykes, Erik Valind, David Rogers, Michael Sheehan, Keith Winn, Rob Herrera, Scott Krebs, Dan Underwood, Tony Gomes, Emily Haskin, and Wendy Weiss, who gets to pull double duty as my photography buddy and doctor. You couldn't imagine what an office visit is like now!

A special thanks goes out to Yolanda, Neil, and the Corteo family for being such great friends to us here in Tampa (and for having the best pizza around).

To Bonnie Scharf: I've known you for over 18 years, and you're like a sister to me. Fortunately for me, you've been there through thick and thin. Unfortunately for you, you've had to put up with me for that long!

To Albert J. Fudger: you are my best friend. I've talked to you on a daily basis for over 16 years and there's not been a time when I have not been laughing through it. Thank you for letting me write this book on your kitchen table. An even bigger thanks for being the friend that you are to me and my family. Boop!

This book would not have been possible without the guidance and tutelage of Scott Kelby. I met Scott several years ago, and still keep a picture of that meeting to this day. While I'm grateful for his experience and skill at being the best in the business, I'm an even bigger admirer of his grace, candor, goodwill, trust, and unbending dedication to his friends and his family. He's an awesome mentor, and he and his wife Kalebra are models for what true friends and dedicated Christians should be. For that, I am forever grateful.

I'm privileged to have Moose Peterson as a mentor and friend. Through countless meetings, you've served as a photographic compass for me. You and Sharon will always be near and dear to our family for that.

I've been inspired by Joe McNally's work for longer than I've been using Photoshop. To be able to count him and his wife, Annie, as trusted friends and mentors has been one of the best gifts a person could ask for.

To Bert Monroy: you embody what it means to be brilliant at Photoshop. Thank you for being a great friend and inspiration to me.

Then there's my family at Kelby Media Group. To my editors, Cindy Snyder and Kim Doty: thank you for chiseling and polishing this book to perfection. To Jessica Maldonado: you're the best book designer in the business! To Kathy Siler, for always making me smile! To Felix Nelson, our Creative Director: thank you for steering this ship on top of the five thousand other things you're busy amazing people with. To Justin Finley and Tommy Maloney: you guys are aces in the design and programming biz. Thanks for all of your help. To Brad Moore: thanks for being such a great sounding board and lunch partner. To our IT director, Paul Wilder: thanks for keeping me up and running, and letting me run my experiments on the computer. To Dave Moser: thank you for being our fear-less leader, and such a wonderful friend.

A special shout out to my fellow Photoshop Guys, Dave Cross, Corey Barker, and Matt Kloskowski. Matt, I can't thank you enough for being such a great advisor on so many things. It's a privilege and an honor to call you my friend.

My sincere appreciation goes out to all of my friends at Peachpit Press: Scott Cowlin, Sara Jane Todd, Gary-Paul Prince, Nikki McDonald, Glenn Bisignani, Barbara Gavin, Jennifer Bortel, Laura Pexton Ross, Lisa Brazieal, Nancy Davis, and Nancy Aldrich-Ruenzel. A special thanks goes out to my editor, Ted Waitt, for all of his help on the book!

The work of the following people never ceases to inspire me: Jay Maisel, Katrin Eismann, Deke McClelland, Terry White, Eddie Tapp, Jim DiVitale, Joe Glyda, Rich Harrington, David Ziser, Trey Ratcliff, Cliff Mautner, John Paul Caponigro, Lois Greenfield, David Lynch, Andrzej Dragan, David Hobby, Steve McCurry, Jeremy Cowart, Susan Meiselas, Gregory Heisler, Vincent Versace, Jeff Revell, and John Loengard.

Many thanks go out to some people who I find amazing in the world of HDR: Michael Steighner, Jacques Gudé, Rick Sammon, Brian Matiash, and David Nightingale. A special thank you goes out to Trey Ratcliff. Trey, you're a wonderful trailblazer for this technique, and your passion truly shows. I am honored to call you my friend.

Thanks to Jim Begley, Roger Laudy, and Barb Cochran for agreeing to be profiled in the book. You should each stand and be proud for producing amazing work.

To my wife, Jennifer Concepcion: Aside from being my loving wife, you are such an integral part of my success. You are my editor, my proofreader, my assistant, my confidant, my advisor, and the shoulder that I rest on when I can't go any longer. You're the inner eye no one sees, and the reason I get to do any of this. I love you more than I could ever say.

To my little girl, Sabine Annabel: I tear at the mere thought of coming home and hearing "Whatcha doing Daddy?" for it takes every single boo-boo away. You're the apple of my eye, and your smile brings me the greatest peace. Daddy loves you through and through. Yesterday, today, and tomorrow, too.

Last, but certainly not least, thank you, my dear reader. By the sheer grace and goodwill from the Almighty, He has blessed me with a life where I get to share the things that I truly love with each and every one of you. It's a gift I accept with great humility, and enormous pride, and I am very grateful.

ABOUT THE AUTHOR

Rafael "RC" Concepcion is an education and curriculum developer for the National Association of Photoshop Professionals, co-host of *D-Town TV* (the weekly videocast for DSLR shooters), and one of the Photoshop Guys. An award-winning photographer and Adobe Certified Instructor in Photoshop, Illustrator, and Lightroom, RC has over 14 years in the tech industry, designing sites and training thousands in technologies from Adobe and Microsoft. RC spends his days developing content for all applications in the Adobe Creative Suite at Kelby Media Group. His ability to speak passionately about technology and the Web has engaged audiences in the U.S., Europe, and Latin America. Most recently, RC has combined his photographic and Web experience to teach with famed wildlife photographer Moose Peterson at the "You Can Do It, Too" workshops in Mammoth, California, the Digital Landscape Workshop Series, and at the Voices That Matter Web Conference in San Francisco. RC recently became a best-selling author with his debut book, *Get Your Photography on the Web*, and also writes columns for *Photoshop User* magazine. He lives in Tampa, Florida, with his wife, Jennifer, and daughter, Sabine Annabel.

CONTENTS

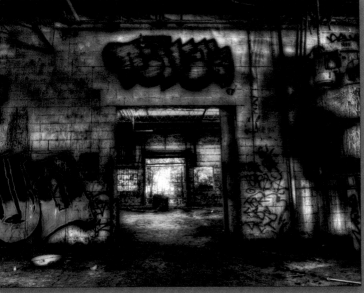

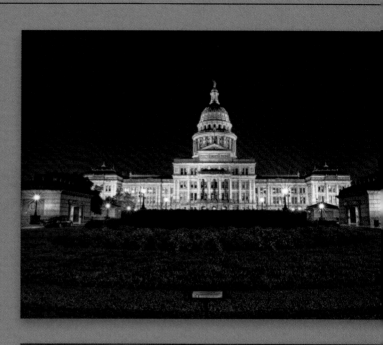

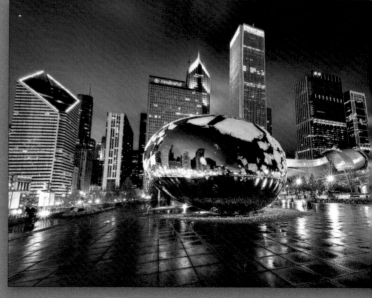

CONTENTS

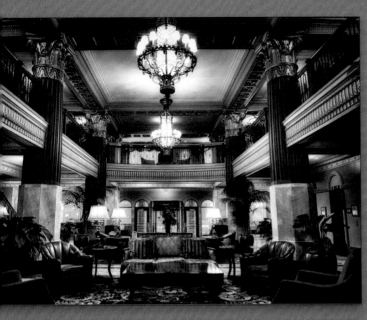

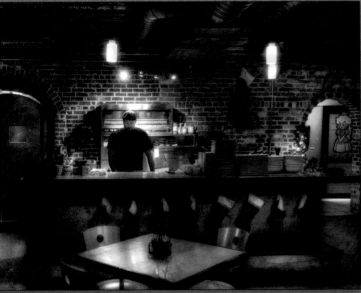

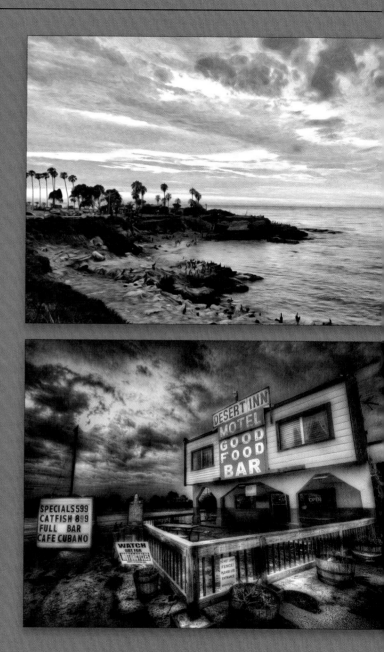

INTRODUCTION

High dynamic range photography has taken off in the last couple of years. With cameras becoming cheaper and memory getting inexpensive, as well, we are shooting more and more frames with little worry for what each image may cost. Hey, it's pixels. You don't have to buy film anymore. Even the iPhone is doing HDR—a true sign that this art form is hitting the mainstream.

The one thing that had always interested me about doing HDR was that the community doing it was very open about sharing the methods for their creations. With every picture put out on the Internet, they were always quick to say, "These are the settings I used in Photomatix. Have at them!"

As more and more people become interested in this, I've noticed the opposite has started happening. You still see the pieces being shared, and people still share their exposure information, but those settings alone do not produce the final piece that you see on the screen. It's as if people are only interested in sharing *some* of the technique, keeping some of the key pieces to themselves, for fear of giving away the entire trick. Yes, you got the settings, but just plugging those settings into the software didn't make the image. In some cases, it made your image worse.

There are two secrets to HDR photography: (1) The settings you use to make the HDR are largely built on taste. Yes, you can have someone give you an overview of what this slider does, or that slider does, but for the most part, we all spend time in front of the screen, jiggling sliders around, thinking, "Hmm...that looks kind of interesting. I'll go with that." And, (2) when you process your HDR image in any software you choose, you're only halfway done. Many of the images that you'll really come to love are based on key post-processing. The post-processing isn't hard, but it's there. The problem is that no one has really spent time talking about *that* part. This book aims to change all of that.

HDR photography is surprisingly easy. I'd say it's probably one of the easiest techniques to get good at because of how easy the process of generating an HDR is. You need some specific tools, some specific rules, and a heck of a lot of experimentation. We will spend some time talking about what things you need to be able to capture the shots from a hardware standpoint, as well as some hardware tips that make it easier to get those images.

From there, we will talk about how to get out there and look for HDR images. If you spend some time looking at HDR images on the Internet, you will see that there are patterns that emerge. Learn those patterns, and you can immediately make your HDR better.

We'll then spend some time talking about how three major pieces of software work to make your tone mapped image: Photoshop's HDR Pro, HDRsoft's Photomatix Pro, and Nik Software's HDR Efex Pro. We'll go over the general sliders, what they do, and how to save your presets to come back to them later. These three parts are done as fast as possible to get you to what you *need* to know.

The rest of this book is dedicated to the post-processing of the images, using 10 actual HDR projects from my collection (with four extra added, shown only in their finished state, but using the same techniques you've learned on the others). All of the source files for these projects (including the four extra images) can be downloaded from the book's companion website at: **www.kelbytraining.com/books/hdr**. Each of these project chapters starts with screen captures showing you what tone map settings I used in all three programs (there are presets you can download from the companion site and load into each program, if you choose). Then, we use tried-and-true Photoshop techniques to get them to show-ready condition.

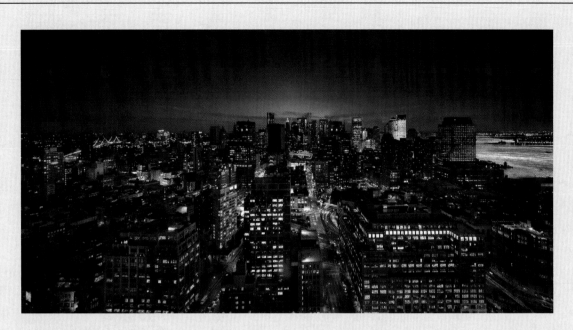

The four additional projects I've included are at the end of Chapters Four, Nine, Ten, and Thirteen, and are labeled "It's Your Turn." I want you to experiment with them. The images are yours to have fun with and to come up with your own creation. The only thing I ask is that if you post one of your works of art on the Web, let them know that you got it from this book!

The projects here cover a wide range of subjects, from natural landscapes, to portraits, to surreal cityscapes. I included everything from medium-format imaging to a real estate image taken with a point-and shoot—it's all in here. We'll spend some time faux-painting an impressionist landscape. We'll double-tone-map an image. We'll make HDR portraits, panoramas, recomposited pieces, a black-and-white image, as well as single-image HDR works of art.

All of the tricks in this book require the use of specific software, and their inclusion in the book does not give me a penny toward my kid's college fund. If it's in this book, it's because the pros out there use it and I use it. You don't need every single one of them, and most of the time, you can get trial versions of the software to experiment with. Once you settle on a style, you can buy the ones you need.

Throughout the book, I also wanted to introduce you to people out there living in the HDR world, so you can learn more about their passion, become inspired by their work, and see the different faces of the technique.

We are about to go on an awesome journey exposing HDR for what it is, a technique that you can totally master. By working on these projects, you can develop your own style for processing this really dynamic technique.

I hope you're as excited as I am. Let's get to it!

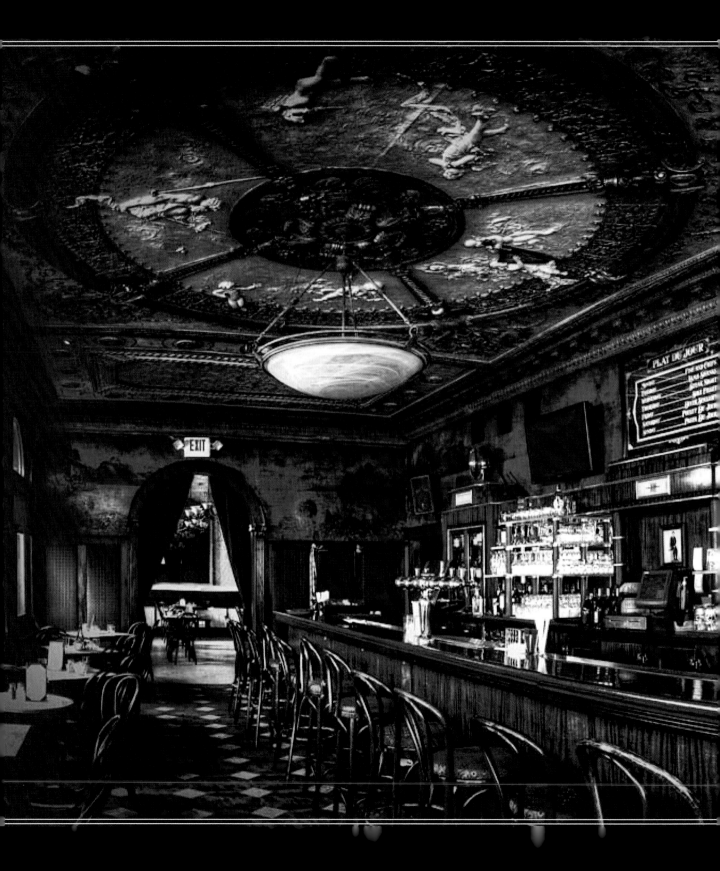

ONE
Tools & Techniques

Like with anything in photography, working with HDR images will require three distinct things: hardware, software, and technique. On the hardware front, you don't require that many things to set up an HDR series. Camera aside, the hardware listed can even be seen as recommended, rather than required—you can make HDR images without it. What you'll find, however, is that while the images will certainly be good, it's the extra investment in the hardware that can take them to the next level. Steadying your camera is paramount in HDR, so anything you can do to make that happen is key.

On the software side, there are a multitude of options for you. In this book, I make certain recommendations (I'm a big supporter of Nik Software, for example), but you can obviously substitute with your own choice. That said, I will point out that when you take a look at the HDR images out there on the scene, you'll see common pieces of software that are used. Many times, that look that you think is really cool is all based on a specific piece of software. Is that a bad thing? Not at all. Look at it this way: if you were off to build the frame of a house, you wouldn't try to use plumbing tools. There are specific things to be used for specific reasons, and HDR does have a specific list. Do you need all of them? It's up to you. Thankfully, you can work with all of the software in a trial version to see which one fits.

Finally, there's technique. Whether it's panning with your feet, or how to press a specific button on a screen, there are certain tips and tricks out there that make getting that great shot easier. This chapter is about pointing out those things that will make your life easier (the result of a lot of frustrating moments for me, by the way). Enjoy!

YOU NEED A BRACKETING CAMERA

Back in the film days, photographers had to use their best guess as to the exposure of a scene. They'd look at the scene and say, "I think this scene is 1/60 of a second at f/5.6. Man, I hope I'm right." Not having the luxury of a display on the back of their camera, they often had to wait a few days to see if their guess was right. Because of this limitation, photographers finally said, "Forget this! I'm going to take an image at the exposure that I think it is, and then I'm going to take the same shot 1-stop underexposed, and then take it again 1-stop overexposed." By taking these three shots of the scene, they'd ensure that at least *one* of these frames would be right. Sure, this meant that they needed to develop three negatives to see which was right, but it sure beat missing a moment or having to travel back to the location and set up the image again.

This process is known as bracketing, and most DSLR cameras can now do it automatically for you. What I think is cool about this is that it's just an extension of the early days of bracketing. Instead of developing those three images to see which one is the best, you can use software to merge all three of them together. The software then lets you control how those files blend with one another!

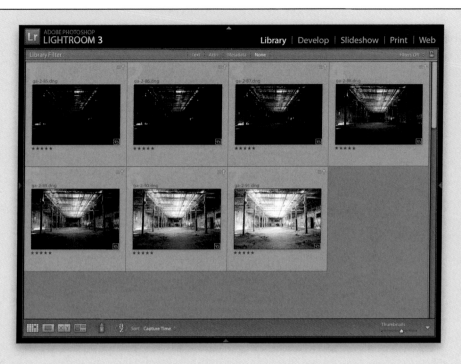

When working with bracketing, you tell the camera how many frames you want to shoot, and how much of an exposure difference you want in between the images. Let's say that the scene reads 200 seconds at f/8. If I set my camera to capture seven images with a 1-stop difference in between them, the images shown here would be the exposures that would come out.

Now, how many images you need and how much of a range you need between them is the subject of much debate. At a minimum, the images should be about a stop apart from one another, which incidentally happens to be the maximum increment for most Nikon cameras. Canon cameras can shoot brackets with as much as a 2-stop difference between images—something I've always been jealous of, being a Nikon shooter. To make a good HDR, you should start with three exposures: one is the "normal" metered image, and the second and third are the overexposed and underexposed ones. You can do some cool images with one shot, as you'll see at the end of the book, but get used to getting at least three. There are some scenes where I think having five, seven, or even nine frames will help (shooting in daylight, I almost always use nine frames), but three should be your minimum.

By the way, Canon cameras will only allow you to shoot three frames per bracket. This is where my jealousy is tempered. If your camera doesn't shoot more than three, that's fine, just start with that.

SETTING A NIKON FOR BRACKETING

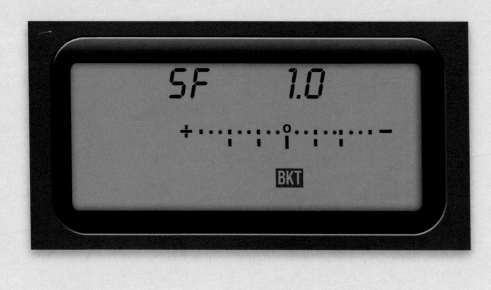

On the back of your camera, press the Menu button, then select Auto Bracketing Set<AE Only. On the front of you camera, below the lens, press the Fn (function) button, and then use the main command dial to choose how many frames you want to shoot (this will appear in the control panel on the top of the camera). Now, use the sub-command dial in front of the shutter button to adjust how many increments there will be between exposures. The maximum increment of exposure on most Nikons is 1 stop.

SETTING A CANON FOR BRACKETING

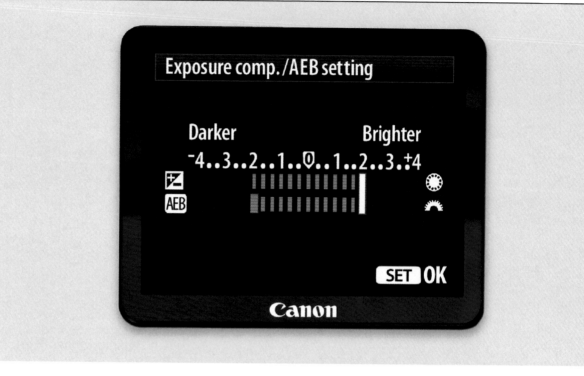

Go to the Camera tab menu in the LCD on the back of the camera, then scroll down to Expo Comp/AEB (Auto Exposure Bracketing), and press the Set button. Now, use the Main Dial on the top of the camera to choose how many frames you'd like to capture, then use the Quick Control Dial on the back of the camera to set the exposure compensation amount. The –1 and –2 settings speak to how many stops difference there will be between the images. I usually set this to –1, but in situations of bright/high contrast, I switch it to –2.

CHANGE YOUR BRACKET ORDER

By default, when you shoot a bracket of images, your camera will shoot the metered image first, then shoot the underexposed image, then shoot the overexposed image. The problem with this is that when you go to look at the images (on your LCD, in Bridge, or even in Lightroom), it's hard to tell which image was the "start" of the series.

To help with this, change your camera's bracketing order. On a Nikon, from the Custom Settings menu, choose Bracketing Order>Under>MTR>Over; on a Canon, from the Camera tab, choose Custom Functions>Exposure>Bracketing Sequence>1. Now, when you look back at your images, you'll always know that the darkest image is the start of the bracket series.

KEEP STEADY WITH A TRIPOD

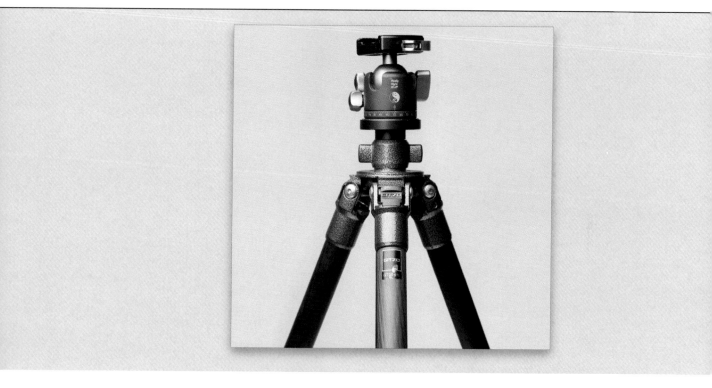

Because you are exposing a series of images that will be merged together, it's extremely important that your camera stay as still as possible. Not only will you reduce blur during those longer exposures (where hand-holding just isn't possible), it will also eliminate any micro movements you make from shot to shot.

Note: I use a Gitzo GT2541L tripod with a Really Right Stuff BH-40 ballhead. But, keep in mind that any tripod you use will be better than having no tripod at all.

USE A CABLE RELEASE

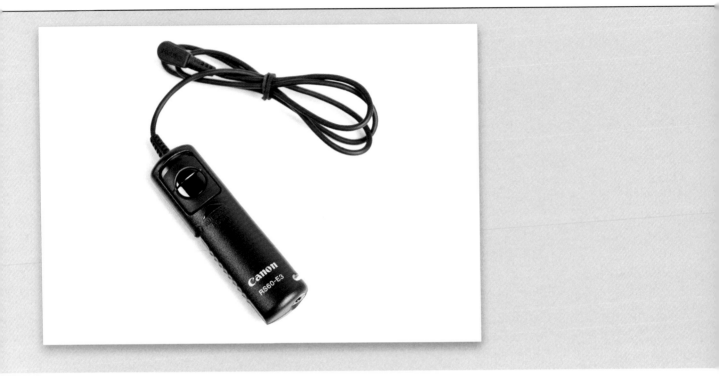

The more you touch your camera, the more you have a chance of introducing camera shake. To combat this, I always recommend using a cable release. This will let you click the shutter button without having to touch the camera. Very, very essential and quite cheap.

MIRROR UP MODE/MIRROR LOCKUP

There is a mirror near the sensor in your camera that flips up to expose the image that you are making. When you absolutely need to guarantee a tack sharp image, Mirror Up mode (on a Nikon; Mirror Lockup on a Canon) is key. When you set your camera to Mirror Up mode, the press of the shutter button will automatically open the mirror and lock it up in place. A second press will make the exposure. By giving yourself a second between those two clicks, you can minimize the amount of shake that the camera feels when the mirror comes snapping up. On a Nikon, just unlock the Release Mode dial on the top of the camera and turn it to MUP. On a Canon, go to the Camera tab menu on the LCD on the back of the camera, then go to Custom Functions>Autofocus/Drive>Mirror Lockup>Enable. On both cameras, you'll have to press the shutter button a number of times to get your bracketed shots.

SHOOT IN CONTINUOUS MODE

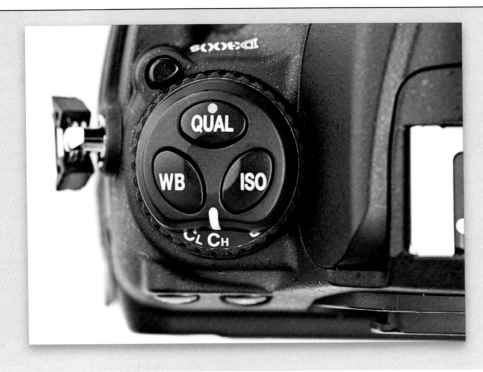

If you're not as concerned about the images being tack sharp, most DSLR cameras have a continuous shooting mode, allowing you to hold down the shutter button and fire off a series of images. The camera will continue firing off images, so long as its internal buffer does not get full. Now, when you have your camera set to shoot a bracket, you can hold the shutter button and the camera will only shoot the bracketed series and then stop. This will help you when working with longer exposures, because each time you press-and-release the shutter button, you're introducing the possibility of camera shake. By pressing-and-leaving your finger down, you minimize that shake. On a Nikon, change the Release Mode dial to CH or CL; on a Canon, press the AF•Drive button on the top of the camera, then using the Quick Command Dial, choose Continuous Shooting.

Note: Five or nine frames should fill up your camera buffer. So, for me to eliminate that worry, I shoot with the fastest memory cards I can get my hands on. In terms of speed and reliability, I'm a big fan of Lexar cards.

SHOOT IN APERTURE PRIORITY MODE

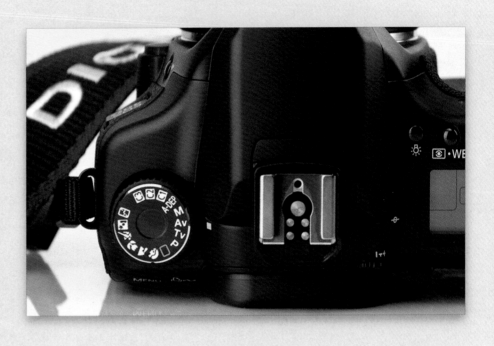

In order to get great HDR images, you want to collect a series of images that vary based on exposure—from really underexposed to really overexposed. You can achieve that goal in a variety of ways: changing aperture, adjusting the shutter speed, or adjusting your ISO. You want to make sure you shoot these images in Aperture Priority mode. Aperture Priority mode controls how much depth of field you have in an image. A shallow depth of field (f/2.8 for instance) could have an element in focus and the area immediately around it out of focus. An f-stop of f/11 would keep more elements in the area in focus.

When you set your camera to Aperture Priority mode (the A mode on Nikon cameras, and the Av mode on Canon cameras), you're telling your camera to keep your aperture fixed for the duration. This forces the camera to use shutter speeds to make the exposure changes and prevents any change in the depth of field, which can ruin the image.

When you look through your camera's viewfinder and focus on something, your camera takes the scene in and processes what it thinks it should be exposed as. Most cameras now use three different settings to do this:

Spot Metering: The camera uses the exact area your "dot" in the viewfinder is on to calculate the exposure.

Center-Weighted Metering: The camera uses the center area of the viewfinder as its start, and takes into account some of the area around the center to calculate the exposure.

Matrix Metering (or Evaluative on a Canon): The camera takes multiple areas of the whole scene into consideration, and calculates an exposure based on all of those factors.

HDR is about getting that one specific thing exposed properly, then adjusting the exposure based on the bracket. By switching to Spot Metering, it lets you get very specific about the area in question and expose from there. On a Nikon, rotate the Metering Selector on the back of the camera and choose the Spot Metering icon (the single dot within brackets) and on a Canon, press the Metering Mode Selection/White Balance Selection button at the top of the camera and then, while looking at the LCD panel, use the Main dial to choose Spot Metering (its icon is also a single dot within brackets).

SHOOT IN RAW

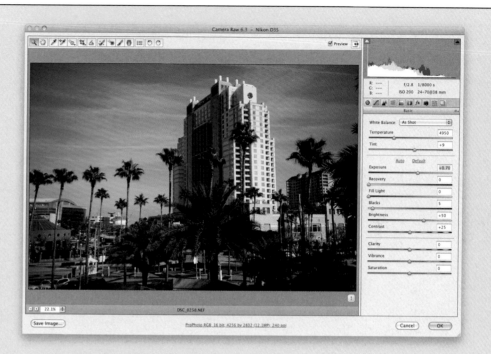

Whether you're making an HDR or shooting any other photographic work, shooting in RAW is one of the best ways for you to be able to have latitude with your images. A RAW file is essentially a negative for an image. The camera captures all of the data of a scene and stores it in this file for you to process later. Once you open up the RAW file in Photoshop, Lightroom, or another program, the file is then converted to its pixel-based counterpart. While they may be bigger than JPEGs, they are the original source work for your images. Shoot them, keep them, and treat them well.

EXPERIMENT WITH JPEG

Wood-1.jpg
10/16/10 8:01:15 AM
1366 x 910

While shooting in RAW is something that I constantly encourage, a conversation with my buddy Matt Kloskowski got me really thinking one day. Matt revealed that he had spoken with someone at one of the more popular HDR software companies, and that person said that an HDR image could actually look "better" from a JPEG than a RAW file.

What's the logic behind this? When HDR software attempts to tone map an image, it first converts the file to its pixel-based counterpart. While their JPEG conversions may be good, you're not going to be able to beat what your camera, Photoshop, or Lightroom can do.

This is one that I'm really playing with now by either shooting RAW+JPEG in my camera, or exporting a series of JPEGs before I tone map. You should give it a try, too.

SHOOT MORE THAN YOU NEED

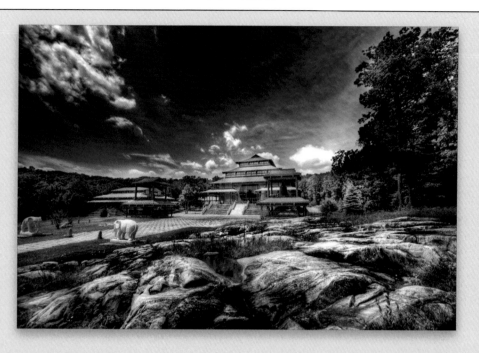

There's a lot of debate going on about just how many images you need when working with an HDR file—three, five, seven, or nine. The best way to handle this is to think, "When is the next time I'll be standing before this moment again?" If your answer is "Probably not anytime soon," then shoot as many as you can. The usual counterpoint to this is "Shooting nine frames wastes space and takes longer." My answer? Don't shoot the same scene so many times, and you'll be fine. As far as waiting goes, I'd rather wait a little longer and get a good shot than take a shortcut and miss it.

SHOOT FOR THE BASEMENT

S2C1-109.DNG
$^1/_{1500}$ sec at f / 19, ISO 160
70 mm (Summarit-S 70)

See the image here? Chances are you can't, but there is an image there. When I shoot in daylight scenarios, more often than not, I tend to shoot so that my lowest exposure has very, very little detail. To do this, I make sure that I shoot between seven and nine frames. If, after shooting the seven (or nine) frames, the lowest of the exposures is too bright, I will adjust the EV spacing to –1 or –2, until I make sure it gets me to the basement. *Note*: For more on this, go to the book's companion website, mentioned in the introduction, where I've provided a video.

SHOOT WITH A LOW ISO

HDR photography produces noise, no doubt about that. Because of this, you want to make sure that you shoot at as low an ISO as possible. For your ISO setting, the lowest number you can get to (100 or 200) is usually the best. This will surely make some of the shots you make in your bracketed series hard to hand-hold, so in this case, you will need to use a tripod.

When you're working with HDR images at night, you're going to get really long shutter speeds. This is one of those cases where I think it's always best to wait. If you set up a bracket of five images, and then you shoot image one and two, then you see people coming near the frame, just stop. Let those two exposures finish and let the people/car/cloud/bird, etc., go by. When the scene is where you need it again, continue. Sure, the ghosts of the people can sometimes be cool, but often they're a little distracting.

USE PHOTO BUDDY!

There are times when the Auto Bracketing of your camera may not necessarily suit what you need. Perfect example: some Canon cameras only allow a maximum of three exposures in a bracket (not altogether bad, but not great). What if you wanted five frames? What if you wanted to do it on the cheap? Then what? If you have an iPod, iPhone, or iPad, go to iTunes and buy Photo Buddy. For $1.99, it does a host of photographic things that I feel are just invaluable. My favorite? The bracketing calculator. Enter your shutter speed, how many images you want, and what EV value, and it will churn out all of the settings you need to do it manually. Set your camera to Manual, dial the settings in yourself, and you're all set.

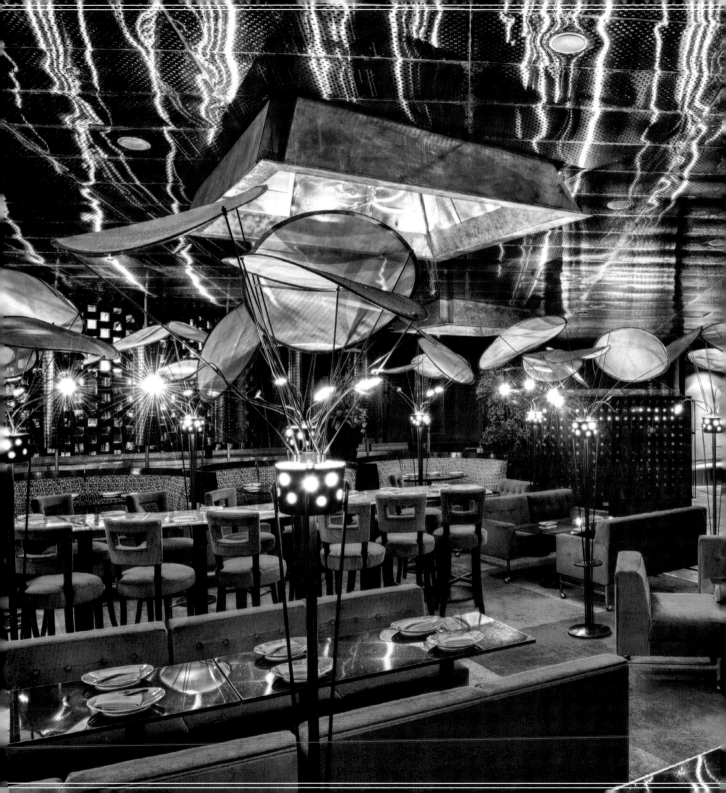

TWO
What to HDR

Not too long ago, I sat with Scott Kelby and Jeff Revell, taping the second episode of the new talk show, *The Grid*. One of the topics of conversation that came up was whether HDR, as a technique, was dead. Jeff made a really good analogy for how users think about HDR photography. He called it the "Cinnabon analogy." Basically, when someone first runs into a Cinnabon, they can't get enough of it—the sweet goodness! In no time flat, they're having Cinnabon all the time. Then, all of a sudden, they realize that they're really not into it, because they've overdone it.

While I can certainly see where something like that *could* happen, I have my own theory: I think that many people who get into HDR photography tend to go into it guns blazing, shooting everything that sits in their path in a series of bracketed images, hoping that the HDR gods will smile upon them and bestow them a good image. But, there are two problems with this line of thinking: (1) Most of the HDR that you see out there that you really like has been post-processed in Photoshop to some degree (I would argue, to a large degree). (2) There are certain images that just "work" with HDR photography, and others that do not.

If you look at the images out there that have been processed, you'll notice that there is a series of patterns that comes up. Once you know what those patterns are, you can make better choices as to when you think you will go for the HDR or not.

While this may not be a complete list of what to HDR, this is certainly a start for you to think about. Combine a couple of these, and you're sure to have an HDR hit.

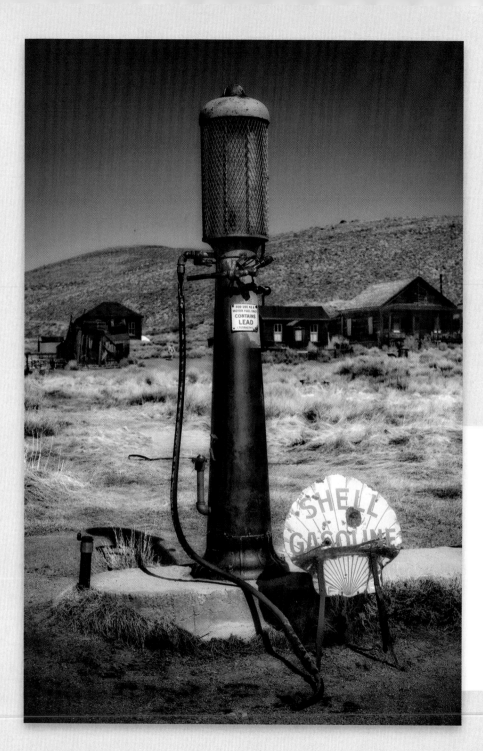

Old Stuff Rocks

Part decay, part nostalgia, it seems like anything from yester-year is automatically a great candidate for HDR photography. The textures that you can find in older things, combined with their novelty (when was the last time you ran into a gas station like this?) makes it surreal enough to really do well with this treatment.

Overhang? Shoot It!

Whenever I see something near an overhang, I will automatically HDR the shot. More often than not, the exposure that is outside of the overhang is very different from the exposure inside of it. Because of that, we're predisposed to expect one part of the image to be darker.

When HDR is done properly, and we can see both parts, it stands out for us.

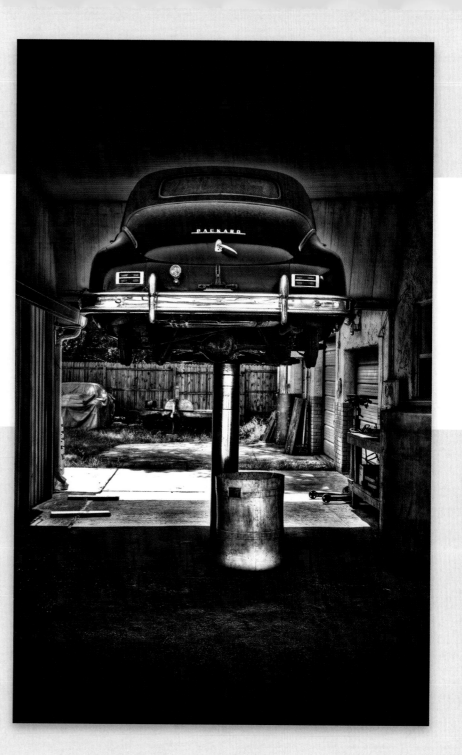

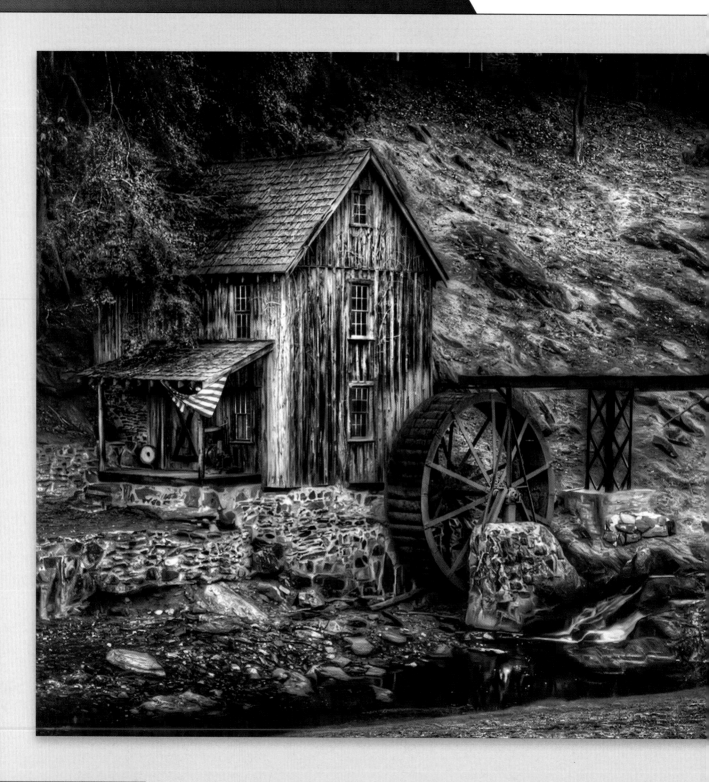

It's All About Texture

I've always argued that HDR is more about texture and tone than it is about color. Textures in photography tend to make the image a little more tangible to us. When HDR amplifies these textures, it makes people want to reach out and touch the image. That kind of connection is very important.

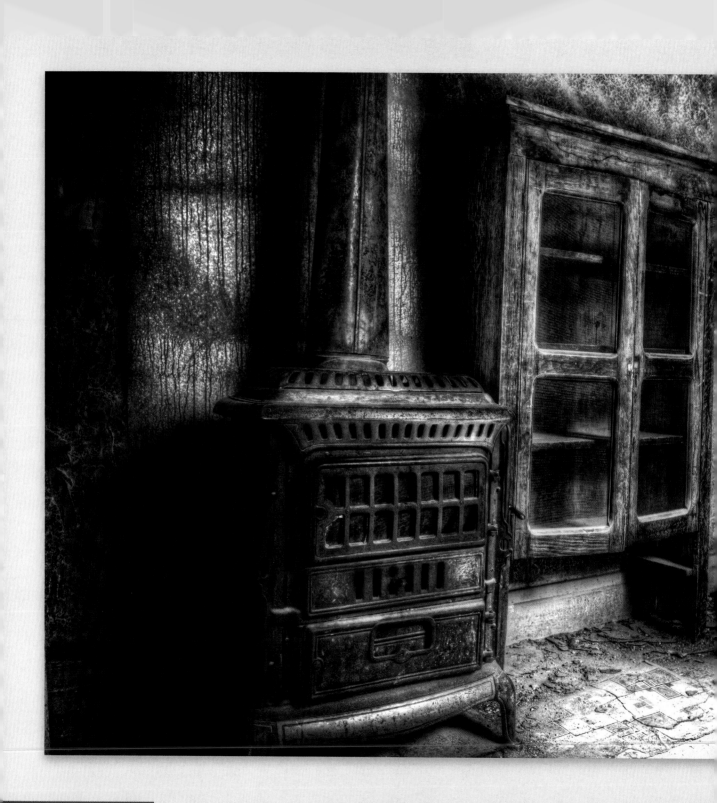

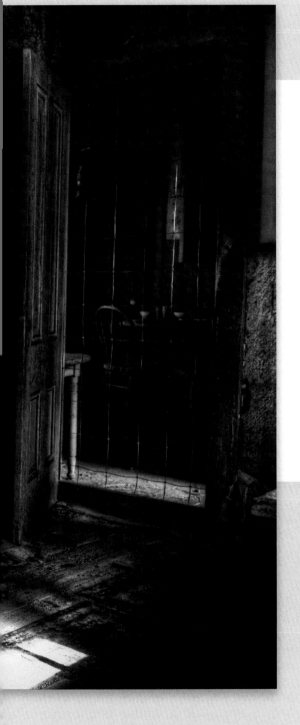

Two Rooms with a View

If you're in a room when you are taking an exposure, and you have the ability to see clear into the next room, there's a good chance that you may want to consider doing HDR. In this example, the room that I'm in is at one exposure, but we can easily see that exposing for that one would mean that the second room would be dark. By doing an HDR of this area, the image is closer to what we would normally see.

It's quite interesting. We're pretty in tune with what we expect our photographs to deliver to us. Normally, if we saw this picture without HDR, we wouldn't think twice about it. But, because we can see both areas, our brains say, "Hey, how did he get the other room...?" Blammo. You have people's attention.

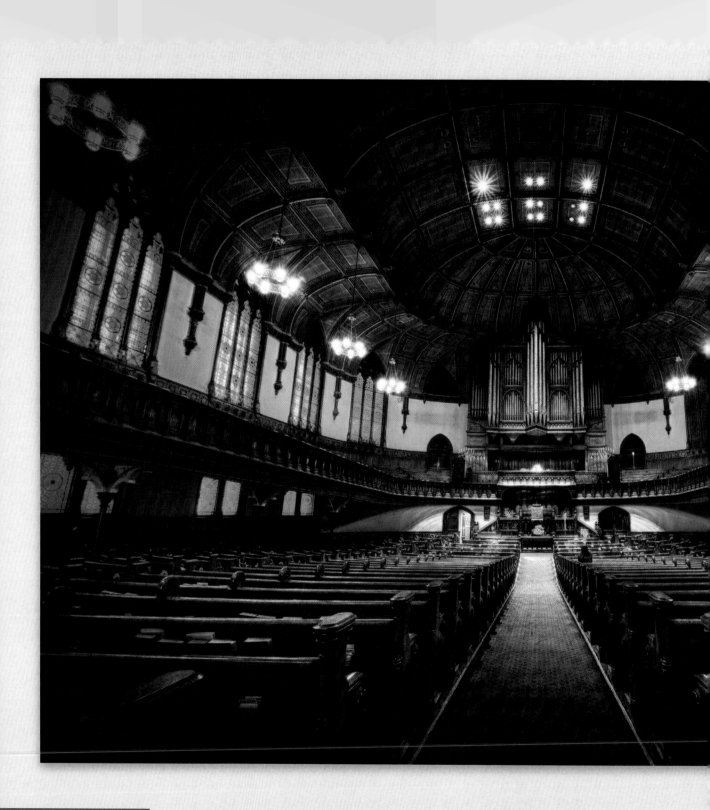

Dimly Lit Interiors

I almost wrote this tip as Church Interiors, but truth be told, anything that is indoors that is dimly lit does very well with HDR. The over-exposed areas bring out the details in the room, while the underexposed portions of the image give almost an ethereal nuance to it.

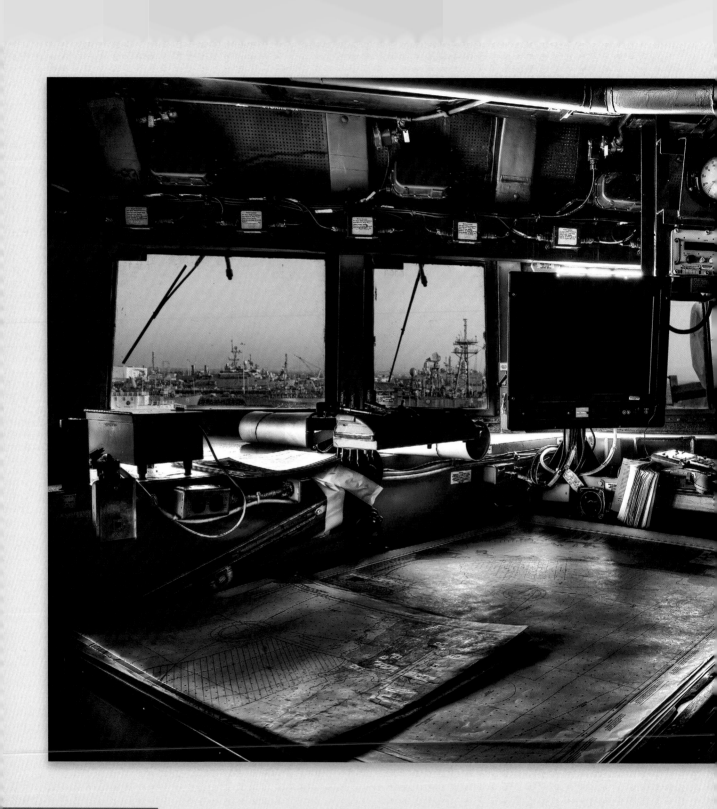

Machinery HDRs Well

Metal is just made for HDR. The more knobs
and controls that you are faced with, the easier
the choice to make the image into an HDR.
In the case of this Navy destroyer, I was also
able to see out the windows—double bonus!

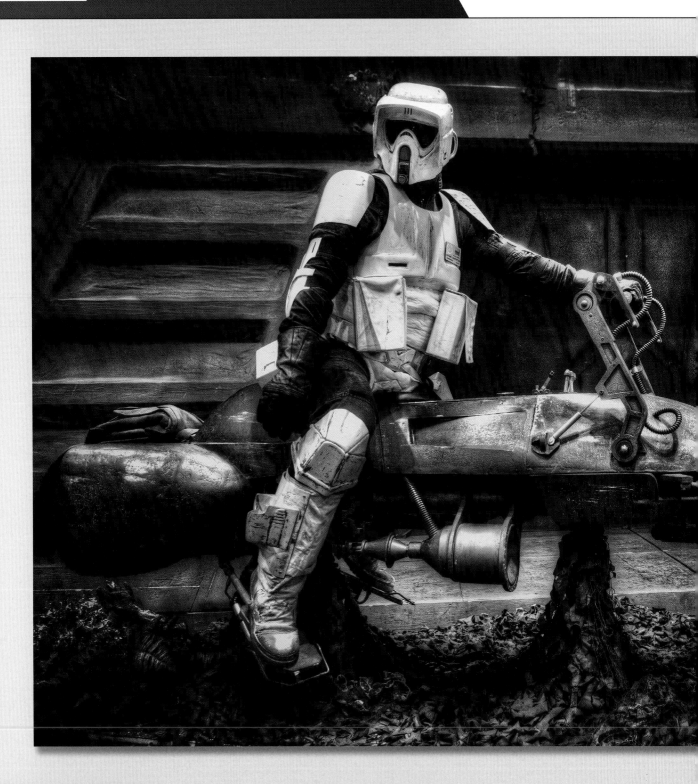

Sci-Fi Was
Meant for HDR

There's not that much to say here.
If you're anywhere near a *Star Wars*,
Star Trek, or other type of sci-fi con-
vention, you should be thinking about
HDR. The metal and interesting char-
acters will make for a great series.

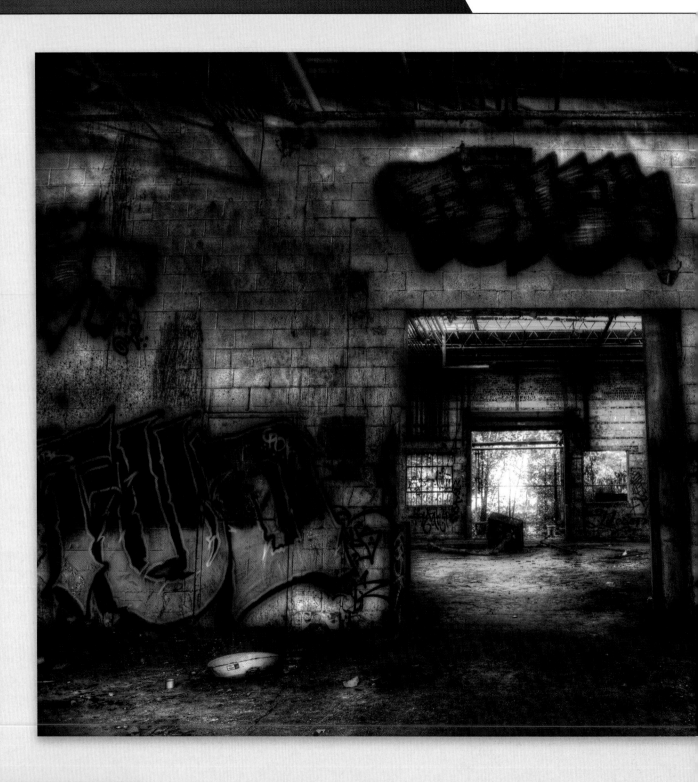

UrbEx HDR Is *du Jour*

Urban Exploration, also known as UrbEx, is a trend that's popping up more and more in HDR photography. People going into abandoned, decrepit buildings to explore what is in them has been happening for several years now. With the advent of HDR, photographers that have been into UrbEx have taken to recording their explorations in HDR. Interesting colors, textures, and abandonment—sounds like great HDR territory.

Twilight (Not the Movie)

While this is true in photography in general, it is definitely something to keep in mind when shooting HDR. There's something to be said about the last few minutes of light when you're shooting HDR that really brings out some amazing colors and tones. I think this has to do with how saturated in color these moments are, and how that saturation complements the texture that you see in the image.

HDR Angry Men

While you can certainly HDR both men and women, it seems like the roughness of the HDR technique really does favor men. I think it just goes with the rough and rugged images we tend to portray men with.

Given this, I wouldn't HDR a glamour portrait for a female customer. However, if the female customer was a hard-core rocker and showed up in a cool leather jacket and a baseball hat, the HDR is coming out!

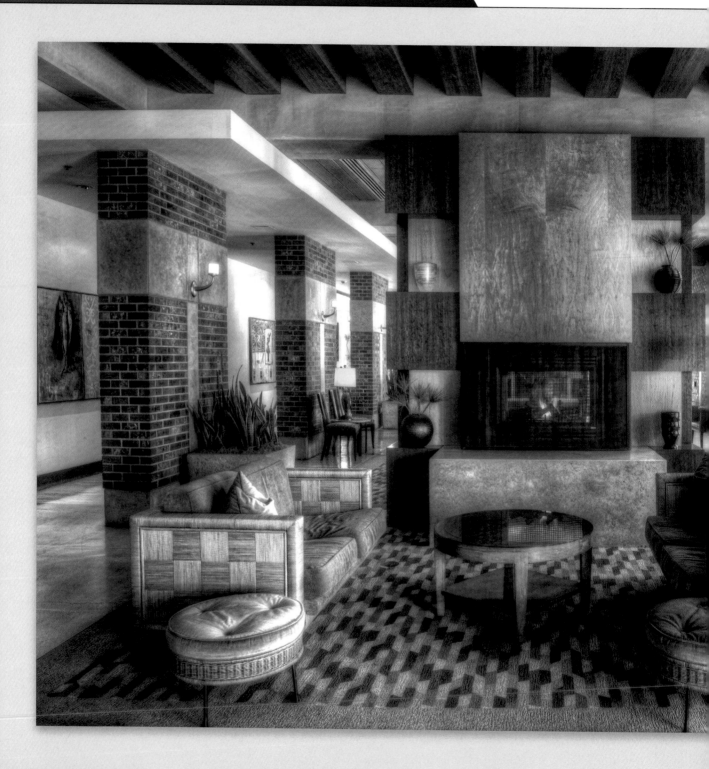

See Outside a Window? HDR It

Whenever I am looking for places to shoot, I'm always particularly interested in windows. If there is a window in a shot, more often than not, people are not prepared to see out of them in daylight shots. The exposure that is indoors is usually different from what you see outdoors. When you process such an image so that both of these areas are properly exposed, the picture looks magical.

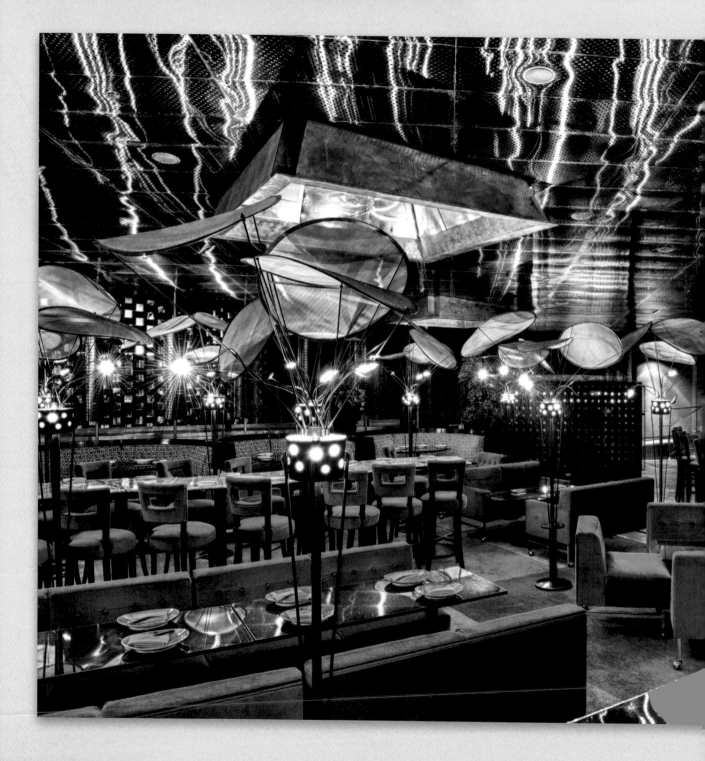

Careful with Putting Too Many Together

I'm a big advocate of putting several of these tips together to make an even better picture. Take a look at this picture as an example. There is texture in the ceiling and chairs. There are rooms with windows and guys in them in the upper-right corner. There's great color. All of these make for a great HDR image, but combining too many of them can be a little overpowering. There is *one* thing that can make this thing better, though...we'll talk about it on the next page.

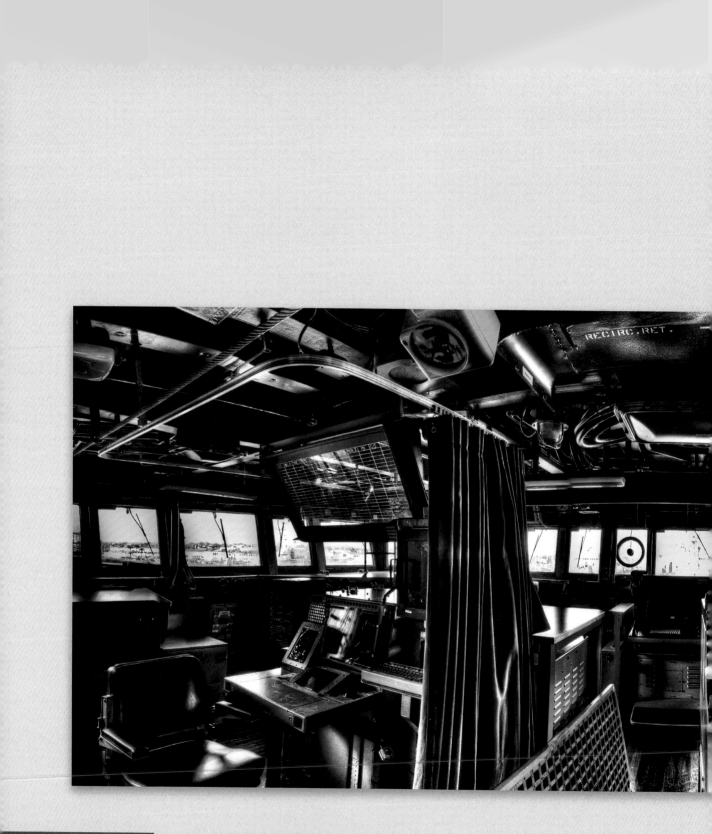

Go Big or Go Home

One thing that I've noticed is that when you combine multiple elements into an HDR image, you don't really get to see the full value of it unless it's printed big. I mean really big. This shot is a 30-image composition that I've printed at around six feet wide. When you have an image this big, you can really stand in front of it and explore regions of it, getting lost in all of the tone and texture.

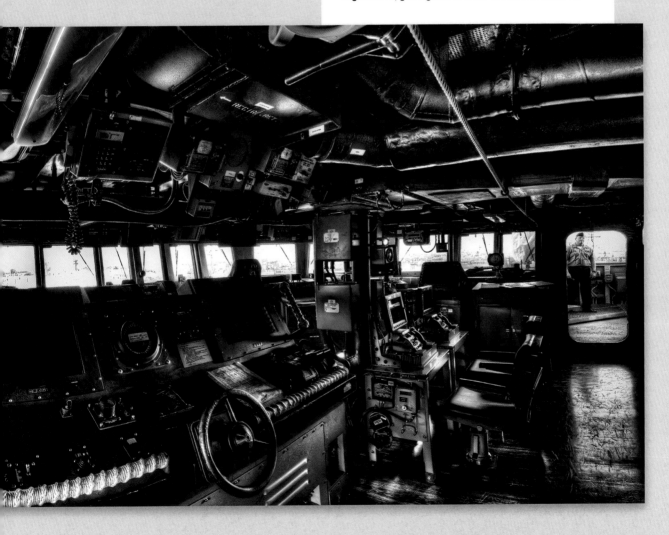

HDR Spotlight: Brian Matiash

Q. Tell us a little bit about yourself.

My name is Brian Matiash. I'm a New Yorker (a Brooklynite, technically), a photographer, and an educator—three things I am most proud of. I'm extremely fortunate to be able to help others help themselves learn how to be better photographers behind the camera, as well as in front of the computer, with my role as Curriculum & Education Manager at onOne Software. I'm a self-taught photographer who first picked up a camera about 15 years ago and hasn't looked back since. HDR has played a critical role in my overall photographic style for about five years now, in both fine art and commercial applications.

Q. What got you into HDR photography?

Simply, I love starting flame wars and HDR is a perfect way to ignite one.

No, that's not really true at all. I fell in love with HDR because of what it affords me in my endeavors to share an image as I remember seeing it *and* subsequently imagine it. I first stumbled onto HDR photography about five years ago while browsing through Flickr. I saw an image that was beyond rich with detail and tone. One of the tags associated with it was "HDR." That was it. From that point on, I made a conscious decision to learn, and try to master, this processing technique.

I've made every mistake you can make with HDR and have churned out my share of jarring images, chock-full of haloes, overly saturated colors, and ghosting artifacts. But, I couldn't shake my fascination with it and I kept learning from whatever materials I could find until it started to really make sense.

Q. How does HDR help you achieve your vision with your images?

This really is a great question because it requires you to differentiate your vision from HDR itself. They are not one and the same. Contrary to many of the attempts you can find online, HDR is not a substitute for keen photographic vision. Rather, I treat it as a supplement to it. My goal is to always try to make a compelling image using my camera and my lens. HDR comes into play when it is warranted, and when it is to the benefit of the final product.

As for how HDR helps me achieve my vision, I tend to gravitate toward scenes rich with tone, detail, and texture. My eyes and brain are not concerned with whether there are actually 14 stops (or greater) of dynamic range in a scene. I just see everything in

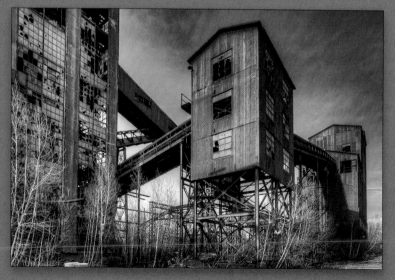

Images Courtesy of Brian Matiash

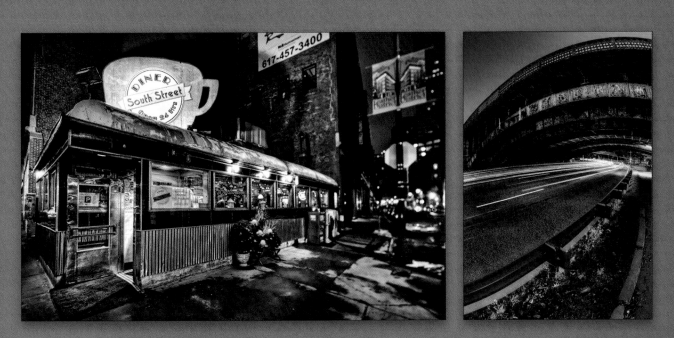

front of me. My camera, on the other hand, is limited in how much dynamic range it can capture in any one exposure. However, by correctly employing HDR processing, I can accurately represent the scene photographically. This is a very exciting and important concept for a photographer like me.

Q. Is there a specific style you find yourself shooting?

I certainly gravitate toward architectural and Urban Exploration (UrbEx)/Abandonment photography. The architecture stems from growing up in a city rich with a tremendous diversity of architectural styles. While I may not be an architect by trade, I certainly love and appreciate it, and want to pay homage to the designers and builders through photography.

The UrbEx style of photography stems from an overall curiosity and amazement about what happens to manmade structures when they are simply abandoned. I often rationalize it as finding beauty in the decay—the art of abandonment.

The two are tied together by what I consider to be my style of shooting. Namely, I love bringing out texture in my images. I don't want to stop at engaging your sense of sight with an image. I want something to register with your sense of touch. If somewhere in the back of your mind, you begin to interpret the content of my

images by imagining what it feels like in tandem with all of the details that you are seeing, then I have succeeded.

Q. What kinds of experimentation do you find yourself doing now with HDR?

There are a few fun experiments that I've been playing around with. I've been studying the differences in HDR when it comes from shooting exposures with a traditional DSLR camera (I primarily shoot with a Canon 5D Mark II) vs. with a medium-format camera with a digital back. It's been pretty amazing to see how much more dynamic range you can capture in a single exposure with a medium-format camera. On top of that, you get unprecedented sharpness in each image.

Another fun area of HDR photography that I've been spending a lot of time with is infrared. I modified my old Canon 40D and had an infrared filter applied on top of the sensor. This has provided me with some very unique results, and I can still take advantage of all of the tonal range within my scenes because of HDR.

Q. Where can we find more information about you?

For more information about my photography, or to contact me, visit my website at http://brianmatiash.com.

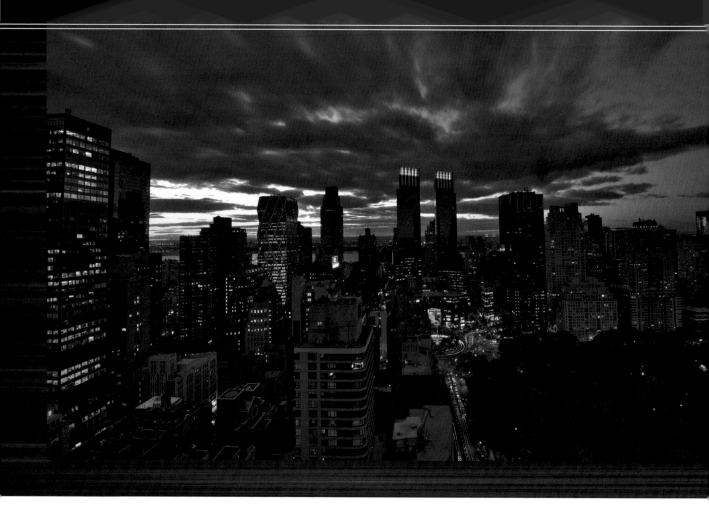

Which Is the Best HDR Software?

One of the most common questions I'm asked is, "Which is the best software to use for making HDR images?" Many people are surprised when I say "All of them," as if I were trying to be cagey about sharing what my true favorite is. The fact of the matter is that it's a lot like listening to someone playing the guitar.

Take B.B. King, for example. B.B. is considered "The King of the Blues." Listen to "Every Day I Have the Blues" or "The Thrill Is Gone" and you'll hear a very distinct sound, and that sound is made by his guitar, Lucille—a custom-built Gibson ES-355. Now, listen to Metallica covering "Whiskey in the Jar" from their *Garage, Inc.* album. James Hetfield (the lead singer) is also playing a guitar, but that sound is very different. His guitar is usually an ESP Explorer. While these two instruments are both guitars, they can sound completely different. The same can be said about HDR software. They essentially do the same thing, but are designed differently.

When software grabs a series of images and makes a tone mapped file, it uses a specific algorithm to make this happen. Photomatix has its own algorithm; Photoshop does, as well. Obviously, these algorithms are their "secret sauce" to creating a file, and they have their own interpretations of how to make it, making the results you see different from software to software. Photomatix files have a specific look—much in the same way Metallica has a very specific sound—and if you like that look, then that's the software you're going to use.

Nik's HDR Efex Pro Is My Main Sound

Lately, when working with HDR files, I have become a pretty big fan of HDR Efex Pro from Nik Software. Coming to it as a user of their other plug-ins, the software looked clean and easy to use. Add to that the fact that HDR Efex Pro has a bunch of algorithms that you

THREE

Creating a Tone Mapped File

HDR Is Tone Mapping

While many people see the HDR effect and say "Oh, that's a really cool HDR," that's not entirely correct. "HDR" is actually the term for the overall technology behind what you see. What you generate out of HDR-processing software is technically known as a "tone mapped file," but it just doesn't sound as sexy.

HDR is all about making sure you make an image where you see all the details in the shadows, as well as the highlights, capturing an entire range of tonality. The problem here is that the file that comes out has so much range, your monitor has no way to show you all that detail. All of the meat is there, but on your monitor, all you see is a big, hot mess.

That's where the process of tone mapping begins. You start by using software to take areas of tones in your image that you can't see and map them to areas that you can see. The parts of the image that become visible, textured, etc., are completely within your control. This is why there are so many different varieties of HDR images and why there are so many arguments about it (I'd start getting used to the following three sayings: [1] The pulling of the sliders is the artwork in HDR. [2] You are the artist. And, [3] everyone argues over what is art and that's okay). The final file has those areas of the image that you couldn't see tone mapped, so you can see them. Voila!

can use in one place and it's like multiple HDR programs in one. Not to mention all of the finishing tools they include in it that make it a one-stop shop. We'll take a look at it in this chapter.

Create Tone Map Presets

You'll find that creating tone-mapped files is largely an experimental process. You'll spend more time dragging sliders around thinking to yourself, "Yeah, I think this looks good. No, wait, how about this," than you will referring to some technical settings for working with files. So, I think it's a great idea for you to save all of that work that you do as a preset. All three software choices I cover in this chapter give you the option of saving presets and calling them up whenever you want. This gives you a quick jump start to a look and can even help you take an image to a level you may not have considered.

Don't Limit Yourself

As cliché as it may sound, I think it's important to remember to not limit yourself to a specific software. Despite my love of Nik Software, I still process using other pieces of software, and always try different techniques. When I open an HDR image to work on, I'll quickly scan through the presets I have set up to see if something jumps out at me. Even if I am going for a very natural look in my image, I'll experiment with a little surreality. You never really know what it's going to look like until you try.

In this chapter, we'll go over my two preferred methods—using HDR Efex Pro and Photomatix—and you'll see how easily they generate a tone-mapped file. But first, we'll go over processing a file using Photoshop's HDR Pro. So, what are we waiting for? Let's get started!

USING PHOTOSHOP CS5'S HDR PRO

There are a lot of people that process their HDR images quite successfully using Photoshop CS5's HDR Pro feature. Photoshop has come a very long way in terms of how it deals with HDR files and considering the fact that you may already own it, being able to tone map your HDR images without having to buy another piece of software is compelling enough for us to take a look at how it works. So, let's check that out!

STEP ONE:

To get started, from Photoshop's File menu, simply choose Automate, then choose Merge to HDR Pro. When the Merge to HDR Pro dialog appears, click on the Browse button, select the images you want to process, and then click OK. To access this feature from Bridge CS5, select the images you want to process, then from the Tools menu, choose Photoshop, and then choose Merge to HDR Pro.

Accessing Photoshop's HDR Pro feature from Lightroom is just as easy. Select the series of images, Right-click on one of them, choose Edit In, and then choose Merge to HDR Pro in Photoshop.

STEP TWO:

After a few moments, you'll see the large Merge to HDR Pro dialog appear, showing you a preview of the processed file. Below the preview window, you'll see a filmstrip with all the different exposures that made up the image, and the options on the right side of the dialog allow you to make adjustments to the image.

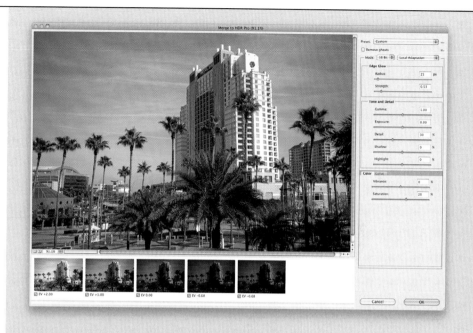

STEP THREE:

One of the things that's really good about this feature is its ability to neutralize ghosting. When there are items in your image that slightly move, this movement produces a blur in the image—think things like clouds, water, fire, people, and your shaking hand on the camera. Turning on the Remove Ghosts checkbox at the top right of the dialog (as shown here) will have Photoshop reprocess the image and remove any ghosts. If you're not happy with the results, you can always select one of the other exposures down in the filmstrip to use as a new "source" image, and it will reprocess the image with this new source file. Here, I clicked on the exposure all the way to the right (the –0.68 exposure; you can see the green selection border around it here).

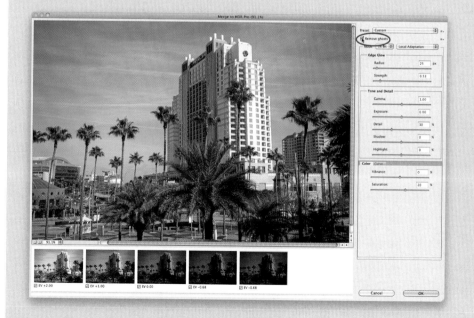

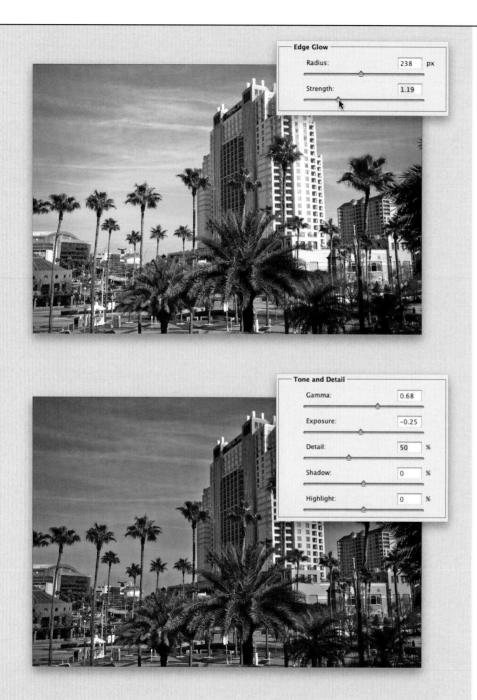

STEP FOUR:

The overall HDR effect is controlled using the two sliders in the Edge Glow section in the top right: Radius and Strength. The Radius slider lets you define how big a specific bright area is, and the Strength slider specifies how far apart pixels need to be before they belong to a specific bright area. Confusing, huh? Well, here's the short of it: most of the time, you'll just end up moving these sliders around looking for the best effect for your image. Here, I increased the Radius to 238 and the Strength to 1.19.

STEP FIVE:

Once you have the overall effect dialed in, you can use the Tone and Detail section to make some fine-tune adjustments. With the exception of one slider—Gamma—all of the sliders in this section easily make sense to anyone who has ever worked with digital photography and Photoshop. The Gamma slider controls the relative amount of brightness and darkness of an image—dragging it in one direction makes more of the image brighter; dragging it in the other direction makes more of the image darker. Think of it as a seesaw: one side is shadows, the other is highlights, and the center is Gamma. Moving it to the left or right changes the overall balance of the image. Here, I set the Gamma to 0.68, lowered the Exposure to –0.25, and increased the Detail to 50%.

STEP SIX:

Once your processing is done, it's time to add a bit of color to the image. You'll notice that there are Vibrance and Saturation sliders in the Color tab at the bottom right of the dialog. Vibrance tends to enhance colors that are under-represented in an image, while leaving colors that are already very prominent alone. It also tends not to overprocess flesh tones, which is what makes it one of my favorite sliders. Saturation? Well that slider just throws color all over the place, so I only use that one for very soft touches. Here, I increased the Vibrance setting to 39% and decreased the Saturation to 1%.

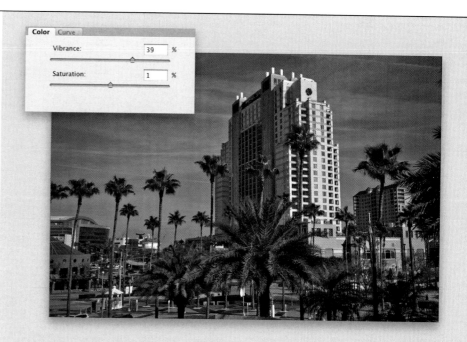

STEP SEVEN:

If you'd like to adjust the overall contrast in the image, you can do this in the Curve tab, also in the bottom right of the dialog. Simply click on the curve to add a point, and then drag that point to increase/decrease the contrast as needed. In this case, I wanted to increase the contrast a little bit, so I added an S-curve by clicking near the shadow areas of the image (near the bottom of the curve), adding a point, and dragging it slightly down. Then I added another point near where the lighter areas of the image begin (near the top of the curve), and dragged it up a bit (as shown here).

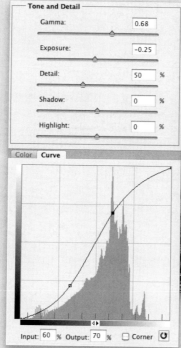

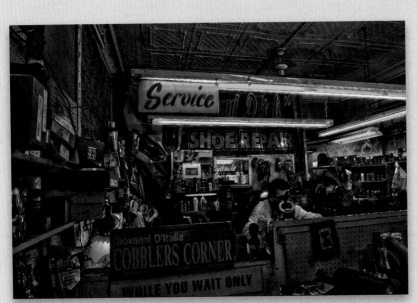

Scott 5 Preset

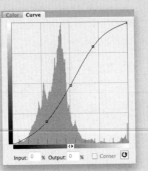

Default

The "Scott 5" Preset

When we were first covering the release of Photoshop CS5 here at Kelby Media Group, we spent a lot of time playing with the HDR Pro feature. While The Photoshop Guys thought that there was a lot of promise in Adobe's implementation of HDR, there was a general feeling of "What were they thinking?" when it came to the presets that were included (none of the presets really met our needs). Scott had just come back from a vacation in China, when he immediately called us into his office. With a confident smile on his face, he said, "Guys...I have it! The preset that will make everything look the way it should in Photoshop's HDR Pro." We looked at his screen and saw a preset called "Scott 5." After applying it to some images, we too were convinced that this one preset would really give you a great effect, or at least a wonderful start (as far as what happened to Scott 1 through Scott 4, they're probably floating around somewhere near Kowloon). Want the Scott 5 preset? You can download it at: **www.kelbytraining.com/books/hdr.**

STEP EIGHT:

Now, while a lot of what you do with HDR toning is experimentation, that doesn't mean you can't take shortcuts here and there. So, once you get a setting that you like all dialed in, make sure you click on the Preset Options icon to the right of the Preset pop-up menu, choose Save Preset, name your preset, and click Save. Now, you'll find this preset in Preset pop-up menu.

TIP: Finding Your Presets

If you need to export a preset, they're saved in the following locations: On a Mac, you can find them in Home/Library /Application Support/Adobe /Adobe Photoshop CS5/Presets /HDR Toning. In Windows Vista, you can find them in Program Files \Adobe\Photoshop CS5\Presets \HDR Toning. In Windows 7, you can find them in User\AppData \Roaming\Adobe\Adobe Photoshop CS5\Presets\HDR Toning (if you don't see the AppData folder in Windows Explorer, go under Tools and choose Folder Options. Click on the View tab and then click on the Show Hidden Files, Folders, and Drives radio button).

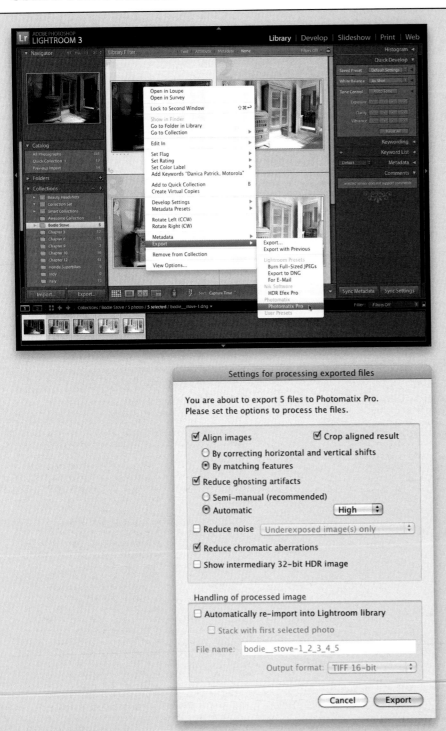

Entering the world of HDR tone mapping, the first program outside of Photoshop that you'll probably run into will be Photomatix by HDRsoft. So, it's a good idea for us to go through the tone mapping process using this software, as I still come back and use it from time to time for a specific look. The results that Photomatix can bring out are quite outstanding. I'll start by showing you how to process an image from Lightroom and then I'll show you how to access Photomatix from Bridge CS5, as well as how to use it as a standalone application.

STEP ONE:

Here, I've selected a series of images inside of a collection in Lightroom by Command-clicking (PC: Ctrl-clicking) on them in the Filmstrip. This gives you a good idea as to what the individual images look like in the bracketed series. Right-click on any of the images in the grid, go under the Export menu, and choose Photomatix Pro.

STEP TWO:

Once you choose Photomatix Pro, you'll get the Settings for Processing Exported Files dialog, where you'll be able to choose how the images will be aligned (in case your camera moved). I usually choose By Matching Features. Then, I turn on the Reduce Ghosting Artifacts checkbox (these are things that may have moved when you took the images, like clouds, water, etc.), click on the Automatic radio button, and choose High from the pop-up menu to the right. I also turn on the Reduce Chromatic Aberrations checkbox.

STEP THREE:
The Handling of Processed Image section at the bottom of the dialog is the most important. I usually turn on the Automatically Re-Import into Lightroom Library checkbox, then add "_HDR" to the end of the filename to make it easier to find the file later. Once you've made your selections, click the Export button.

Handling of processed image

☑ Automatically re-import into Lightroom library
☐ Stack with first selected photo

File name: bodie__stove-1_2_3_4_5_HDR

Output format: TIFF 16-bit

TIP: The Exposure Settings for Generation HDR Image Dialog
In the process of exporting an HDR image, you may run into the Exposure Settings for Generation HDR Image dialog. You'll often see this dialog when you make a really large bracketed exposure (think nine frames) and Photomatix has a hard time understanding what the difference is between the images. You can usually just set the difference in the exposure values in the Specify the E.V. Spacing pop-up menu (if you're doing nine frames, it'll usually be 1), or you can manually enter the values by clicking on the Exposure Value field next to each exposure (as shown here).

Exposure settings for generation HDR image

Exposure information is missing, or one or more images have the same exposure settings.

Please check the estimated Exposure Values (E.V.) on the right column. If they are incorrect, either:

Specify the E.V. spacing: 1
OR
Change the Exposure Values manually

	Exposure Value
bodie__stove-4.tif	2
bodie__stove-5.tif	1
bodie__stove-2.tif	0
bodie__stove-3.tif	-1
bodie__stove-1.tif	-2

Note: The estimated Exposure Values have been rounded to the nearest integer.

Cancel OK

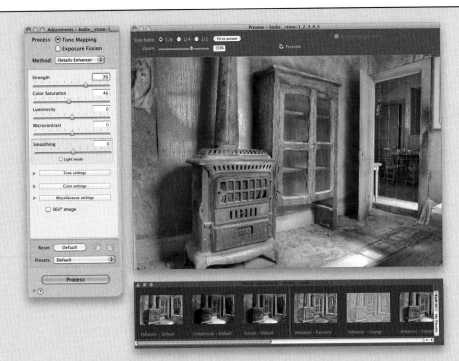

STEP FOUR:

Once you click the Export button, your images will be exported and your tone mapped file will open in Photomatix. The image preview window will show you either the default tone map or the previously used settings (in this book, we'll always start from the default), and in the Presets Thumbnail panel at the bottom, you'll see a series of presets that you can use for your image. For the most part, you'll be spending a lot of time in the Adjustments panel on the left, experimenting with the sliders to make your HDR creation.

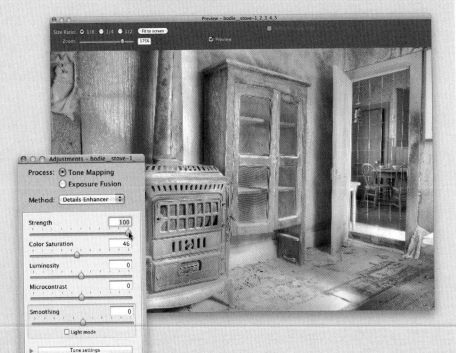

STEP FIVE:

Drag the Strength slider to the right (as shown here), and you'll immediately see a change in the image. To make it easier to see, close any panels you're not currently using, leaving only the Adjustments panel and preview window visible. This will also let you to make the preview window a little bigger.

STEP SIX:

When working on an HDR tone mapping effect, at the top of the Adjustments panel, you'll keep your Process set to Tone Mapping, and your Method to Details Enhancer. Three sliders generally control the overall HDR effect that you see the most: Strength, Microcontrast, and Smoothing. Generally, I keep the Strength setting at 100% and play with Microcontrast and Smoothing for different looks. Microcontrast takes areas of fine detail and makes them more contrasty. This affects the overall texturing of the image. So, if you want the textures to be really "crunchy," drag this slider to the right (here, I dragged it to 9.4). Smoothing is the main effect slider. Drag it to the right, and your image starts looking more realistic. Drag it to the left (here, I dragged it to −0.4), and you start applying the typical HDR effect. By dragging Microcontrast to the right, and keeping Smoothing in the middle, you get a little bit of that HDR look, and definitely a texture boost, but it still stays within the realm of the realistic. I also increased the Color Saturation a little and decreased the Luminosity.

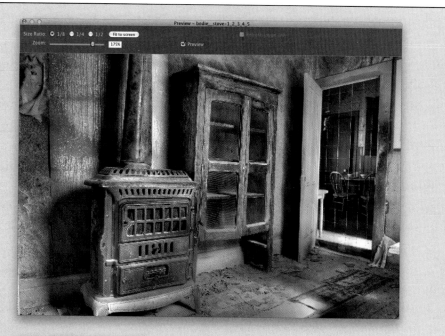

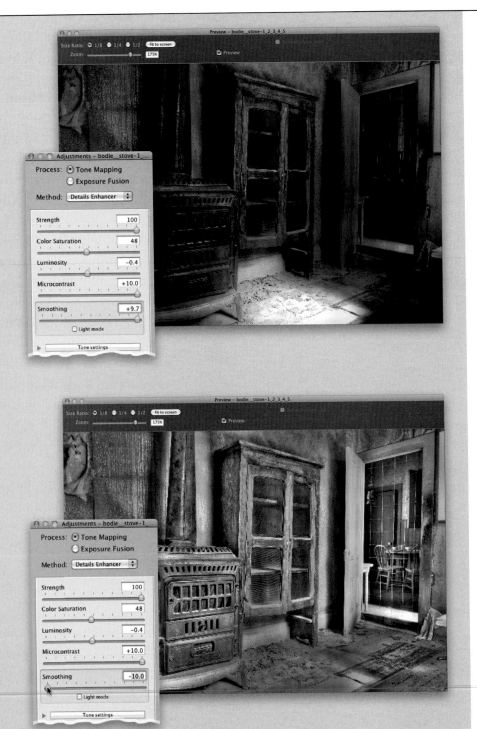

STEP SEVEN:

Here's an example of what it looks like with both Microcontrast and Smoothing set all the way to the right. It starts looking a lot like an underexposed image. You lose a lot of the detail that you were able to see in the doorway on the right side of the image.

STEP EIGHT:

Dragging the Smoothing slider all the way to the left (as shown here) gives you more of a surrealistic look. It's a lot brighter, but you'll also see that the area around the stovepipe looks like it's glowing or radiating. Generally, this is known as a halo, and is very undesirable in HDR photography. Halos are single-handedly responsible for giving HDR the bad name that it has, so you want to avoid them. (*Note:* Before moving on to the next step, be sure to decrease the Smoothing setting. I decreased it to −3.3.)

STEP NINE:

To balance out the effect with a little realism, you can play around with the Black Point, White Point, and Gamma settings in the Tone Settings section. The Black Point slider takes the darkest areas of the image and makes them darker as you drag to the right; the White Point slider takes the brightest areas of the image and makes them brighter as you drag to the right; and the Gamma slider controls the overall brightness in the image. Think of Gamma as the slider that changes the proportions of the dark and bright areas—dragging it to the left makes the overall scene darker (something I always seem to do). By playing with the Tone settings, you can get something that's visually pleasing without being overdone (here, I've adjusted all three sliders). Texturally, the image looks good, but tone mapped files can also suffer a little bit from electric colors.

STEP 10:

Usually, I tell people not to worry about the Color settings here, since we're all about getting good texture. That said, the Temperature, Saturation Highlights, and Saturation Shadows sliders can really cancel out a lot of the neon-looking colors in the image, and save you a step in post-processing. You might want to tweak them a little before you move on. Here, I increased the Temperature and Saturation Shadows settings.

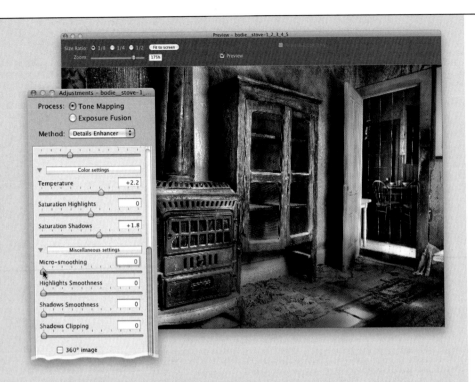

STEP 11:
The last section in the Adjustments panel, Miscellaneous Settings, contains smoothing options that serve as a counterbalance for all of the contrast you create with the sliders in the sections above. If you added a high Microcontrast amount, you can soften it by adding a little bit of Micro-smoothing. Sometimes it's used for softer, more ethereal HDR images, but I personally tend not to use it much. By default, you get a small amount of Micro-smoothing, so I'll just set that down to 0 here.

STEP 12:
What I do like to use, however, are saved presets. A good deal of time can go into experimenting with these sliders to find something creative. While we can't really expect one setting to work wonders on everything, keeping a set of presets handy serves as a good starting point for an effect, and it cuts down the amount of time you'll have to work on a file. So, at the bottom of the Adjustments panel, click on the Presets pop-up menu and choose Save Settings. Give your preset a name and, once you click Save, you'll see your preset in the My Presets tab of the Preset Thumbnails panel. *Note:* I'll be saving presets for all of the images we'll be working on and I'll make them available for you to download on the book's companion website. You can find the address in the book's introduction.

STEP 13:

We're done working on this file now, so to save it back into Lightroom, click on the Save and Re-Import button at the bottom of the Adjustments panel.

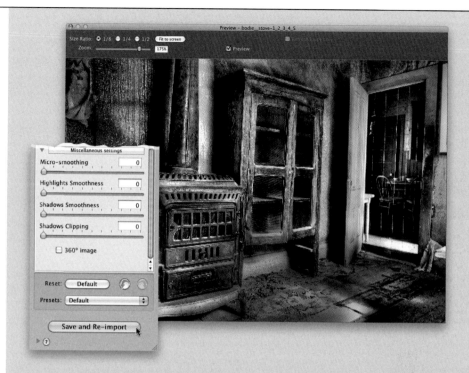

STEP 14:

Now, here's one thing that I can't figure out for the life of me: if you're in a collection in Lightroom and you export a series of files to make a tone mapped file, when you save and re-import, that file will not appear in your collection. I'm telling you this now, so when you save and re-import the file and realize it's not there, you don't start a mad scramble to find it. Here's a quick tip to find it after it has been re-imported: Do *not* deselect the files in the collection that you used to create the tone mapped file. Leave them selected, and click on All Photographs at the top of the Catalog panel (as shown here). You'll be brought to the All Photographs Grid view of your Lightroom catalog, with your images still selected. The tone mapped image is generally between two of the selected frames. From there, all you need to do is click-and-drag the file into your collection and you're all set.

STEP 15:
If you want to use Photomatix as a standalone application, most of the steps are pretty similar to what you just learned, but getting it up and running and saving the file is a little different. So, let's take a look at those differences. First launch it, then choose Load Bracketed Photos from the File menu.

STEP 16:
The Select Bracketed Photos dialog will appear, where you'll click the Browse button and select the images you want to process from a folder on your computer. (If you want to bypass the 32-bit image [the one that looks like nothing happened to the file—see the following tip], just leave the Show Intermediary 32-Bit HDR Image checkbox turned off.) After you've selected your images, click OK.

TIP: The Show Intermediary 32-Bit HDR Image Option

If you turned on the Show Intermediary 32-Bit HDR Image checkbox in the Settings for Processing Exported Files dialog, you may get an image that, well...doesn't look all that good. This option used to confuse a lot of people, because after they clicked the Export button, they thought the resulting file was the exported HDR image. Not the case. This file is actually the super-huge, 32-bit image that contains all of the tonal range, including what you can't see onscreen. This is why the image looks the way it does. So, if you chose this option, you'd have to choose Tone Mapping/Fusion from the Edit menu (or press Command-T [PC: Ctrl-T]) to make the adjustments to the image.

ANOTHER TIP: Save It as a 32-Bit Radiance File

You could also choose Save As from the File menu and save the file as a 32-bit radiance file (just make sure Radiance RGBE [.hdr] is selected from the File Format pop-up menu). This would give you a large file that you could open in Photomatix that could serve as a source file for the HDR. The 32-bit radiance file is to a finished HDR image what a RAW file is to a JPG file.

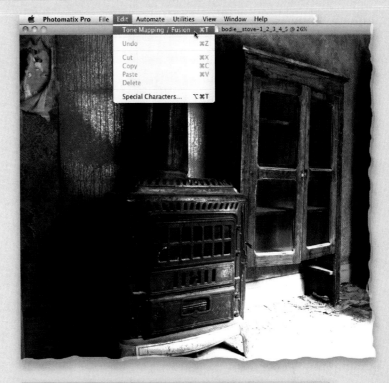

Exposure settings for generation HDR image

Exposure information is missing, or one or more images have the same exposure settings.

Please check the estimated Exposure Values (E.V.) on the right column. If they are incorrect, either:

Specify the E.V. spacing: [1 1/3 ⬍]
OR
Change the Exposure Values manually

		Exposure Value
	bodie__stove-4.dng	2
	bodie__stove-5.dng	1
	bodie__stove-2.dng	0
	bodie__stove-3.dng	0
	bodie__stove-1.dng	−3

Note: The estimated Exposure Values have been rounded to the nearest integer.

[Cancel] [OK]

Preprocessing Options

☑ Align source images ☑ Crop aligned images
 ○ By correcting horizontal and vertical shifts
 ◉ By matching features

☑ Reduce ghosting artifacts
 ○ Semi-manual (recommended)
 ◉ Automatic Detection: [High ⬍]

☐ Reduce noise Strength: ———⬤——— 100%
 ◉ on source images (underexposed image(s) only ⬍)
 ○ on merged image

☑ Reduce chromatic aberrations

RAW conversion settings

White Balance: [As Shot ⬍] []
 (Preview sample)

Color primaries HDR based on: [Adobe RGB ⬍]

(Preprocess)

STEP 17:

Next, you may get the Exposure Settings for Generation HDR Image dialog (like you learned earlier; see the tip after Step Two), and then you'll get the Preprocessing Options dialog (similar to the Settings for Processing Exported Files dialog in Step Two). Here, though, at the bottom of the dialog, you'll have a RAW Conversion Settings section, where you can choose your White Balance and the color mode your HDR image will be based on. Select your options and click the Pre-process button.

STEP 18:

Once you have processed the file in Photomatix (like you learned earlier), you're going to need to save those changes to the file, so at the bottom of the Adjustments panel, click on the Process button. Then, from the File menu, choose Save As. Give your file a name and specify its location. This is also where you'll want to add "HDR" to the end of the filename, which will make it a lot easier for you to locate your HDR file later.

STEP 19:

To process files in Photomatix from Adobe Bridge CS5, the process is just as easy. Simply select your images, Right-click on one of them, choose Open With, then choose Photomatix Pro. You'll get the dialog shown at the bottom here, where you'll want to choose Merge for HDR Processing and click OK, then you'll get the same dialogs shown in Steps 16 and 17. The process is the same from there.

USING HDR EFEX PRO FROM LIGHTROOM, PHOTOSHOP & AS A STANDALONE

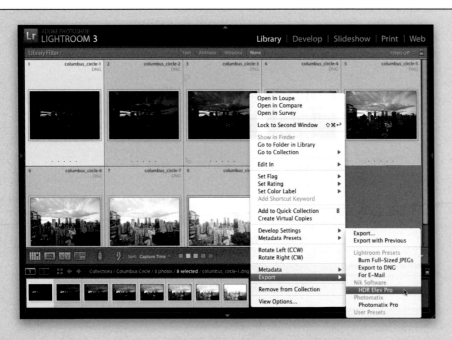

HDR Efex Pro, from Nik Software, happens to be my favorite way to make tone-mapped images. Aside from having really good presets, they've created a one-stop shop for processing and finishing your images. The killer feature, however, is the ability to have different algorithms in one spot. It's like having multiple programs in one.

STEP ONE:

Here, I've selected a series of images inside a collection in Lightroom (we'll cover Photoshop and as a standalone later) by Command-clicking (PC: Ctrl-clicking) on them. This shows you what the individual images look like in the bracketed series. Once the files are selected, Right-click on one of them and choose Export>HDR Efex Pro from the pop-up menu to start the process.

STEP TWO:

After the files are processed in Lightroom, the HDR Efex Pro window, where your tone-mapped image will be processed, will open. The section on the left is dedicated to presets and the section on the right is dedicated to modifying the tone-mapped file. In the Loupe & Histogram panel at the bottom of the section on the right, you have a loupe preview where you can see a close-up of the image, if you want to check for detail. (*Note:* I changed the background color in the center preview area to black by clicking the Change Background Color button—it looks like a light bulb—at the top right of the preview area.)

STEP THREE:

Clicking on one of the preset thumbnails on the left side of the window will automatically change the settings on the right, and the image will change to reflect this in the center preview area (as shown here, where I clicked on the 01 Realistic [Subtle] preset). This is a great place for you to get a quick start when working on an HDR file (but, I'll click back on the 00 Default preset in the next step for this project).

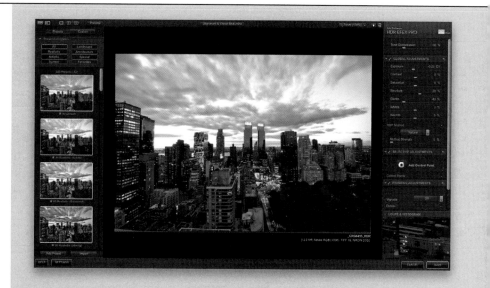

STEP FOUR:

There are three settings that control the overall HDR effect in HDR Efex Pro: Tone Compression, HDR Method, and Method Strength. (If you want to make a comparison to Photomatix, the Tone Compression slider is a lot like Photomatix's Strength slider, while the Method Strength slider is a lot like Photomatix's Smoothing slider.) I usually keep my Tone Compression set relatively high (here, I've increased it to 65%) and do a lot of the heavy lifting with the Method Strength slider, which adjusts how "surreal" the effect will be. Leave it set all the way to the left, and you'll get an image that's pretty unaffected. Drag it to the right (as shown here at the bottom of the Global Adjustments panel, where I dragged it to 50%), and it becomes more and more stylized (but, it can also bring out halos in the process, so be careful).

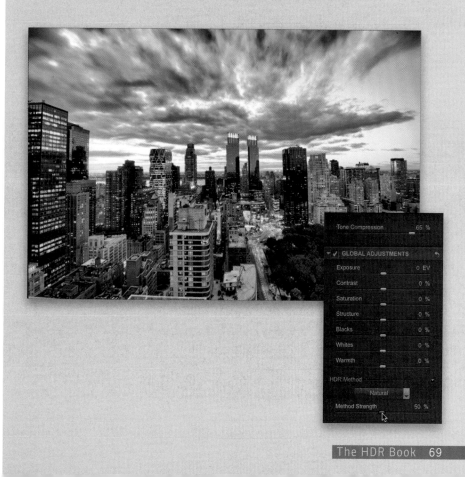

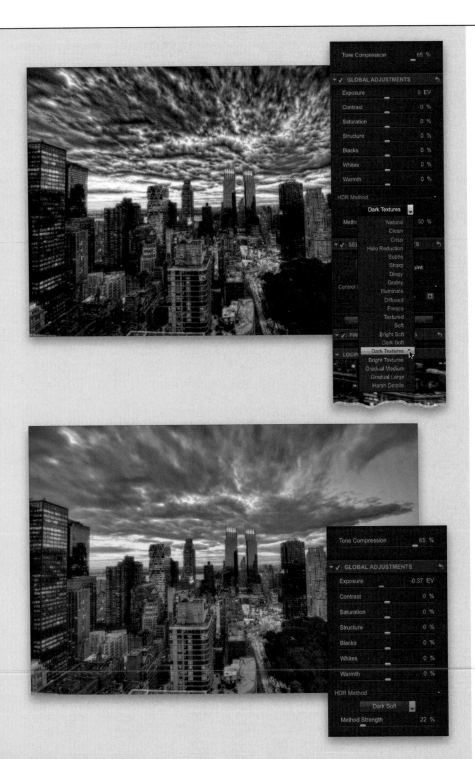

STEP FIVE:

One of my favorite adjustments in HDR Efex Pro is the HDR Method options (found at the bottom of the Global Adjustments panel). Back in the chapter intro, I talked about how different HDR programs use their own algorithms to tone map an image, making each one of them unique. HDR Efex Pro has a bunch of these algorithms in one spot that you can try out, which allows you to get a bunch of different "looks" out of a set of frames. It's like having multiple HDR programs in one. Choosing Dark Textures from the HDR Method pop-up menu, and leaving the Method Strength pop-up menu set to 50%, creates the effect you see here.

STEP SIX:

Choosing Dark Soft from the HDR Method pop-up menu smoothes out the sky and gives this image a little bit of a surreal look. Dark Soft is one of my favorites, but I tend to use it with a relatively low Method Strength (here, I lowered it to 22%) to get a great effect.

STEP SEVEN:

Once you've chosen the appropriate preset on the left and then the compression, method, and, strength for your image on the right, you're still left with some adjustments to take care of. By and large, tone mapping creates oversaturated images, and some care should go into making sure that these images are balanced, so you're not pulling out your hair later. HDR Efex Pro easily lets you change the Exposure, Contrast, Saturation, Structure, Blacks, Whites, and Warmth (similar to color temperature) settings. Use the Exposure, Saturation, and Warmth sliders to make sure the color of the image doesn't get too electric. For this image, I decreased the Exposure to –0.37 and the Saturation to –8%, and then I increased the Contrast to 16% and the Warmth to 61%. Also, Structure is one of my *favorite* sliders Nik makes. It's a great contrast-adding effect, and I tend to apply it liberally to my images if I want that effect.

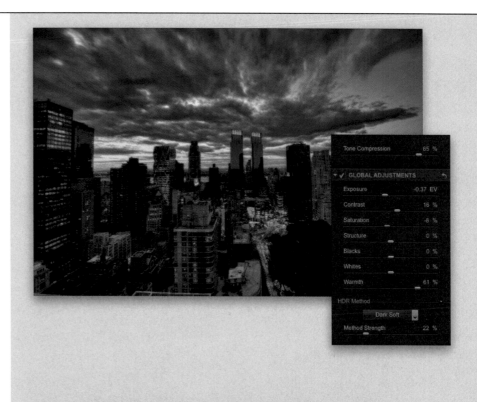

STEP EIGHT:

Another killer feature in HDR Efex Pro is its Control Point feature. In the Selective Adjustments panel on the right, you'll see the Add Control Point icon. Click on this icon and you can drop a point on your image, and then adjust the area beneath it by clicking-and-dragging the onscreen sliders. The top slider (shown here) sets the size of the adjustment circle and the adjustments you make will only affect the area that's covered in the circle.

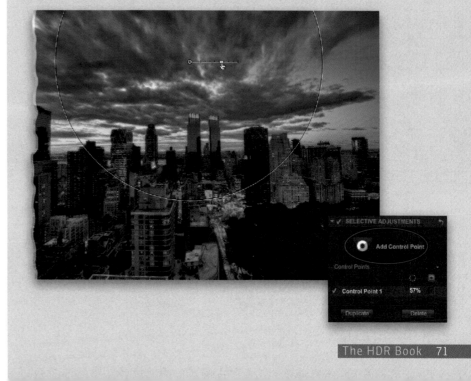

STEP NINE:

With a point in place, you can selectively change all sorts of settings: Exposure, Contrast, Saturation, Structure, Blacks, Whites, Warmth, and Method Strength (if you don't see sliders for all of these settings, just click on the black down-facing arrow beneath the bottom slider to expand them). This is awesome, because you can go around your image and think to yourself, "Okay, this part should be a little underexposed, yet more saturated. This part should be warmer and have more HDR effect." All the while, making these changes by dropping points onto the image and adjusting the onscreen sliders. There are times that the entire image can be completed by just using this feature, which is great. Here, I increased the size of my Control Point adjustment circle to 100% and decreased the Exposure and Saturation. Then, I went back to the sliders on the right side of the window and decreased the Tone Compression and increased the Method Strength.

STEP 10:

I took this picture right during the blue hour time of day, when there is almost no sun left in the sky and everything takes on a bluish look. Since this time of day is never called the "electric blue" hour, I want to pull some of the excessive blue out of this image. HDR Efex Pro scores aces for doing this, because it gives you a panel on the right called Finishing Adjustments. Here, you have the ability to add a vignette to your image, in addition to making channel-specific curve adjustments. So, click on the Details link, below Levels and Curves, to expose the curve, and then from the pop-up menu above the curve, choose Blue. Click on the line to the left of center (the midtones area) and drag slightly down (as shown here). This will pull some of the blue from the image, leaving something more pleasing. You could also switch the pop-up menu back to RGB and use the curve to add more contrast, if needed. Here, I also ended up increasing the Tone Compression.

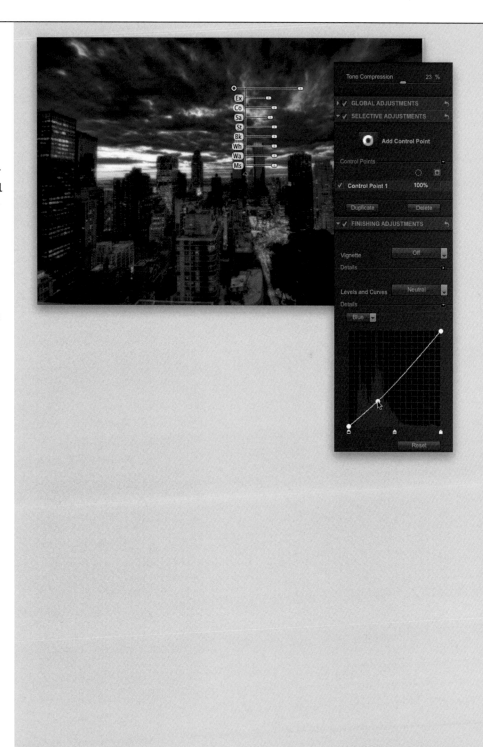

STEP 11:

Like I've mentioned before, if I spend any amount of time working on the tone mapping of an image, I will make sure that I add it to my collection of presets. This lets me cut down my toning process time by getting me close to a specific look, if I need it. So, click on the Add Preset button at the bottom of the Presets tab on the left side of the window, and then give your preset a name.

STEP 12:

Once you've done that, you'll see the preset you made in the Custom tab in the Presets area. If you hover your cursor over the preset thumbnail (as shown here), three icons will appear. The X icon in the top-left corner will allow you to delete the preset, the arrow icon in the top right will let you save your preset if you want to export it, and the two circular arrows icon in the bottom right lets you update your preset with whatever new settings you've added to it.

STEP 13:

You also have the option to open up a series of shots directly from HDR Efex Pro. Simply launch the program and, from the File menu, select Open Exposure Series.

Also, when you download HDR Efex Pro, it's integrated right into Photoshop (if you chose that option). So, from Photoshop's File menu, choose Automate, then choose Merge to HDR Efex Pro.

The only difference that you would see using HDR Efex Pro from Lightroom as opposed to using it as a standalone or using it from Photoshop is how you access your images. When you choose the menu options mentioned above, you'll get the HDR Efex Pro import dialog (shown here). Here, you just click the Select button and choose the files that you want to process. You also have alignment and ghost reduction merge options in the dialog.

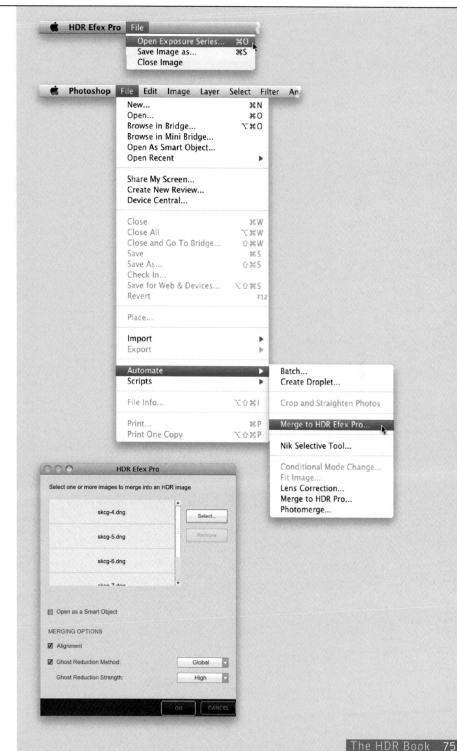

When you're working on the post-processing side of the following projects in Photoshop, you'll notice that there are a number of steps that just keep coming up. Rather than have you re-read the same steps over and over, I figured we could talk about them now, let you know what they are, and focus on just playing with the image.

DEFAULT COLORS/SWAP COLORS

When you're working with layer masks in Photoshop, it's all about painting in black to hide an area and painting in white to show an area. Because you're not always sure what color you have as your Foreground or Background color, I always do this:

Press the letter D—Normally, this switches your Foreground and Background colors to the default of black and white, but when you add a layer mask (or an adjustment layer, which automatically comes with a layer mask), Photoshop switches the Foreground color to white and the Background color to black. If it doesn't, pressing D will get you the same white/black colors.

Press the letter X—This swaps the Foreground and Background colors.

Now, when you're retouching, you don't have to move your mouse and select a color. Two keys, and you're all done.

CREATING LAYER MASKS THAT SHOW AND HIDE BY DEFAULT

A lot of post-processing in Photoshop includes creating a layer mask to hide or show something. Clicking on the Add Layer Mask icon (the third from the left) at the bottom of the Layers panel automatically adds a white mask to a regular layer, revealing the content of that layer. (*Note:* Adjustment layers automatically come with a white mask. We'll talk about them on the next page.) To hide a part of that layer, and reveal the layer below, you'll paint in black with the Brush tool.

If you want to create a layer mask that hides the entire layer, press-and-hold the Option (PC: Alt) key and click on the Add Layer Mask icon. This creates a black mask. To reveal parts of the layer, you'll paint in white.

USING ADJUSTMENT LAYERS

Oftentimes, when you're working with an HDR image there will be corrections that relate to color and tone. In early versions of Photoshop, users had to create a duplicate layer and make the adjustments on this layer. Doing this repeatedly can really increase the overall file size of the image. Adjustment layers allow you to do the same thing without as large a file size, because an adjustment layer does not contain any of the image—it only contains the adjustment (hue/saturation, curves, etc.) and a layer mask to hide the effect from a portion of the image.

If you click on the Create New Adjustment Layer icon at the bottom of the Layers panel (it looks like a half-white/half-black circle), you'll see a menu of adjustments to pick from. Once you select the adjustment you need, it will be created as a separate layer with a white layer mask, which reveals all of the effect, and the adjustment options will appear in the Adjustments panel. If you add an adjustment layer and want to hide the adjustment, simply press Command-I [PC: Ctrl-I] to Invert the layer mask and make it black.

ADJUST YOUR BRUSH ON THE FLY

Photoshop CS5 has made it really easy to adjust your brush. Press Control-Option (PC: Alt-Right-click) and drag right or left: drag to the left, and your brush will be smaller; drag to the right, and the brush gets larger. If you drag up and down, it changes the hardness of the brush: drag upward to make the brush softer; drag downward to make the brush harder. You'll never go back to changing your brush settings in the Brush Picker again! (*Mac Users:* This is the actual Control key, to the left of the Option key.)

MERGE UP!

Whenever I can, I think working non-destructively is the way to go. However, there are times you'll need an actual image layer with all of the changes in it. Instead of flattening all your layers and losing the ability to make changes to them, you can select the uppermost layer and press Command-Option-Shift-E (PC: Ctrl-Alt-Shift-E). This will make a new layer from all of the layers directly underneath it, while keeping those layers intact. The great part about this is that if you don't like the changes you've made after this point, you can always get rid of this merged layer and you still have all the layers with changes you made up to that point.

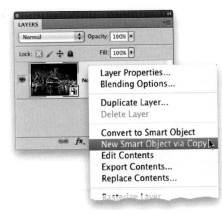

NEW SMART OBJECT VIA COPY

Let's say you have an image as a Smart Object Layer in your document, and you want to make a change, like a really high Luminance Noise Reduction, to only part of the image. If you simply make a copy of the Smart Object Layer, any change you make to the copy will also appear in the original Smart Object Layer. Instead, Right-click on the Smart Object Layer and select New Smart Object Via Copy. This will make a copy of the Smart Object Layer, but break the link between the two, so you can change the settings on one without affecting the other. Then, you can add a layer mask and hide the part of the adjustment you don't want.

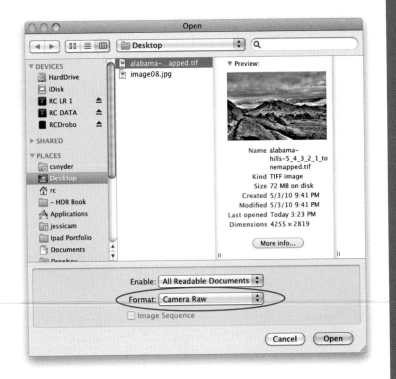

OPEN A FILE IN CAMERA RAW

There will be times when you'll want to open your tone-mapped image in Camera Raw. Perhaps you just get along with the develop settings there better than adjustment layers in Photoshop, or maybe you're trying to access the Sharpening and Luminance Noise Reduction features that are only available in Camera Raw. Either way, if you'd like to take that image into Camera Raw, click on File>Open (PC: Open As) in Photoshop. Select the image, but don't click the Open button yet. From the Format (PC: Open As) pop-up menu, select Camera Raw. Now when you click Open, it will open the image in Camera Raw.

DR. BROWN'S EDIT LAYER IN ADOBE CAMERA RAW

If you're interested in opening individual layers inside of Camera Raw, take a look at a script that Adobe's Russell Brown posted on the Dr. Brown's Adobe Photoshop CS5 Scripts website:

www.russellbrown.com/scripts.html

After installing the script (installation instructions are included in the download), you'll have the Dr. Brown's Edit Layer in ACR option available to you through the File>Scripts menu in Photoshop. Keep in mind that there are some settings you'll have to change before you start running the script, so take a look at the QuickTime videos he has posted with the installer download—they'll take you through the process.

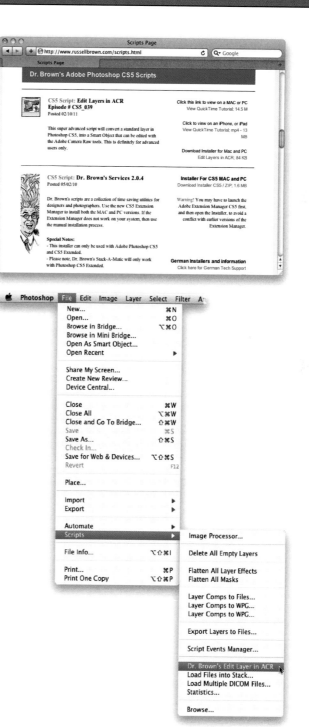

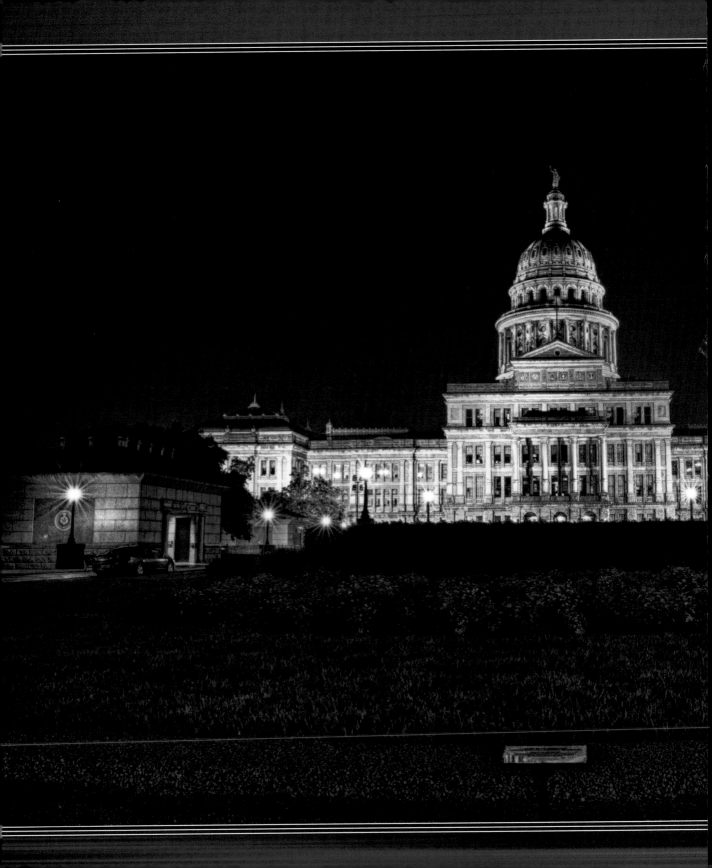

FOUR

Project: The Austin Capitol

I was sitting in my hotel room the day before giving a seminar in Austin, Texas, staring out at the rain. I'd had high hopes for going out and making some great night images, yet the persistent drizzle put a damper on what I wanted to do.

I was wondering what kind of interior photography I could do to pass the time when I got a call from Christina McLaughlin and Dan Zientek. As it turned out, Christina and Dan (NAPP members, and all-around great people) were in the area the day before the seminar and wanted to venture out in the rain to shoot puddles. Rather than mope in the hotel room, off I went on an adventure.

When we got to the Austin Capitol building, I set my tripod down and started making five-bracket exposures, wiping down the front of the lens as best I could in between. After about six attempts at this, we moved on to another vantage point. I didn't think much of the images until I processed them for HDR. It was only then that I was rewarded with something quite interesting.

Bracketing has been around since way before HDR. When you're out in a field, you don't really know when you'll get a chance to shoot it again. Bracketing allows you to hedge your bet for a correct exposure. When you get back to the computer, you can sift through the bracketed shots and throw out the exposures that are off. Now, with HDR, you have an opportunity to add those exposures together to see if the image speaks to you. In that, HDR is just another option in my photographic bag of tricks.

TONE MAP: PHOTOSHOP CS5 HDR PRO

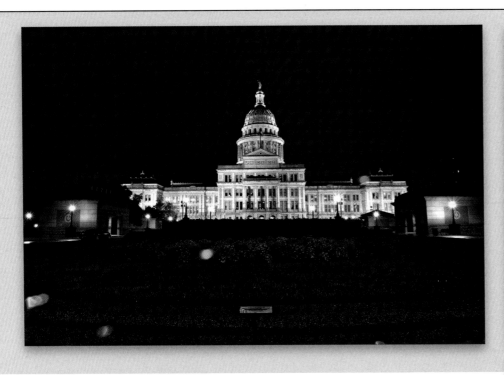

NOTES ON TONE MAPPING

Because of the rainy weather, I figured that a stronger tone mapping would be more appropriate here. Increasing the Radius and Strength allowed me to produce more of a surrealistic night scene. Since it was a darker scene, I adjusted the Gamma setting so there was more of a preponderance of darker tones, and even underexposed the tone map settings. A slight bump in the Curve gave me just the amount of highlight I needed for the building. The processing of the image was a tad bit blue, so that's something I would need to correct later on in Photoshop.

⊡ Download this preset at: www.kelbytraining.com/books/hdr.

TONE MAP: PHOTOMATIX PRO

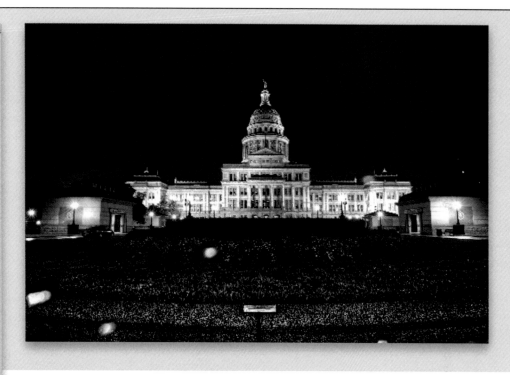

NOTES ON TONE MAPPING

Photomatix made the overall image a little electric in color, so I adjusted the Saturation Highlights and Color Saturation to be a little below what I normally use. My Strength usually stays at 100, so that did not change here. I wasn't looking for too much of a surrealistic scene, so my Smoothing slider didn't drift too much from the right. Because it's a night scene, I did adjust the Gamma and Luminosity to provide a few darker tones to the image. To get the textures on the face of the building, I opted to use a high Microcontrast setting. If I had found later that the image suffered from a noisy sky, I could have gone back and smoothed it out with Photoshop's (or Lightroom's) Luminance Noise Reduction or a blur. Photomatix's resulting image was also a bit blue, so I increased the Temperature to make the building look nicer.

⊠ Download this preset at: www.kelbytraining.com/books/hdr.

TONE MAP: HDR EFEX PRO

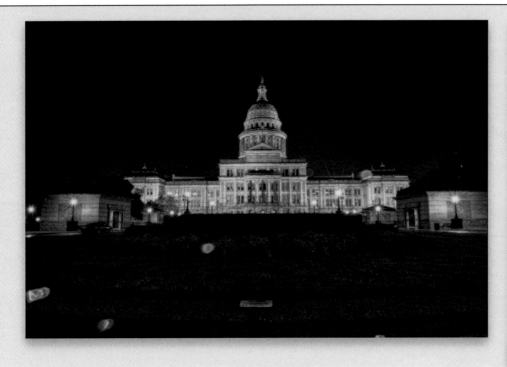

NOTES ON TONE MAPPING

I liked using HDR Efex Pro on this image, because it gave me just the right amount of night feel by using the Dark Soft HDR Method (that's probably my most-used HDR Method). I usually start by setting the HDR Method in the pop-up menu and setting the Method Strength to around 40%, then I fine-tune the image using the Tone Compression slider. Once that was complete, I took down the Exposure and Saturation a little bit, and added a bit of Warmth to the image. To add some darkness, I went back in and added some Blacks to the image. Normally, I add a lot of Structure to my images, but I actually thought it took something away from this one, because it really textured the grass.

🖪 Download this preset at: www.kelbytraining.com/books/hdr.

POST-PROCESSING IN PHOTOSHOP

Out of the three tone-mapped images we just saw, I really like the look from HDR Efex Pro. There are quite a few imperfections in the image, though. Thankfully, all of them are very easily correctable. A couple of clicks, and you can turn this image into something special.

STEP ONE:

Whether it's a dusty sensor or rain on the front of your lens (as was the case here), spots or specks in your photo will immediately appear magnified on the tone mapped image. While they're distracting in an otherwise normal picture, they scream, "Look at me!" in a tone mapped image. So, let's take care of them first. When you look at a photo full-screen, it may look good, but you may see a host of problems when you zoom into it. You should always zoom in to 100% to get the best idea of whether the image needs a little bit of spot work. When I zoomed in here, I saw all of the distracting areas marked with arrows. Ouch!

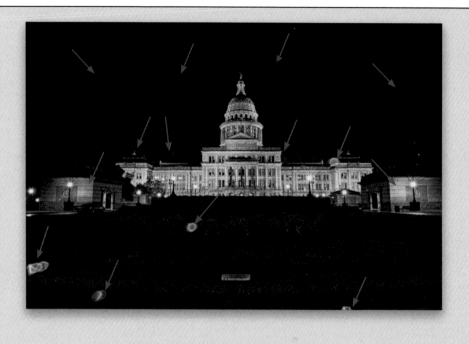

STEP TWO:

For fixing spots on a background, the Patch tool (press Shift-J until you have it) does very well. Sometimes, it can be a little repetitive, though, so here's a quick tip to help you: Instead of making one selection and dragging it immediately to patch, press-and-hold the Shift key after your first selection is made and then make another selection around another spot. This way, you can select a series of spots and once you have all of them selected, you can then drag them in one fell swoop and get rid of them.

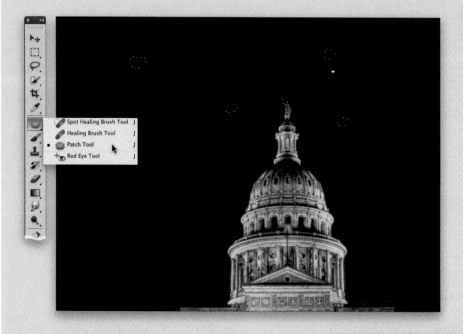

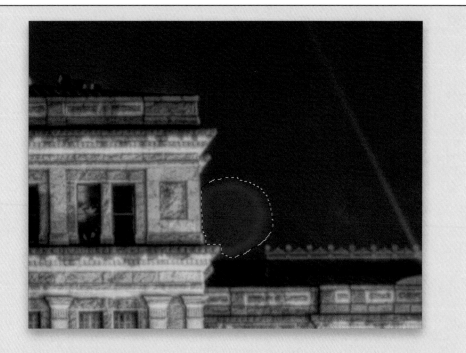

STEP THREE:

Sometimes, you'll work in high-contrast areas with a dark area next to a light area, like the side of this building. Trying to patch this will leave you with something worse than what you already have because of that contrast. So, instead of patching, create a new layer, zoom in really close, and make a selection of the offending area with the Lasso tool (L). Make sure you include only the area that you want to fix, and stay as close as you can to the building edge (the more you zoom in, the easier it will be to make the selection. This is also where a Wacom pen really shines).

STEP FOUR:

Using the Clone Stamp tool (S), Option-click (PC: Alt-click) on some of the sky above this selected area to sample it. With a low Flow setting (up in the Options Bar) and the Sample pop-up menu set to All Layers, paint the sky back in inside your selection. If your Flow setting is low enough, you should be able to make this area look good without a second step. (*Note:* If the selection border is getting in your way, you can hide it by pressing Command-H [PC: Ctrl-H]. Just don't forget to deselect when you're done.) There are times, however, where the edge of the selection will look very "painted in" because of the color of the cloned area (as seen here). This edge will have to be feathered out a bit.

STEP FIVE:

Merge your cloned layer into the Background layer, switch back to the Patch tool, and only select the very edge of the area. Once you have that selected, drag it just a tiny bit away from the building and it should feather itself out, giving you a smoother transition. You may need to use a small Clone Stamp brush to fix the edge of your cloning just above the lower roof.

STEP SIX:

Now, you'll notice that tone mapping an image can introduce a bit of color contamination in some areas. When things you expect to be a certain color look different, it automatically makes the viewer question the authenticity of the image. So, a small adjustment can go a long way here. In this image, the green of the grass has been enhanced to look great, but that green color has transferred itself to the walls of the small buildings at the front left and front right of the picture. You wouldn't look at this scene in person and see green walls, so we're going to need to fix that.

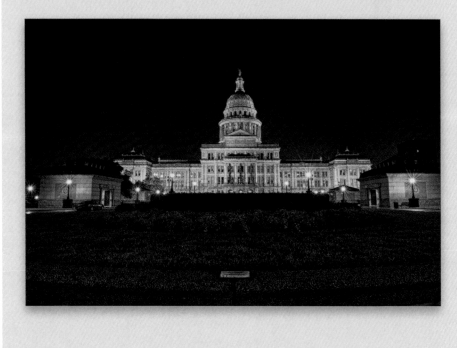

STEP SEVEN:
Add a Hue/Saturation adjustment layer (we covered this on page 78). In the Adjustments panel, change the second pop-up menu from the top to Greens, and then change the Hue from its present green color to another color. Keep in mind that it's going to affect the entire image right now, so just focus on what the wall looks like. Then, press Command-I (PC: Ctrl-I) to Invert the mask and make it black, hiding all of the color change.

Select the Brush tool (B) and with a soft, round brush, paint with white on the mask, revealing the color change you made on the walls. Also, change the Flow setting of the brush, up in the Options Bar, to somewhere around 50%, so you slowly paint in the change on the image.

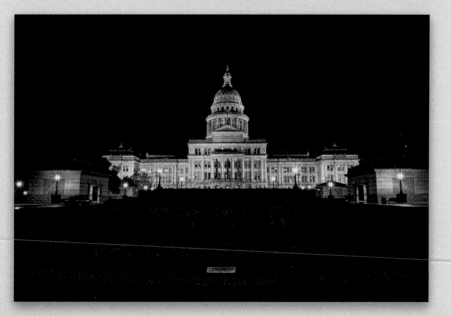

STEP EIGHT:
In film photography, we used to put a filter on our lens to change the color of the scene to match a specific taste. While we can still do this with our DSLRs, making the change in post-production allows you to selectively make those changes to the image, giving more realism to the image. Much of the Capitol building looks great, but it seems that the tone mapping has left the top portion of the building a little blue. Because we don't expect the colors to shift so dramatically on the face of the building, it's a good idea for us to apply a warm Photo Filter to the image, hide it, and paint in only the areas we want to keep.

STEP NINE:

Click on the Create New Adjustment Layer icon and select Photo Filter. In the Adjustments panel, you'll notice that you can select from a series of Filter presets, or a specific color. Here, we'll choose Warming Filter (85) as the start of the effect. Then, invert the mask, hiding the effect behind a black mask. With the Brush tool still active, choose a soft, round brush at a lower Flow, and paint in white on the layer mask to reveal that effect only on the top of the Capitol building.

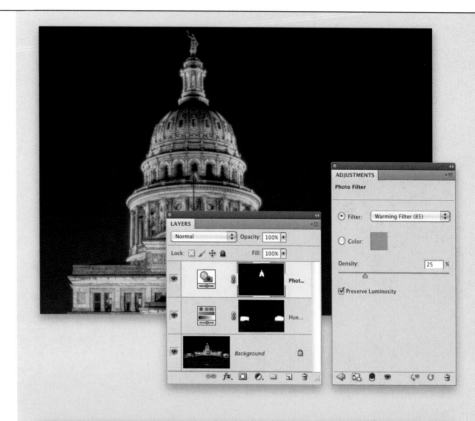

STEP 10:

There are times when you look at an image and, while you don't really know what looks wrong from a color point of view, you know something doesn't look right. In cases like this, Color Balance is one of the simpler adjustments to use. In this example, it appears that the building and foreground look great, but the sky could have more blue in it, making the night look a little bit colder. So, we'll add some additional colors with a Color Balance adjustment layer.

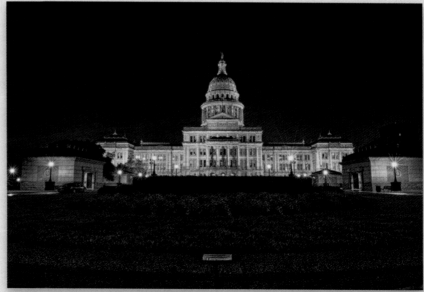

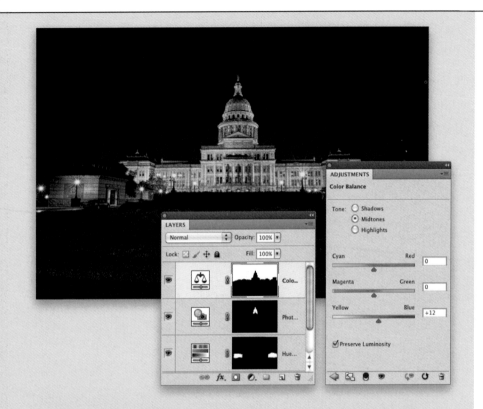

STEP 11:

Add a Color Balance adjustment layer. In the Adjustments panel, you'll see three sliders that you can adjust for shadows, midtones, and highlights. In this instance, we'll leave the Tone set to Midtones, and drag the Yellow/Blue slider a little bit to the right to get some more blue in the image. As we did before, we'll invert the mask, then choose a soft, round brush with a low Flow setting (about 50%), and paint in white on the layer mask, revealing the color change only in the sky area.

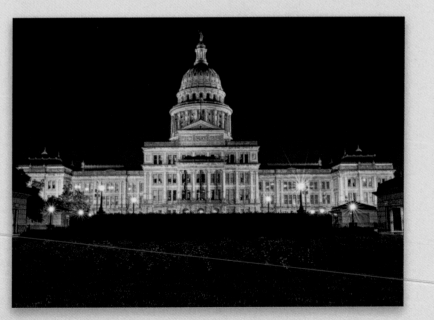

STEP 12:

Now, while a tone mapped file can certainly provide a lot of contrast in images, there are times when you'll want some portions of the image to pop out more than others. Curves adjustment layers are a great way to do this. A simple S-curve and a layer mask, and you're good! In this image, the one thing I'd like is for the building to pop out from the rest of the environment, so let's add a quick S-curve to add contrast, hide that added contrast, and paint back in the building at the higher contrast.

STEP 13:

Add a Curves adjustment layer. In the Curves graph in the Adjustments panel, click on the line in the lower-left portion of the curve to add a point. Drag that point downward slightly, and the dark areas in that range will be made even darker (as you see here). Click again, this time on the upper-right portion of the curve, to add another point, and drag it up slightly to brighten up the highlights in the image. From here, you can adjust the contrast to your taste. Then, invert the layer mask, get a soft, round brush set to a low Flow (about 50%), and paint in white on the layer mask over the Capitol building, revealing the added contrast only on the building.

Adding that contrast to the small buildings on the sides made them greener again, so I clicked back on my Hue/Saturation adjustment layer, switched the second pop-up menu to Greens, and reduced the Saturation and increased the Lightness. I also switched it to Yellows, changed the Hue a little, then reduced the Saturation and increased the Lightness. See the next page for a before/after.

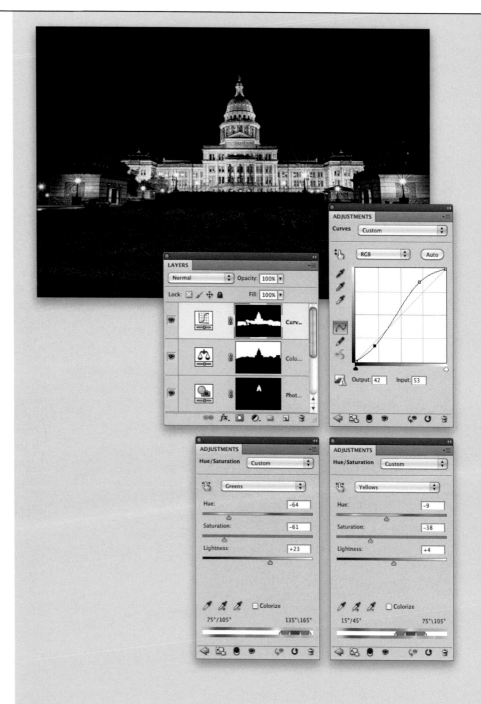

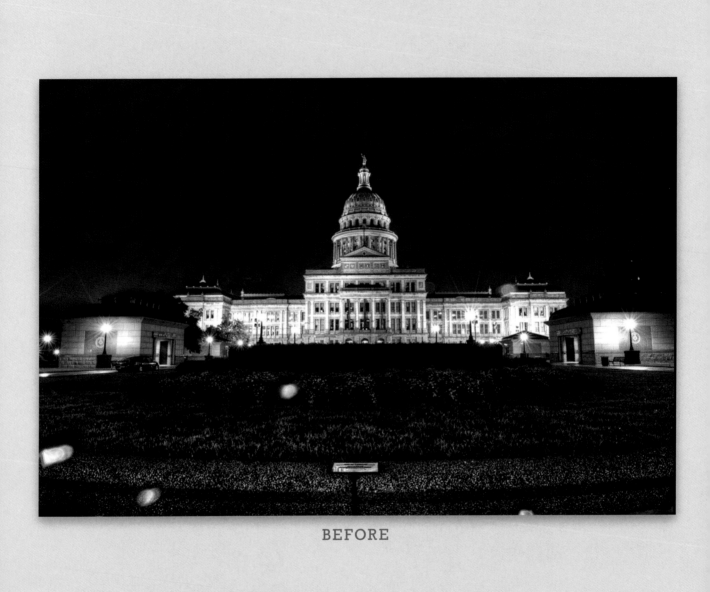

BEFORE

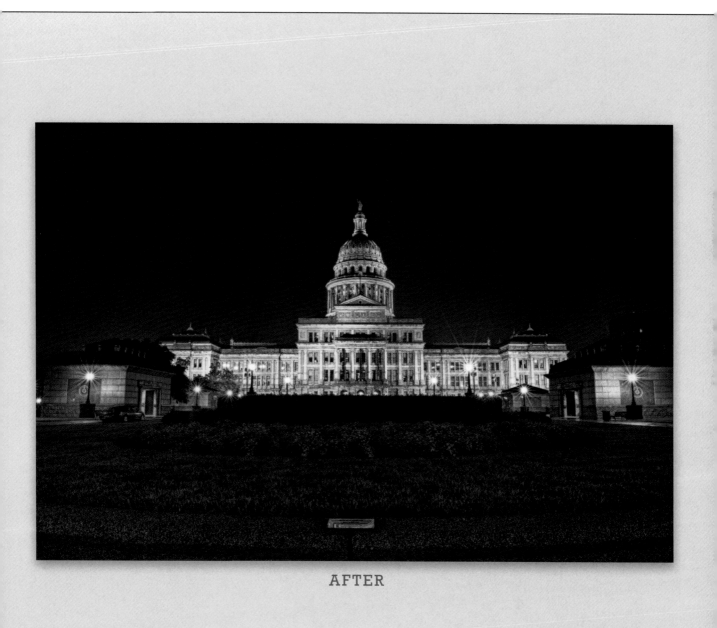

AFTER

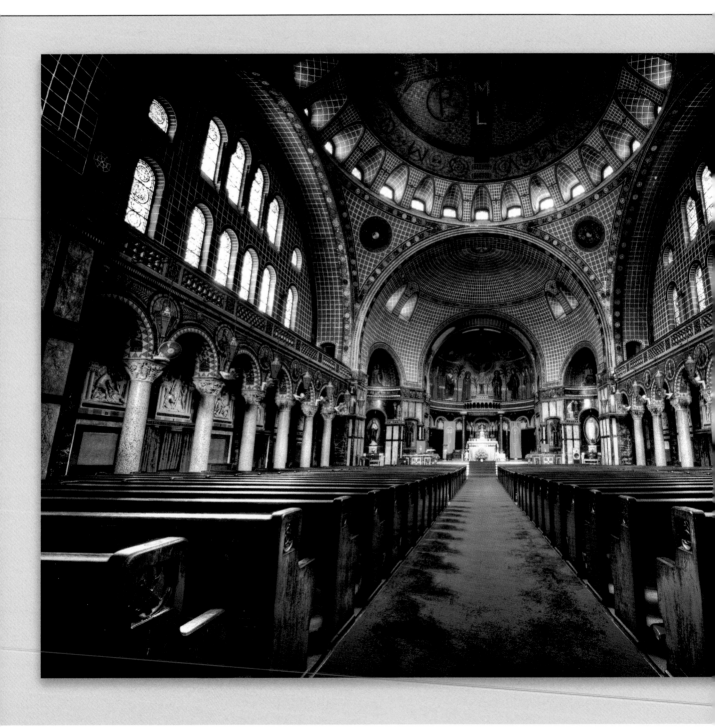

It's Your Turn:
St. Anselm's Church

Felix Nelson is our Creative Director here at Kelby Media Group. When I moved down here from New York City, Felix and I instantly had things to talk about because of the City. As it turns out, Felix spent a lot of his childhood just a couple of blocks away from where I lived in the Bronx. After going back and forth talking about places from the neighborhood, he asked me if I knew where St. Anselm's was. This I did not know, but I made it a point to find out the next time I was in New York.

St. Anselm's is a crown jewel of a church in the middle of the South Bronx. After some talking to the pastor there, I was able to set up a tripod and capture a series of images to make this HDR file. Ever so grateful for the opportunity, I sent them a print of this image. All of the tricks we talked about with the Austin Capitol are in play here. Pay particular attention to the amount of blue toward the center of the image, in addition to the air conditioning vents that line the outside aisles of the church. Now it's your turn. Let's see what your interpretation of this image is.

⊡ Download this preset at: www.kelbytraining.com/books/hdr.

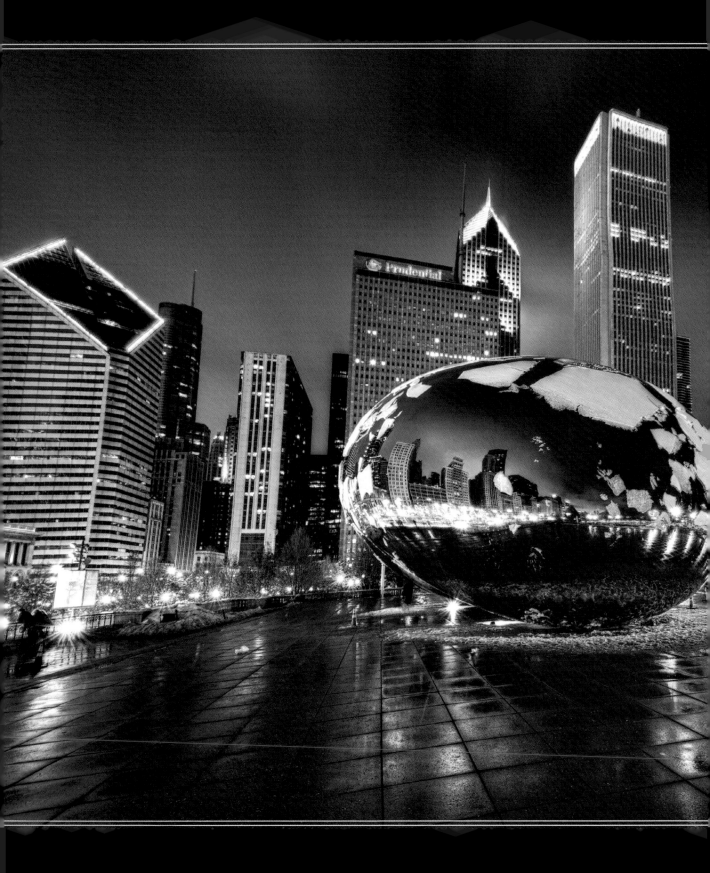

FIVE
Project: Cloud Gate

I've never been that big into sports. It's not that I don't like them, I just never really got around to watching them enough to be able to have an educated conversation about them when they're happening. Most of the time, I'll get invited to watch a football game, only to sit in the back and wonder what the differences really are between Nickel, Dime, 3–4, 4–2, and what everybody is talking about when they say, "Stay in the pocket!"

A lot of this changed when I became friends with Michael McCaskey. Michael is a wonderful photographer whom I made a website for and he's also the recently retired Chairman of the Chicago Bears. After hearing my plight of not understanding the game, he invited me to fly out and watch one firsthand. The game was phenomenal, but the night after proved really good photographically, as well.

I had met up with my friend Sean Bush on the streets of Chicago, and we spent several hours taking images after some snow flurries. Sean invited me to Cloud Gate—a place I'd always called "The Bean" because of the giant bean-like structure that everyone stood for pictures with. With not that many people standing around it, I thought it was a perfect chance to try to do an HDR of it. But, in a shooting situation like this, I didn't think I would get anything special in The Bean and the plaza. What I wanted was the juxtaposition of these elements on an ethereal, dark blue sky. Long shutter speeds, deep colors, harsh textures—this is the sport I most enjoy. That said, I do consider myself a newly minted Chicago Bears fan!

TONE MAP: PHOTOSHOP CS5 HDR PRO

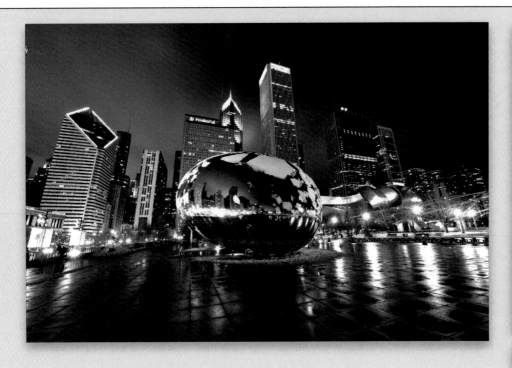

NOTES ON TONE MAPPING

Here, I increased the Edge Glow Radius until I started seeing the textures in the plaza appear. Then, I moved the Gamma slider to the left to make it really dark, and then increased the Exposure for the image. Only when those three settings are complete do I start dialing in Detail in the image, which I increased here. I decreased the Shadow setting to bring the upper-right portion of the image down (and to remove the noise from that area a bit). Then, I increased the Vibrance a bit, and nudged the Saturation down. On the Curve tab at the bottom, I added two points and created an S-curve to add a little contrast.

◨ Download this preset at: www.kelbytraining.com/books/hdr.

TONE MAP: PHOTOMATIX PRO

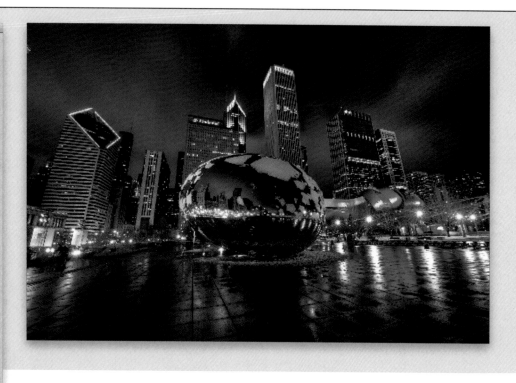

NOTES ON TONE MAPPING

Starting off, I increased the Smoothing and Strength. The Microcontrast adjustment I made started darkening the image, so I recovered some of it with Luminosity. I brought up the Color Saturation, but needed to add some warmth to the image, as it was pretty blue (most of my images end up blue and need to have some warmth added to them). I dropped the Saturation Highlights and Saturation Shadows, as the colors were too electric. I made the sky bluer by reducing the Temperature. Then, I moved the Gamma slider to the left, making the image darker (making the image darker with the Gamma slider is almost a sure-fire way to clean up the tone map), and increased the White Point and Black Point. I make a lot of the changes on the image knowing that it won't look just right until I hit the Tone settings. You can offset any dark Gamma change with Luminosity, and you should be good.

⬇ Download this preset at: www.kelbytraining.com/books/hdr.

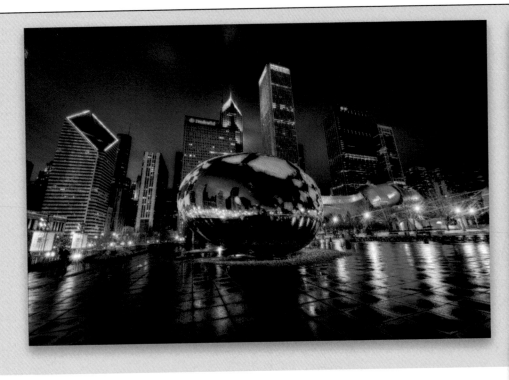

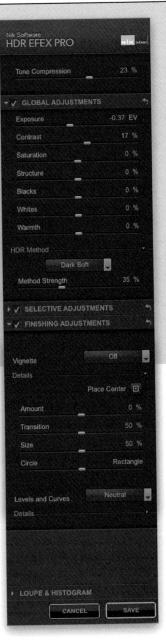

NOTES ON TONE MAPPING

This is another image where I jump right into Dark Soft (in the HDR Method pop-up menu near the bottom of the Global Adjustments section on the right) for some processing. Starting with a medium Method Strength (about 30%–35%), I then dialed back in some Tone Compression. Dark Soft works great for this, because the one reason that I wanted to work with this image in HDR was to produce that ethereal type of sky. I wanted to add some Contrast to the ground and buildings, so I bumped that up a bit and dropped the Exposure. Oddly enough, the image didn't appear to be too cool for me, so there was no Warmth adjustment needed.

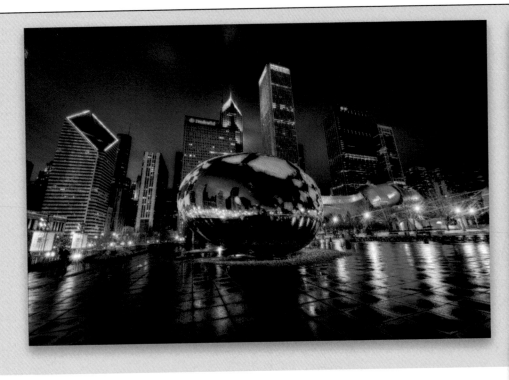 Download this preset at: www.kelbytraining.com/books/hdr.

POST-PROCESSING IN PHOTOSHOP

HDR Efex Pro really gave me that ethereal look that I was looking for in the sky. While the tone mapping was pretty straightforward, the image suffers from problems that aren't really HDR-related. I'd like to geometrically correct the image, as well as texturize the plaza. Let's use Camera Raw to help us with this, and go over how to fix up the scene.

Lightroom 3

STEP ONE:
When you need to work on getting rid of noise in your image, Lightroom and Photoshop have a great tool in their Luminance Noise Reduction feature. To access this feature, you'll need to edit your tone mapped image in the Develop module in Lightroom, or open it in Camera Raw. Here's how to access it:

Lightroom Users
Go to the Develop module and begin processing your tone mapped image for Noise Reduction in the Detail panel. Make sure you zoom in to 100% on the image to be able to see what the noise reduction looks like. The Develop module in Lightroom has exactly the same controls as Adobe Camera Raw in Bridge CS5 and Photoshop CS5.

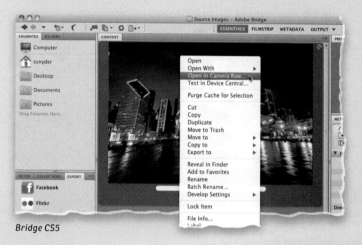

Bridge CS5

Bridge Users
To open your tone mapped image in Camera Raw, Right-click on the image in Bridge and select Open in Camera Raw from the pop-up menu.

Photoshop Users
To open the image in Camera Raw in Photoshop, go to File>Open (PC: Open As). Navigate to the image and click on it to select it. In the Format (PC: Open As) pop-up menu at the bottom, select Camera Raw. When you click the Open button, the image will open in Camera Raw.

Photoshop CS5

Camera Raw

STEP TWO:

Once you're in Camera Raw, click on the Detail icon (the third icon from the left) and process your tone mapped image for noise reduction using the Luminance Noise Reduction slider directly below the Sharpening section. Make sure you zoom in to view the image at 100% to make sure you are okay with the changes you want to make here.

Lightroom 3

STEP THREE:

Oftentimes, when you are working with HDR images, you'll only want to reduce noise in certain portions of the image. Because the Luminance Noise Reduction affects everything in the image, to better control which portions of it have noise reduction and which portions don't, open the image as a Smart Object. Here's how:

Lightroom Users

Right-click on the image that you have applied the noise reduction to and select Edit In>Open as Smart Object in Photoshop.

Camera Raw Users

Press-and-hold the Shift key to turn the Open Image button into the Open Object button. If you find that you prefer to have all of your images open as Smart Objects from Camera Raw, you can click on the link directly below the Preview area and, in the Workflow Options dialog, turn on the checkbox for Open in Photoshop as Smart Objects. That changes the Open Image button to Open Object, and pressing-and-holding the Shift key will convert it back to Open Image instead.

Camera Raw

STEP FOUR:

We now have an image that has Luminance Noise Reduction applied to all of it. If I simply made a copy of this layer and double-clicked on the Smart Object, any changes I made to it would be reflected on both layers—that's the benefit of using them. What I'm looking to do instead is create a second Smart Object, where the settings differ from the first Smart Object. To do this, Right-click on the layer and select New Smart Object via Copy (you learned about this back on page 80). Double-click on the original layer's thumbnail to open the Smart Object back in Camera Raw, where you can reset the Luminance Noise Reduction to 0, and click OK.

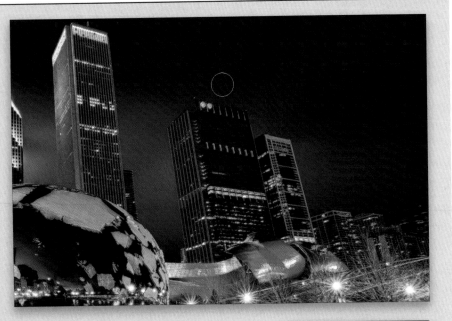

STEP FIVE:

Now we have two layers: one with Luminance Noise Reduction applied, and one with no noise reduction. Rename them, so you know which is which (click on the name to high-light it, then type in your new name). I named mine "No Noise Reduction" and "Noise Reduction." Then, make sure the No Noise Reduction layer is at the bottom of the layer stack.

Make sure the Noise Reduction (top) layer is selected, and add a black layer mask (you learned this back on page 77), hiding the top layer and reveal-ing all of the noise in the layer below. Select the Brush tool (B), and choose a soft, round brush with the Flow set to about 35% up in the Options Bar. Paint with white on the layer mask to reveal the noise reduction only in the areas you want it (as shown here). If you paint too much, you can always switch your Foreground Color to black and paint over it to hide that area again.

STEP SIX:

If you zoom back out, you'll notice there is some distortion, and the buildings are all leaning toward the center. Photoshop CS5 does a great job of fixing these lens correction problems with its built-in Lens Correction settings. Adobe has included a lot of the popular lenses—simply run the filter and Photoshop reads the metadata in your image and makes the changes it needs. First, though, since we want to make these lens corrections to both layers, it's a good idea to create a merged layer (take all of the visible layers and merge them into a new layer at the top of the stack—you learned how to do this on page 79). From here, I would rename the layer (I named mine, "Noise Cleaned Up") and hide the layers underneath the merged layer (click on their Eye icons in the Layers panel). The good part is that if you run into any problems with your image, you can always go back to the source layers beneath it.

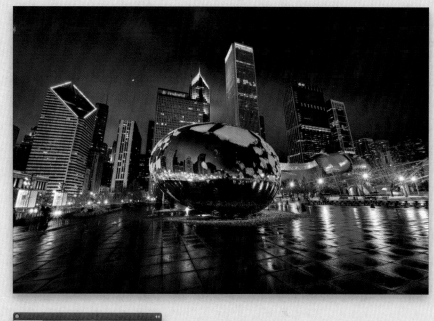

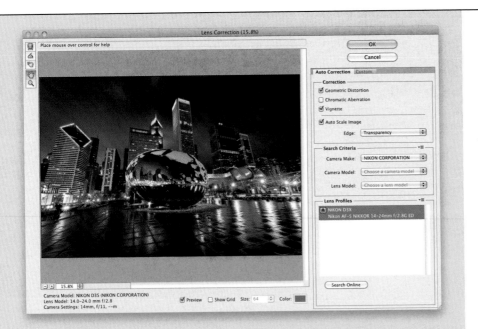

STEP SEVEN:

Now, click on Filter>Lens Correction to open the Lens Correction dialog. Photoshop will read the image's metadata and try to find the camera lens information, then apply whatever corrections it has in its database. They've done a good job of including a lot of lenses here, so you may find that it will automatically take care of choosing that for you. If your image doesn't have metadata or Photoshop doesn't recognize your lens, you may have to do the corrections yourself on the Custom tab. Thankfully, it's just a series of sliders, so it should be easy. When you're done, just click OK.

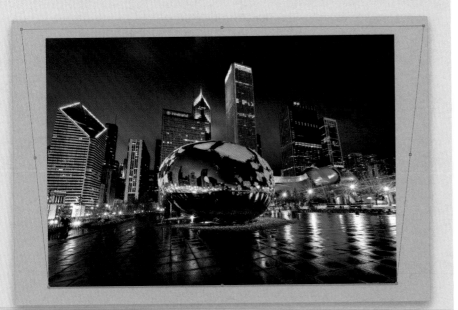

STEP EIGHT:

Here's a trick if you find that the Lens Correction filter didn't quite handle the distortion to your liking. Click on the bottom-right corner of your image window and drag it out so you see some gray around your image, and then press Command-T (PC: Ctrl-T) to access Free Transform. Instead of pressing-and-holding the Shift key to keep any transformations proportional, press-and-hold the Command (PC: Ctrl) key and click-and-drag a corner handle. This will skew the image, letting you set the distortion where you want it. In this case, I am going to click-and-drag both the upper-right and upper-left corner handles to straighten out the buildings.

STEP NINE:

This image does suffer from some water spots, so we'll go ahead and use the Patch tool to clean these up, like we did in the Austin Capitol project (see page 87).

STEP 10:

You'll notice that the plaza (which is actually the roof of a restaurant) and the buildings in the sculpture's reflection and surrounding the sculpture could use a little more sharpness. So, press Command-J (PC: Ctrl-J) to duplicate the layer, then select Filter>Sharpen>Unsharp Mask. I'm using some pretty high settings here to bring back some of that detail in the plaza and on the buildings.

Note: Once you get settings you like, if you only need to sharpen part of the image, you can hide the sharpening with a black layer mask, and paint in white on the mask with a soft, round brush set at a Flow of 35%. This will bring back the sharpness only in the areas where you want it.

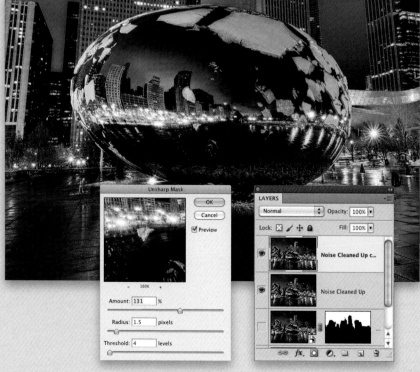

STEP 11:

Take a look at the tall building behind Cloud Gate (the one on the right), and the building at the very left of the image. They are both still leaning toward the center a bit. To fix this, we're going to use Puppet Warp. At first, I dismissed Puppet Warp as a "one-trick pony" effect that was bundled into Photoshop CS5, but my opinions have vastly changed as I find myself using this to correct everything from horizon lines to buildings. Click on Edit>Puppet Warp and you will see a big mesh appear over the image. You'll then have the option to drop "pins" over the image wherever you wish. Once the pins are in place, click on the pin you want to adjust and drag it to where you need it (as shown here, where I'm dragging the top-center pin). Pretty easy, huh? Here's a great analogy to help you understand how the pins interact: Imagine placing a piece of yarn in front of you. On that yarn, you attach three thumbtacks. If you drag one of the thumbtacks, the other two stay fixed, and the string moves in a specific direction. At any point in time, you can add more pins and you can delete pins (by Right-clicking on them and selecting Delete Pin). To adjust the buildings in this image, I dropped nine pins and only moved the top three. Once you're done, press the Return (PC: Enter) key.

STEP 12:

If you need even tighter control with the pins, select More Points from the Density pop-up menu in the Options Bar. This will let you put pins closer together. In this case, I wanted to further adjust the building on the right, so I placed pins all around it and dragged the individual pins until I got the straightening I needed (as shown here). *Note:* If you want to remove the mesh while using Puppet Warp, simply press Command-H (PC: Ctrl-H) to hide it.

STEP 13:

Now that the major problems of the image have been corrected, we can go and adjust the color of the image as a whole using a Color Balance adjustment layer, like we did in the previous project with the Austin Capitol. In this case, I'm adding a little bit of Cyan, Green, and Blue to the image.

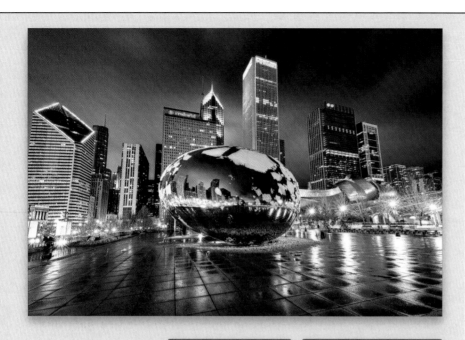

STEP 14:

I wanted the image to have a little more contrast than the original scene, so I added a Curves adjustment layer, as well, and brought the brighter portions of the image up slightly (you learned how to do this in the Austin Capitol project, too). There is a tiny bit of a drop in the curve for the darker tones—just enough to give me a contrast bump.

STEP 15:

To round out the image, I adjusted the blues a little further by adding a Hue/Saturation adjustment layer, as we did in the last project. I liked the color that I was getting with the Color Balance, but I didn't want that color to be so saturated to the right of the Cloud sculpture. Dropping the saturation a bit made that area look a little bit more realistic. Check out the before/after on the next page.

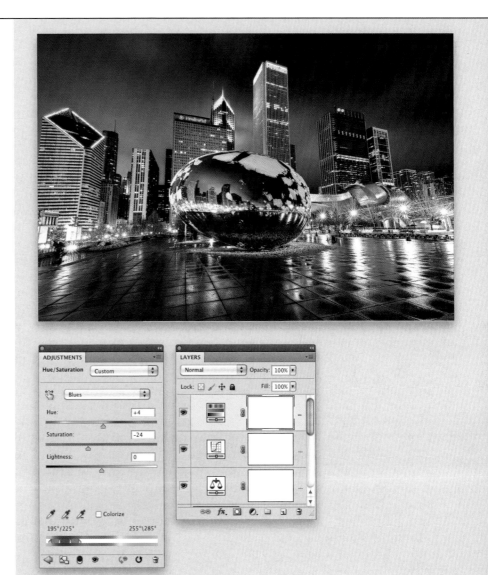

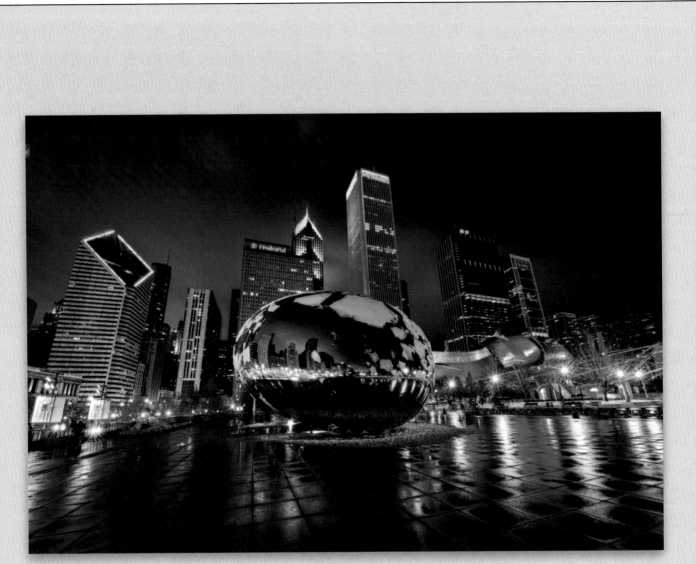

BEFORE

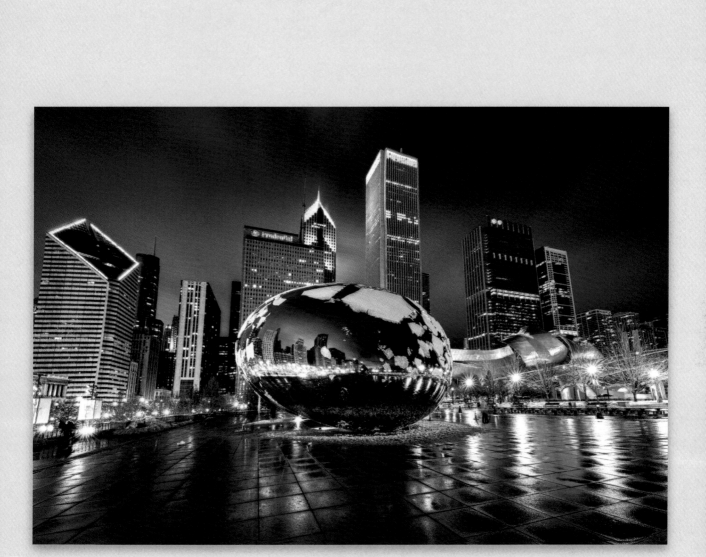

AFTER

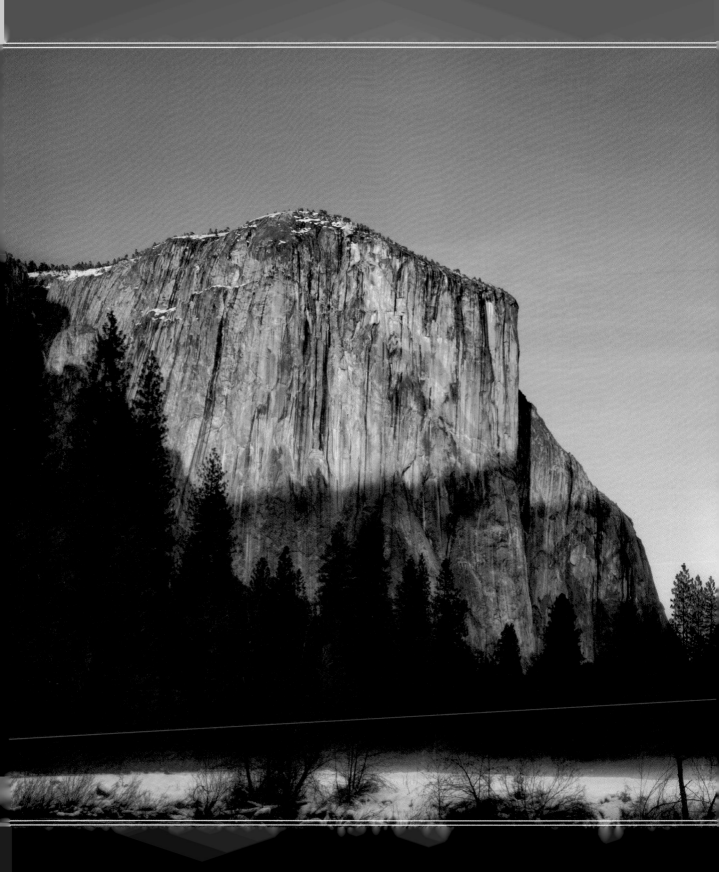

SIX

Project: Yosemite National Park

I recently had the pleasure of teaching with one of my favorite photographers, Moose Peterson, at the Digital Landscape Workshop Series in Yosemite National Park in California. The opportunity to get out there and experiment with a different landscape was something that really called to me. For a couple of days, I found incredible opportunities to just stretch and recharge creatively while exploring this wonderful area.

Of course, I wanted to create some HDR images while I was there, but I knew that I would be fighting a couple of things: You see, as a rule, I don't like shooting skies unless it's during sunrise or sunset, because of the amount of haloing that happens in the image. I also don't like shooting HDR images with trees against the sky, because this seems to be a magnet for halos, as well. So, to combat most of this, I usually go into a "shoot from the basement" mode in my head.

I find that when I'm shooting during the daytime against the sky, shooting five images really doesn't get the darkest points of the scene. So, I like to increase the number of frames that I use to seven or nine. On the most underexposed frame, I'm looking for super-almost-dark images—shoot from the basement. If moving my aperture to a higher f-stop or increasing my brackets doesn't give me this, I will start dialing in exposure compensation to make the image dark. But, because I'm shooting so many frames, I tend to shoot the location fewer times, because it saves me time during the review process to have fewer final images to choose from.

If your camera doesn't shoot nine frames, I would switch to Aperture Priority mode and then choose an aperture. Once that's set, dial in –4 for your exposure compensation and click the shutter. Once that image is done, switch to –3 and click again. Keep going until you get to +4. Get the nine frames. It's worth it, because you never know when you'll be face to face with the beauty in front of you again.

TONE MAP: PHOTOSHOP CS5 HDR PRO

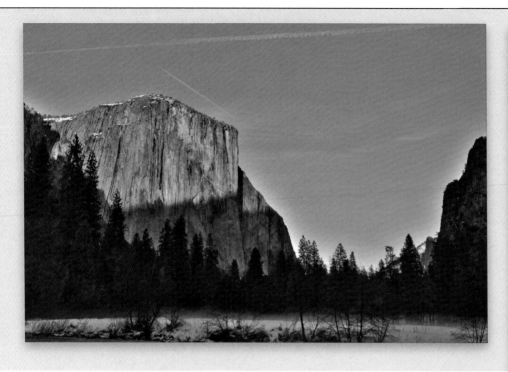

NOTES ON TONE MAPPING

One thing I noticed with this image was that high Strength and Radius settings didn't really do much to help the bright sky. A quick Gamma adjustment, though, darkened it and brought everything into range. The image still felt like it needed more detail in it, so I adjusted the Detail slider to add some. But, be careful with this adjustment, because here it created halo type effects where the trees meet the side of the mountain. I also made slight Shadow and Highlight adjustments. Then, I added a very slight Curve adjustment, but had to be careful as this introduced haloing on the side of the mountain. This was definitely not my favorite software to tone map this image.

◪ Download this preset at: www.kelbytraining.com/books/hdr.

TONE MAP: PHOTOMATIX PRO

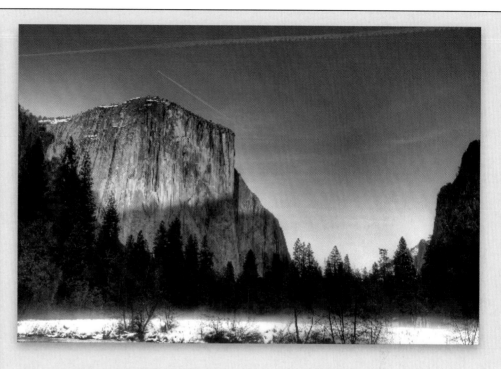

NOTES ON TONE MAPPING

Here, I was happy to see that the image did not contain too many halos where the sky meets the mountain—it gave me a little of bit of wiggle room when working with the tone mapping. I moved the Strength to 100 and increased the Smoothing. I wanted to bring in the detail in the trees, so I increased the Microcontrast, but any changes in Microcontrast usually make the image darker than normal. To counteract that, I increased the White Point and made the Gamma a little brighter. I increased the Color Saturation a little bit, but avoided making it too saturated, as this would cause dark halos where the trees meet the sky. Then, finally, I increased the Luminosity. Another problem in this image is the big contrails, but there's a good chance I will remix a sky from the original images to make this one work. This is common in HDR photographs where you shoot outdoors in the middle of the day against the sky.

▣ Download this preset at: www.kelbytraining.com/books/hdr.

TONE MAP: HDR EFEX PRO

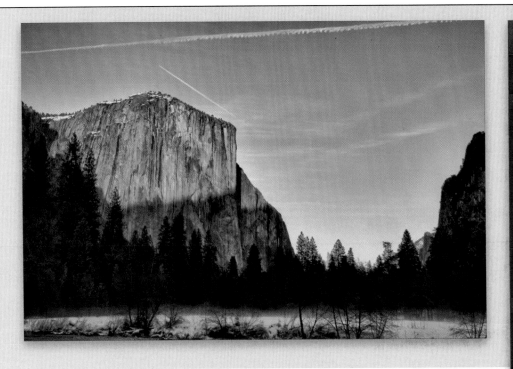

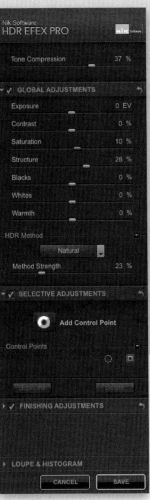

NOTES ON TONE MAPPING

HDR Efex Pro did a great job with the overall tone mapping of this image right out of the gate. But, I did want to punch up the image a little bit more than a normal tone mapped file. So, I increased the Tone Compression and Method Strength to add more detail, then I added Structure and a little bit of Saturation to bring in some of the color on the face of El Capitan.

⊞ Download this preset at: www.kelbytraining.com/books/hdr.

POST-PROCESSING IN PHOTOSHOP

One of the things that I loved about this location was how different the scene was from top to bottom on the frame. Up top, I have a cool sunset happening, while the bottom of the image has a very dreamy winter feel to it. For me, this scene screamed for a very natural, yet ethereal, treatment. We'll rely on some mixing of original images, as well as some adjustments to get a nice blend of real and HDR using the HDR Efex Pro file as a base.

STEP ONE:

Rather than focus on trying to fix the tone mapped version of the sky, let's focus on trying to find the best sky we can from one of the original images. More often than not, with outdoor images shot at non-optimal times of the day, this is a much better course of action. So, to start, I am going to open one of the darker exposures (the –1.00 one) and see how well it works juxtaposed with the tone mapped image. Another reason I grabbed one of the darker images was because it offered a good amount of contrast with the trees and sky. Press Command-A (PC: Ctrl-A) to select the entire image, press-and-hold the Shift key, and drag this image onto the HDR Efex Pro file.

STEP TWO:

To make a selection of the sky, use the Quick Selection tool (W). I love this tool because it really does make your selection as quickly as you can brush on the image. A quick swipe along the sky gave me this start.

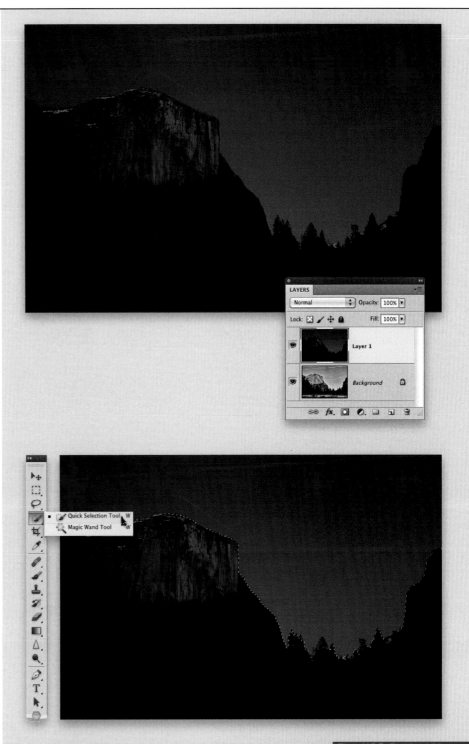

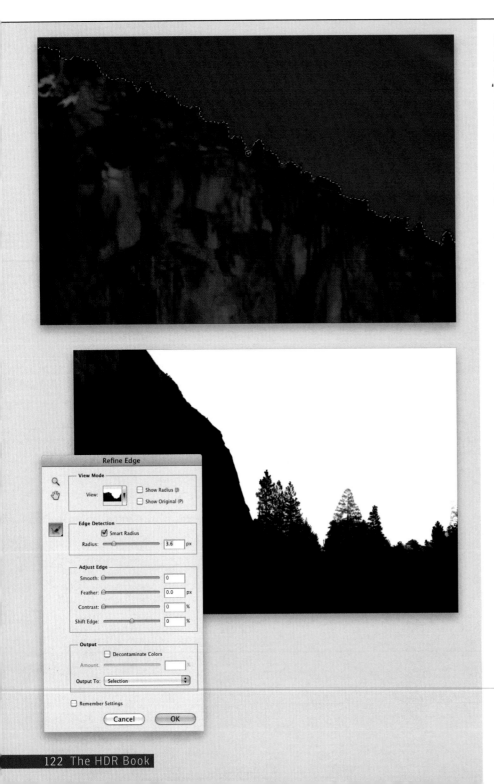

STEP THREE:

Another reason I love this tool is because of the fact that it's a "smart" tool. For example, the selection I made around the mountain isn't really the best, but that didn't bother me. Because, by clicking on the sky areas it missed, the tool easily adds them. If it adds too much to the selection (like part of the mountain), just press-and-hold the Option (PC: Alt) key and click on that area to remove it. Photoshop keeps tabs on what you're adding and removing, so each swipe you make with the tool is "smarter" than the previous one. This makes selecting the smaller portions in the image a lot easier. While this is all great, I still won't spend an incredible amount of time here—good enough is good enough.

STEP FOUR:

Whatever the Quick Selection tool doesn't select, though, the Refine Edge feature can. Once your selection is made, press Command-Shift-I (PC: Ctrl-Shift-I) to Inverse the selection, so that just the mountain and foreground are selected, then click on Select>Refine Edge. Turn on the Smart Radius checkbox and set the Radius to about 3.6 pixels. This will help create a much more accurate selection around the mountain and trees. You can even paint in any area you want to include in the selection, or remove areas by pressing-and-holding the Option key and brushing. This will make selecting the area around the trees at the bottom of the image a piece of cake. Once you're done refining the selection, click OK.

STEP FIVE:

Once the selection is in place, add a black layer mask (you learned this back on page 77) to reveal the new sky with the original foreground. The sky here is actually a little too dark for me, so let's try a different exposure. But, we're not going to repeat the selection steps that you just did. There's an easier way to do this.

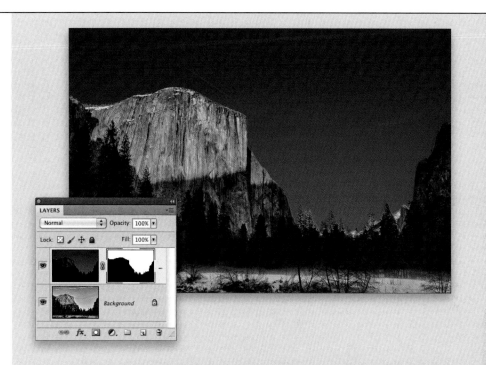

STEP SIX:

Open the new exposure and drag it onto the image the same way we did with the dark sky one. Then, press-and-hold the Option (PC: Alt) key and click-and-drag the mask from the dark sky image on top of the new layer that you dragged over. This will create a duplicate of the mask and place it on the new layer, eliminating the need to redo the selection. With the new mask in place, you'll see that the blending of the trees toward the bottom of El Capitan looks pretty good.

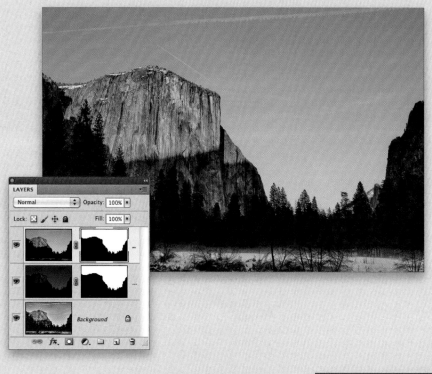

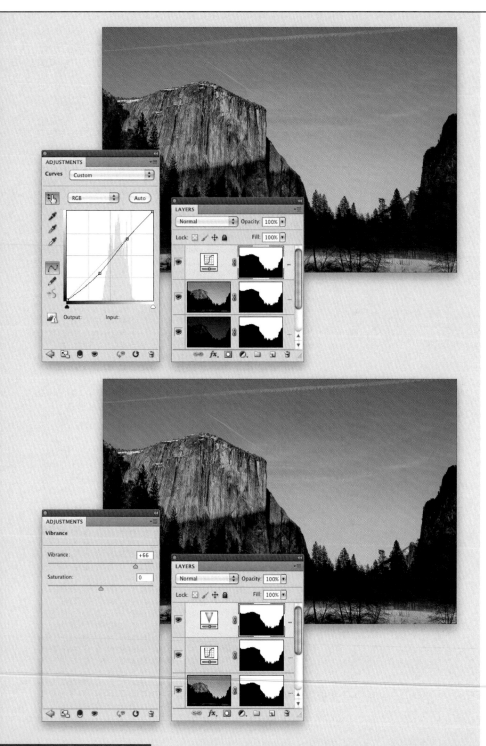

STEP SEVEN:

Let's use that same technique for copying layer masks a couple more times. Create a Curves adjustment layer (you learned this back on page 78) to add a little bit of contrast to the sky with a slight S-curve. Then, Option-drag the layer mask from the layer below onto the Adjustment layer's layer mask to replace it.

STEP EIGHT:

We'll repeat this entire process again, but this time we'll add a Vibrance adjustment layer. This really makes the blue in the sky pop.

STEP NINE:

Removing the contrails in the image is pretty easy. Create a new merged layer at the top of the layer stack (we talked about how to do this in the Things You'll Do a Lot in Photoshop on page 79) and then, with the Lasso tool (L), make a quick selection around the top contrail. Once it's selected, click on Edit>Fill, choose Content-Aware from the Use pop-up menu, and click OK. In a few seconds, it's gone. Press Command-D (PC: Ctrl-D) to Deselect, and then remove the other one.

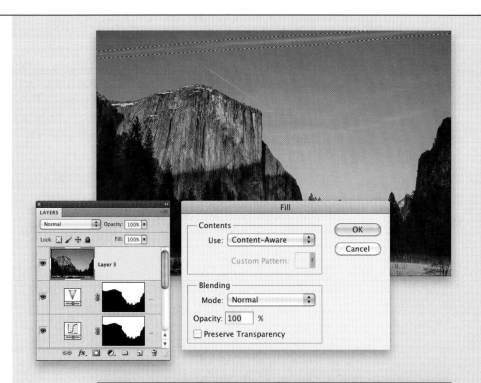

STEP 10:

Now that the major problems with the image have been solved, I'll go back and make some other color adjustments using layer masks. Here, I wanted to play with the blues of the image a bit more, so I added a Color Balance adjustment layer and added more blue by dragging the Yellow/Blue slider to the right. I also ended up moving the Cyan/Red slider just a bit to the right, as well. To remove that adjustment from the trees, I painted on the mask with black using a soft, round brush with a low Flow setting. This let me keep the green in the trees.

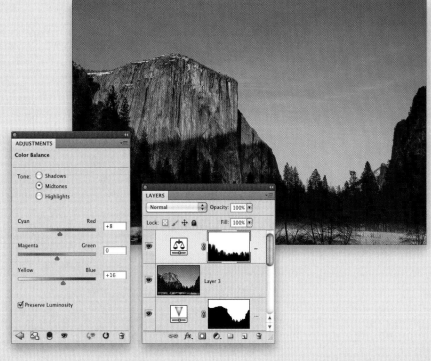

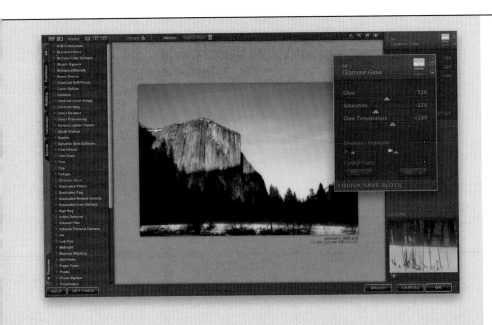

STEP 11:

Now, if I want something to look ethereal, there's a good chance that I will use Nik's Color Efex Pro to achieve that (you can download a free trial at www.niksoftware.com). So, here, after creating another merged layer at the top of the layer stack, I chose Filter>Nik Software>Color Efex Pro. In the Color Efex Pro window, from the list of presets on the left, I chose Glamour Glow, and then I made some quick adjustments to the settings in the top right.

STEP 12:

I really wanted to limit this dreamy look to just the trees. So, in Color Efex Pro, click Brush (to the left of OK in the bottom right of the window) to create the effect on a new layer with a black mask. Now, click the Paint button (under Tools) in the Selective tool (it looks like a Photoshop panel, but will have HDR Efex Pro and Color Efex Pro in it). This will give you the Brush tool with white as your Foreground color, so you can just go and paint in white on the mask over the trees using a soft, round brush with a low Flow setting.

STEP 13:

If the colors shift too much after using the Color Efex Pro filter, you can always go back and apply another adjustment layer. In this case, I decided against having too blue of a sky. So, I added a Hue/Saturation adjustment layer, chose Blues from the second pop-up menu, and dropped the Saturation a little bit. I also adjusted the Hue and Lightness settings just a little.

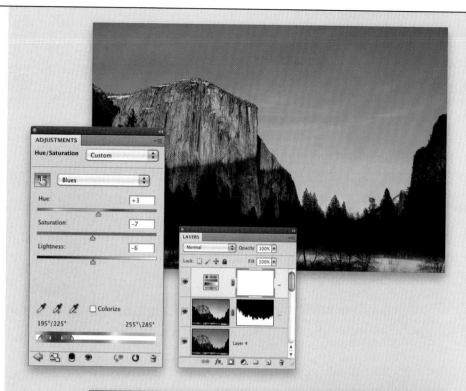

STEP 14:

There were still a couple spots in the sky from dust or snow on my sensor, so I created a new merged layer. Then, I grabbed the Patch tool, selected the spots, and moved the selections to a clean area of sky to fix the spots (we did this back in Chapter 4 on the Austin Capitol photo).

My image is now complete and I'm happy with the effect. In this image, the HDR effect really mimics what my experience was like being there, without being overly processed. You can see a before/after on the next page.

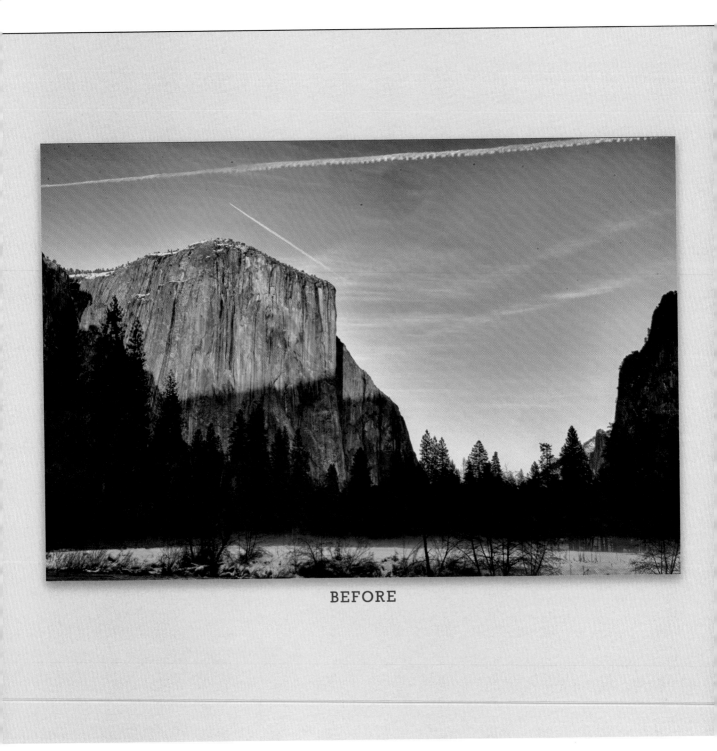

BEFORE

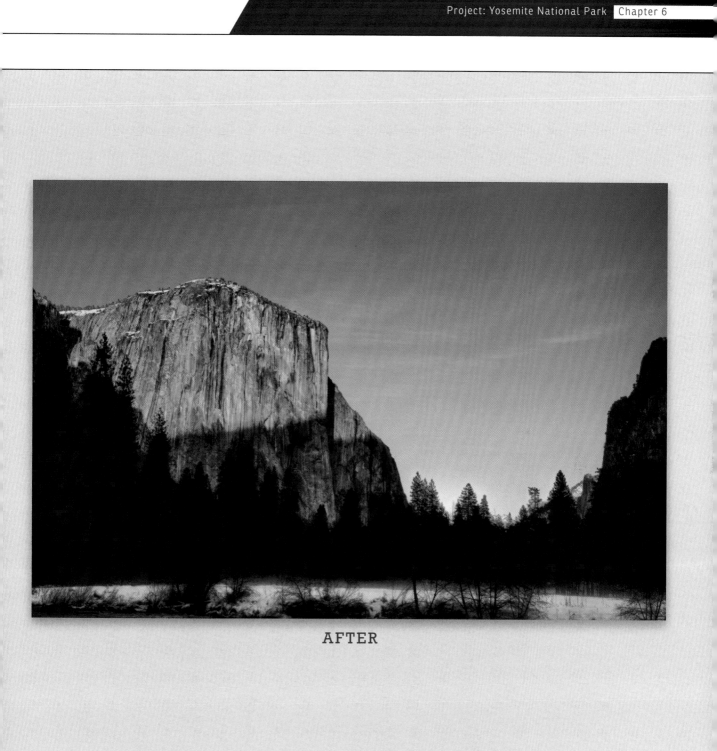

AFTER

HDR Spotlight: Barb Cochran

Q: Tell me a little bit about yourself.

I'm very fortunate to work in the two fields I'm most passionate about: aviation and photography. As a kid, I ran around with my parents' cameras taking pictures, while each night dreaming I could fly. It took me half of my adult life to fulfill the aviation passion.

I learned to fly at a little airport in Vancouver, Washington, called Evergreen Field. They had an antique airplane fly-in every summer that was like a candy store for pilots! I ran around making photographs of all the beautiful planes, and hopping rides in the vintage aircraft. This ignited my flying passion and I dedicated myself to becoming an airline pilot.

After 12 years of airline flying, I still loved flying, but was a little tired of living out of hotels and suitcases. My entire life revolved around flying and aviation. It was out of balance, and my passion was now more like work. I started carrying my DSLR on my trips to exercise the right side of my brain and give the left side a break. I found that the more I got back into my photography, the more energized and jazzed I was about work, photography, and life.

Then I learned HDR, and it totally changed my life! It's the missing dimension, not just in photography, but in life! I see things through "HDR eyes" and especially love making HDR photographs of vintage aircraft, warbirds, paradise, and gators!

Q: What got you into HDR photography?

I was inspired by the HDR images by photographers like Tony Sweet, Trey Ratcliff, and Rick Sammon, and wanted to learn how to do it. One ugly winter day with nowhere to go, I was sitting on a long layover in a dismal hotel room near an airport. That was the day I decided to learn HDR. I signed up for an online HDR class with Tony Sweet right then. After that, I devoured everything I could find on HDR: books, Kelby Training online classes, webinars, etc.

Suddenly, I found myself scheduling my life around the best HDR photo opportunities. If I only had one day off between trips, I'd run over to Cocoa Beach and shoot the Cocoa Beach Pier, or to Warbird Adventures in Kissimmee to shoot vintage aircraft. HDR really set my world on fire and actually changed my life. I jokingly admit that I now see everything through "HDR eyes." A good example of this is the Hydrol containers that were located near our crew room at JFK airport. I looked at them with longing eyes, waiting to capture them with my Nikon and polish their tarnished finish into HDR brilliance.

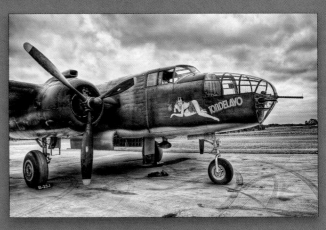

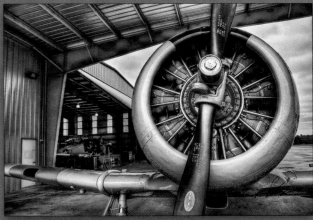

Images Courtesy of Barb Cochran

Q: How does HDR help you achieve your photographic vision?

I once read a quote something to the effect that, "A photograph is not an exact replica of what you see, but rather your opinion." That opinion reflects my mood, feelings, and my vision. HDR is the perfect technique to allow me to express my opinions in a unique visual way. My photographs are positive and optimistic—I see the beauty in the world and my HDR images reflect that. For example, take my three passions: aviation, alligators, and paradise.

Aviation: I love flying and especially love vintage aircraft, which is evident in my aviation pictures. Many of these planes have faded paint and show wear from their years of service. But to look at my pictures, like the one of Tondelayo, I feel I capture the beauty that is only seen through the eyes of the pilots that flew them into battle.

Alligators: Most people find them ugly, but I think they are among the most beautiful prehistoric creatures and I am fortunate to share the planet with them. HDR imagery captures their character and the depth of their wrinkled and textured skin, like a beautiful mosaic work of art.

Paradise: I love all things tropical, and that's why I live in Florida. Visitors often see the colorful shanty shacks in varying degrees of decay, from years of exposure to the salt, sun, and storms. I don't see faded or peeling paint, but vibrant explosions of life through the colors and textures.

Q: Is there a specific style you find yourself shooting?

I find my mood reflects my HDR style for a particular picture. Whether it's mildly illustrative, loosely realistic, or totally painterly. I'm currently having a passionate fling with more painterly images. They are looser and more carefree. When I'm feeling stressed or struggling to balance free time with work, my images are tighter, thus more illustrative or realistic.

The subject matter I'm shooting sets my initial goal. For example, when I shoot airplanes, I shoot with the expectation that they'll be more illustrative, and process the pictures in that style. As I work through the images, I may then rework them and process another version more painterly.

A good example of this is my friend's amphibious plane. It is painted with a vibrant Margaritaville-ish motif, and was sitting in a texturally rich hangar with wood grain and cement blocks. It screamed HDR! I shot wanting to capture the textures and detail, definitely thinking illustrative. Then, I revisited the images, and I totally love a painterly version I did. I guess one complements the physical plane and the other complements the euphoric feeling the plane brings to the pilot.

Q: What kinds of experimentation do you find yourself doing now with the HDR?

I do a lot of post-processing. The right processing can bring out the brilliance of oxidized paint on a plane, or go the other way and capitalize on the textures of the aging surface. Products made by Topaz and Nik are my go-to post-processing tools, and allow me to creatively mix it up and create an endless array of styles. I'm also having a lot of fun with overlays and edges, like Flypaper Textures and onOne products.

Q: Where can we find out more about you?

Visit my webpage at: www.barbcochranphotography.com.

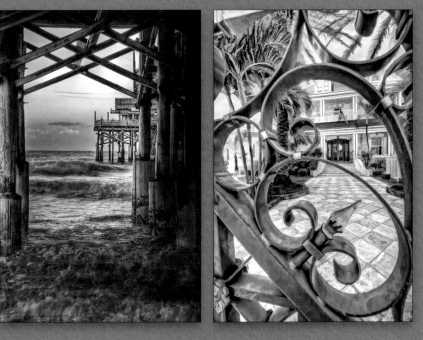

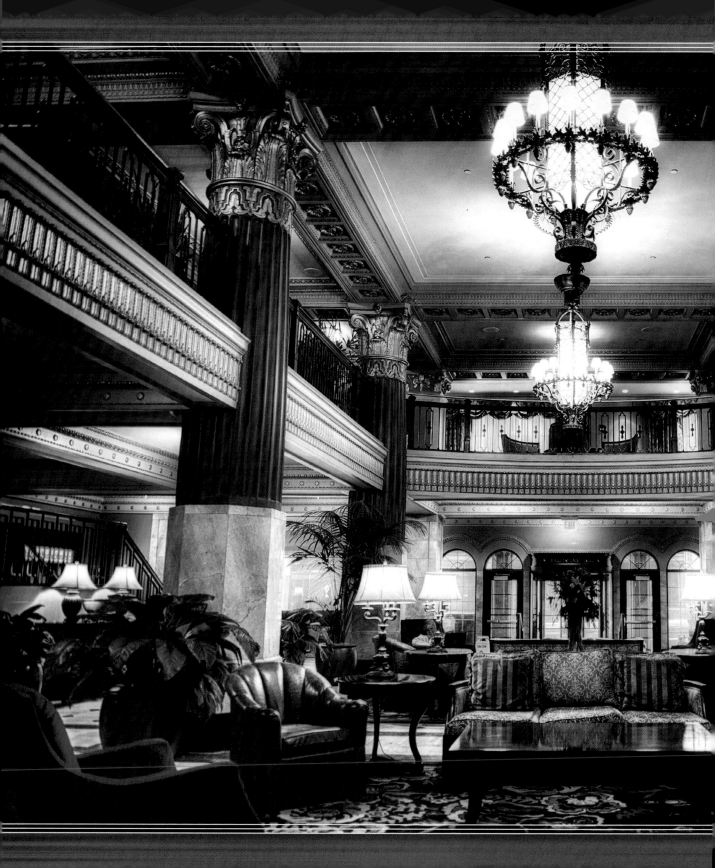

SEVEN

Project: Hilton President Kansas City Lobby

I traveled to Kansas City on a seminar tour, and stayed at the Hilton President Kansas City—a wonderful hotel over in the city's Power & Light District. Despite being in a trendy area, the hotel retains a lot of Old World charm. When you step into the main lobby, you are immediately hit with a lot of ornate design. I instantly thought this would be a great HDR image. There was one problem: I did not have a tripod with me. Did that prevent me from making the shot? Absolutely not!

I noticed that right by the front desk was a bowl of Granny Smith apples for people checking in. As I checked in, I grabbed one of the apples and placed my camera on the counter. Wouldn't you know it? The apple almost fit under the barrel of the lens. After testing a couple of apples (the staff must have thought I was crazy), I found the perfect one. I wiped down the other apples for the rest of the guests, put them back in the bowl, then took the perfect apple I'd found and placed it under my lens. Setting the intervalometer of the camera to fire off five shots every 10 seconds, I got a series of pictures I thought would work for this example.

What else did I get? Why, a very tasty apple!

TONE MAP: PHOTOSHOP CS5 HDR PRO

NOTES ON TONE MAPPING

When the image was tone mapped, I noticed that there wasn't a lot of detail in the default setting. Increasing the Radius gave me back some of the detail I was looking for. Increasing the Strength gave me some contrast in the image, and minimized the amount of blue I was seeing in the windows (which was concerning me). Adjusting the Gamma slider to the left made the image a bit darker, but got rid of a little more color by the windows. To counter-act the Gamma, I raised the Exposure a little bit. A touch of Detail punched up the contrast in the furniture, while dragging the Highlight slider way down brought back some of the blown-out areas in the light fixtures. I also dragged the Shadow slider to the right a bit to brighten the foreground a little.

▣ Download this preset at: www.kelbytraining.com/books/hdr.

TONE MAP: PHOTOMATIX PRO

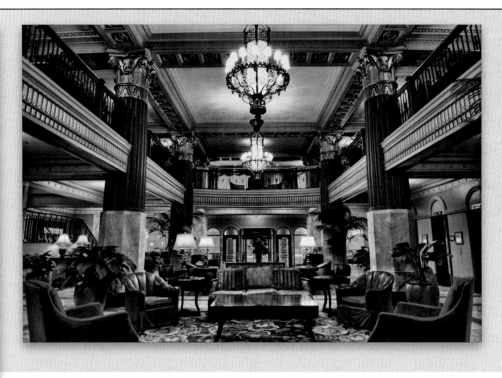

NOTES ON TONE MAPPING

One of the things that jumped out at me was how "dirty" the processing was of the ceiling in the image. There were a lot of dark areas around the light that I thought would need some post-processing later. Increasing the Strength evened the ceiling out a bit, but the Smoothing slider had to be dragged to the right (to normal-land) to get rid of the over-done look. I brought the Color Saturation down, as I thought the image looked too electric right out of the gate. I also increased the Luminosity and White Point to brighten the image a little. The Microcontrast slider and the Gamma slider allowed me to at least get a glow from the light above, but if I want to use this image, I may need to mix in an original image in post-processing (like we did in the last project).

⊠ Download this preset at: www.kelbytraining.com/books/hdr.

TONE MAP: HDR EFEX PRO

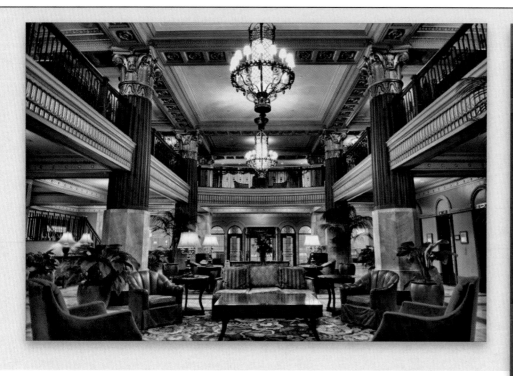

NOTES ON TONE MAPPING

This image required very little fidgeting with the sliders in HDR Efex Pro. The Natural HDR Method setting seemed to look the best here. I moved the Tone Compression slider to 100%, and that took care of the ceiling in the image. From there, I started bringing up the Method Strength slowly, until I got to a number that I thought looked good. I brought the Exposure down a little, decreased the Saturation a bit, and gave the image a little bit of contrast by increasing the Structure and Contrast. From there, it was off to the races.

🔲 Download this preset at: www.kelbytraining.com/books/hdr.

POST-PROCESSING IN PHOTOSHOP

Here, I found that the HDR Efex Pro image was the one that did a good job on the ceiling and outside the windows, and with the textures on the inside of the lobby. This image doesn't need too much post-processing, but there are some tried-and-true things that you can do to really make it sing. The last part of the tutorial showcases Color Efex Pro, one of the most often used tools for creating the HDR ethereal look.

STEP ONE:

Great HDR or not, nothing calls attention to itself like a basic problem with your photography. In this case, I noticed that the apple didn't do a great job of keeping the camera level. So, select the Ruler tool (it's nested beneath the Eyedropper tool in the Toolbox, or press Shift-I until you have it). Now, we'll look for an area in the image that should be straight. Just over the arched windows by the door there's a straight line that you wouldn't expect to be slanted, so that's where we'll click-and-drag with the Ruler tool (as shown here).

STEP TWO:

Once you draw the line that should be straight, click on the Straighten button in the Options Bar, and the image will automatically be straightened. This button is new to Photoshop CS5. If you're using an older version of Photoshop, click on Image>Image Rotation>Arbitrary. It will automatically add a degree in the Angle field based on where you drew the line. Click OK, and it will align the image.

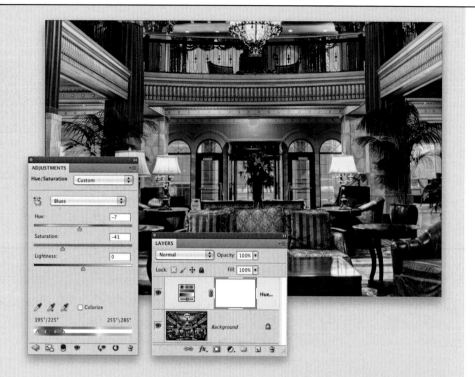

STEP THREE:
If you quickly scan the image, you'll notice that there's not that much blue in it, except for the windows near the front door. We want to fix those windows, so create a Hue/Saturation adjustment layer (you learned this back on page 78). Select Blues from the pop-up menu above the sliders, then drag the Saturation slider to the left until the windows at the back look less blue. I also dragged the Hue slider a little to the left to change the shade of blue in the windows. If you find that portions of the image don't look great after you do this, you can always paint in black on the layer mask to bring the colors back in those areas.

STEP FOUR:
I wanted to add a little bit of roughness to the image, using the High Pass filter. So, merge up your layers (as I showed you back on page 79) to put all your changes into a new layer, then press Command-J (PC; Ctrl-J) to make a copy of the merged layer. Click on Filter>Other>High Pass and set the Radius to about 3. This will give you an image that looks partially gray, with some edges outlined.

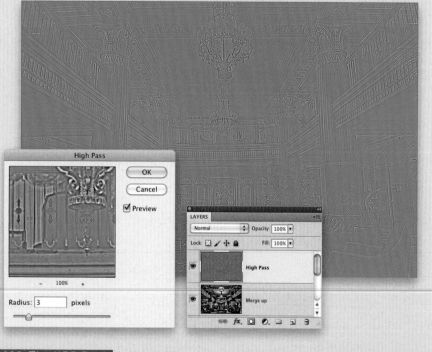

STEP FIVE:

Switch the blend mode of the High Pass layer to Soft Light, and you'll instantly see a more textured appearance in your image. If you'd like a little bit more roughness, simply delete the layer and repeat the previous step with a higher Radius. If you'd like to selectively apply this effect, you can add a layer mask (you learned this on page 77), and paint in black in the areas where you want to hide the effect.

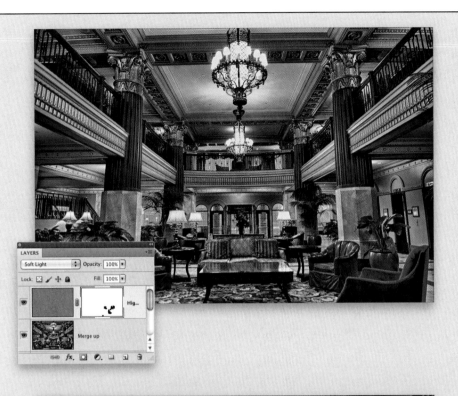

STEP SIX:

I'd like to be able to take the edges of the image and darken them up a bit, but I don't want to use the Burn tool to do this. I'd also like the effect to be uniform—darker than a lens vignette, but controllable on a layer when I need it. So, to do this, first we'll need to merge our layers up again, then we'll make a duplicate of the merged layer, and set that layer's blend mode to Multiply. This will make the image darker, and start the effect off.

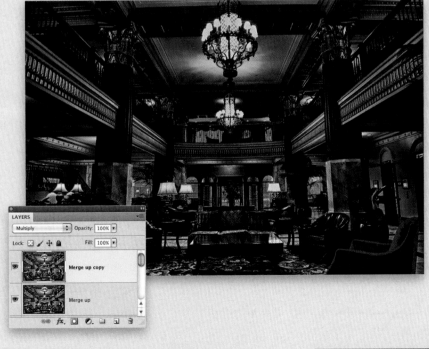

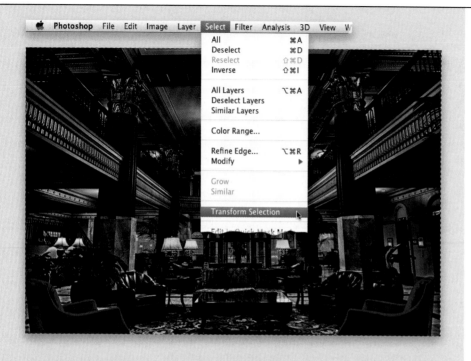

STEP SEVEN:

Now, press Command-A (PC: Ctrl-A) to put a selection around the entire image. A common mistake at this point is to press Command-T (PC: Ctrl-T). This brings up Free Transform, and will transform the entire layer. We're looking to just transform the selection. So, click on Select>Transform Selection instead.

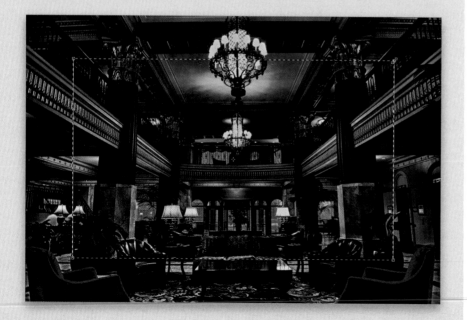

STEP EIGHT:

Press-and-hold the Option (PC: Alt) and Shift keys, click on one of the corner handles and drag it inward. The Shift key will keep the transformation proportional, while the Option key will force the transformation to happen from the center of the image. Once you have the selection resized the way you want, press the Return (PC: Enter) key.

STEP NINE:

Darkening the corners of the image should happen gradually. So, click on Select>Modify>Feather, enter a large number (since this is a high-res image, I entered 200), and click OK.

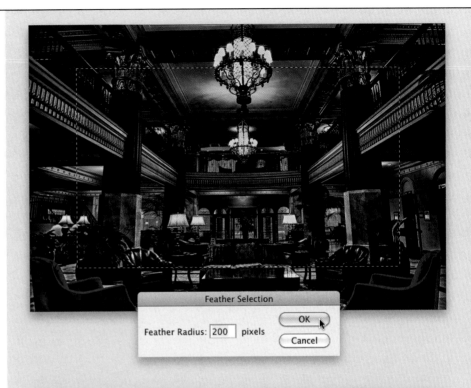

STEP 10:

You'll know the selection that you made is soft if you see the selection rectangle morph more into a rounded rectangle, as shown here.

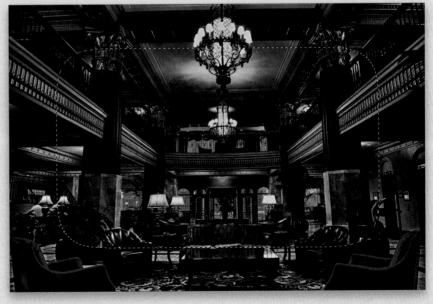

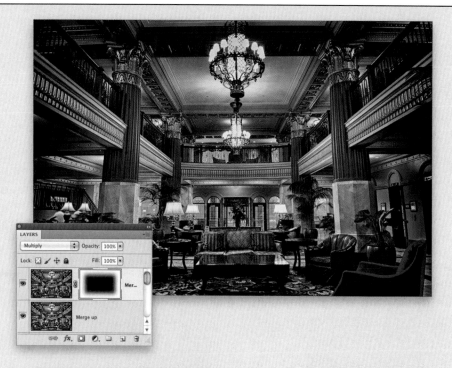

STEP 11:

Option-click (PC: Alt-click) on the Add Layer Mask icon at the bottom of the Layers panel, and you'll notice that only a portion of the image stayed dark. The layer mask hid the portions of the image that were under the selection. It filled the areas outside the selection with white, creating the vignette effect. What I like about doing it this way is that it allows me to taper the effect off with an opacity adjustment, or paint back in any area that I think needs to be brighter.

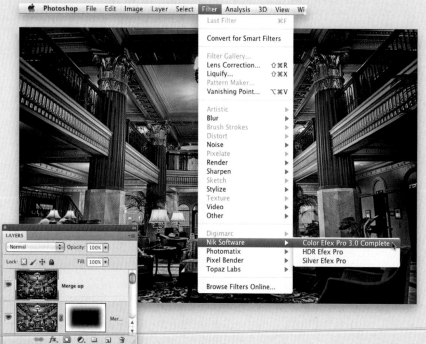

STEP 12:

While I think that this processing is pretty much done, there is one effect that I can add to it to give it another look. Most of the time, when you see HDR images out there that have a very ethereal quality to them, it's usually because of a plug-in (post-processing your images with a plug-in is *du jour* these days). One of the plug-ins that is used most often is Nik Software's Color Efex Pro. If you have it installed, first merge your layers up again, then click on Filter>Nik Software>Color Efex Pro.

STEP 13:

Normally, you wouldn't associate Glamour Glow (in the filter list on the left) with architectural images—the effect is usually reserved for portraits. That said, for HDR images, Glamour Glow tends to work very well. With only three settings to play with—Glow, Saturation, and Glow Temperature—it's easy to tweak it to your specific need. When you're done, click OK. You can see the before and after on the next page.

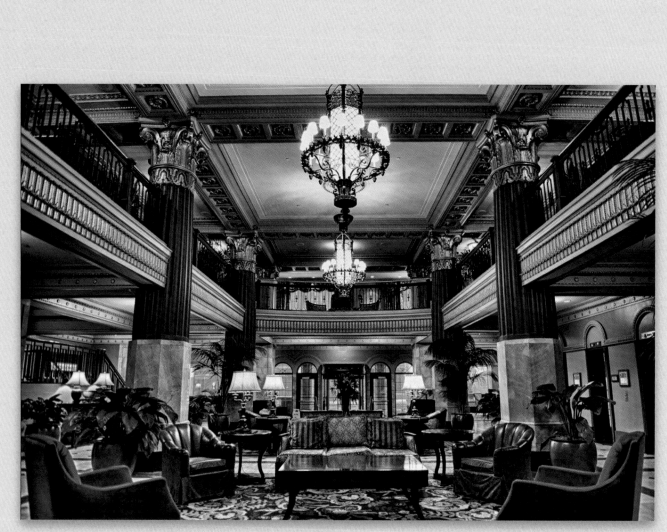

BEFORE

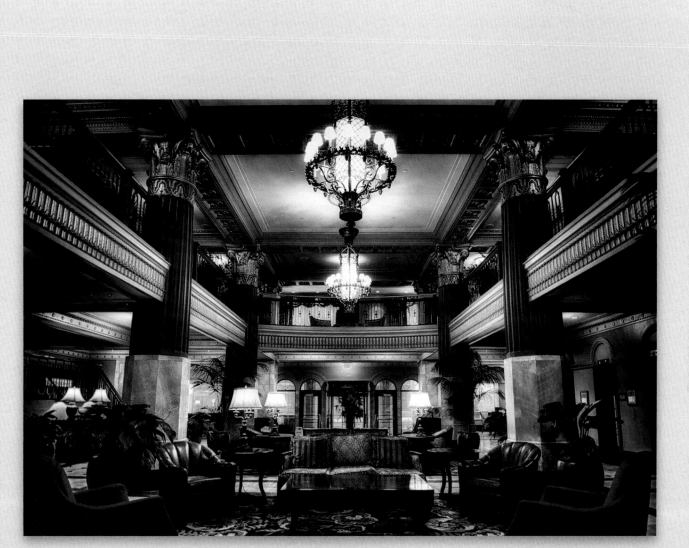

AFTER

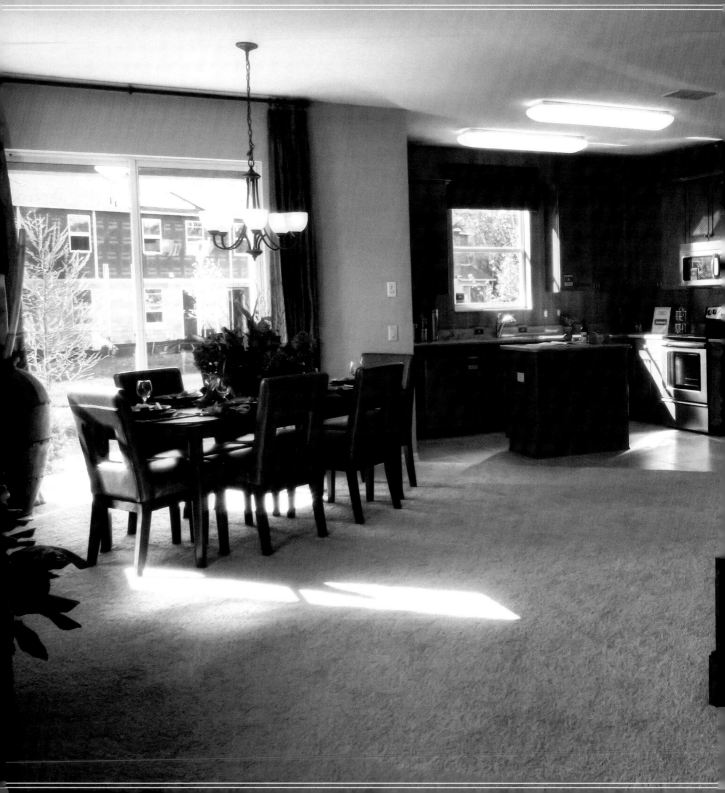

EIGHT

Project: Real Estate

When I first moved down to Tampa, I was on the hunt for a place to live. I wanted to show pictures of the places I looked at to my friends and family back home, but truthfully, the images that were online really didn't do the places justice. This left me with many questions, like, "If real estate is all about trying to convince someone that they want to purchase your home, shouldn't the online images immediately make someone want to do so?"

The images that I saw online were taken with point-and-shoot cameras, but they really didn't provide the feeling of wanting to live there. So, the next time I went to check out a place, I took a camera with me and made some creative exposures that really looked good and were something I wanted to share.

I wanted to do something different with this chapter, so I went out and took some sample pictures with a Nikon P7000 and made an exposure series that was bracketed based on ISO. That's to say that the –2 to + 2 exposures were always at a specific shutter speed and aperture. The only thing that changed here was the ISO. At low settings, this wasn't a problem. As the ISO went higher, though, boy did I start to see some noise.

I wanted us to have a chance to play with two things, here: (1) I wanted to show that even a point-and-shoot, like the P7000, can really hang in the world of HDR, and (2) I wanted to show what it would look like to work with footage that was noisy to begin with. In the end, I think the camera and the technique fared well.

TONE MAP: PHOTOSHOP CS5 HDR PRO

NOTES ON TONE MAPPING

When it comes to incredibly realistic shots, this is where Photoshop CS5's HDR Pro shines. Despite the amount of noise on the higher brackets, the image seemed to merge quite nicely. I increased the Radius and Strength to give the image a little more contrast and increased the Exposure just a bit. Then, a slight Gamma adjustment cleaned up the coffee table.

▣ Download this preset at: www.kelbytraining.com/books/hdr.

TONE MAP: PHOTOMATIX PRO

NOTES ON TONE MAPPING

When I opened the image, I noticed that there was a good deal of tonality, but there was a lot of noise present in the tone map. I adjusted the Strength and then increased the White Point, so that the image was a little brighter. I wanted it to be a little more realistic, so I moved the Smoothing slider over to the right side, and then to add a little more contrast, I increased the Microcontrast. Then, I adjusted the Gamma to compensate for the darkness that the Microcontrast adjustment made. A slight adjustment to Micro-smoothing brightened the image up enough to use.

✉ Download this preset at: www.kelbytraining.com/books/hdr.

TONE MAP: HDR EFEX PRO

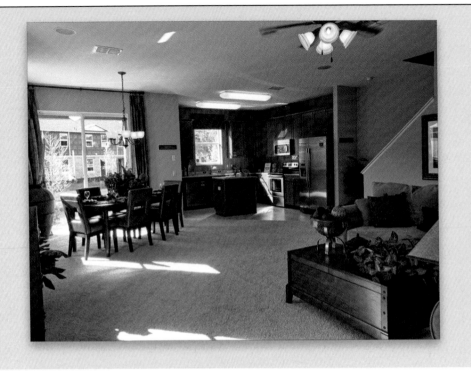

NOTES ON TONE MAPPING

The default settings in HDR Efex Pro looked great—good detail and contrast, not too much noise, and great detail outside of the windows. I increased the Tone Compression slightly and added a little bit of Structure and Contrast to bring in some details in the cabinets. Once I got those settings dialed in, I added a little bit of Method Strength to get more detail in the image. Surprisingly, these were very small changes that needed to be made here.

◨ Download this preset at: www.kelbytraining.com/books/hdr.

POST-PROCESSING IN PHOTOSHOP

Because this is going to showcase a real estate location, I want to make sure that the look stays as natural as possible. That said, I want to make sure I keep as much detail inside and out as I can. Using the HDR Efex Pro file, we'll do some subtle toning, and some cloning to get rid of distracting elements, and then we'll be good to go!

STEP ONE:

Tone mapping images always yields a bit of noise, and different software can deal with it individually. Before, I let third-party software handle noise reduction. But now, Photoshop CS5's and Lightroom 3's Luminance Noise Reduction do a great job of reducing the noise. Here's the problem, though: you can only access this feature from within Adobe Camera Raw or Lightroom's Develop module. (*Note:* Be sure to do this before opening the image up in Photoshop to do additional retouching.)

In Lightroom 3, you'll access the Noise Reduction feature in the Develop module's Detail panel. Here, I increased the Luminance amount.

To access the Noise Reduction feature in Camera Raw, first open the image in Camera Raw (see page 80 for how to do this), and then click on the Detail icon beneath the histogram (it's the third icon from the left). Here, I increased the Luminance amount.

If the image is already open in Photoshop, and you want to quickly get it into Camera Raw, click on File> Scripts>Dr. Browns Edit Layers in ACR, if you have it installed (for more on this script, see page 81). Once your noise adjustment is complete, duplicate the layer and rasterize the contents of it by Right-clicking on it and choosing Rasterize Layer.

STEP TWO:

Now, I want to eliminate the sun spot on the carpet in the foreground, which even the lowest of the exposures wasn't able to do. Sometimes, the only way to fix a problem is in post-processing. Usually, I use Content-Aware Fill to fill an area with no detail. So, in a case like this, it usually works best if the selection overlaps the good area a bit. For example, I usually select the area, and then expand the selection by 3 pixels. Here, however, I just made a rough selection around the sun spot with the Lasso tool (L) and made sure I included a bit of the rug.

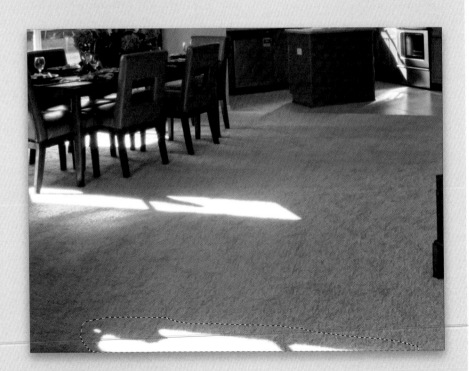

STEP THREE:

Once the area is selected, click on Edit>Fill and then choose Content-Aware from the Use pop-up menu. Content-Aware Fill is one of those random tools out there that at times will give you a very odd result. After you click OK, if you find different portions of the image in the selection, don't worry about it. Simply, press Command-Z (PC: Ctrl-Z) to Undo and fill the selection again. In this case, I found that one shot at it was all it took to get rid of that sun spot. Press Command-D (PC: Ctrl-D) when you're done to Deselect.

STEP FOUR:

While we're at it, there are a couple of other things in the image that will cause a bit of a distraction. Using the Patch tool (press Shift-J until you have it), create a selection around the sign on the back wall (to the right of the sliding glass door). Then, just drag the sign to the area of wall right above it and this will immediately get rid of it.

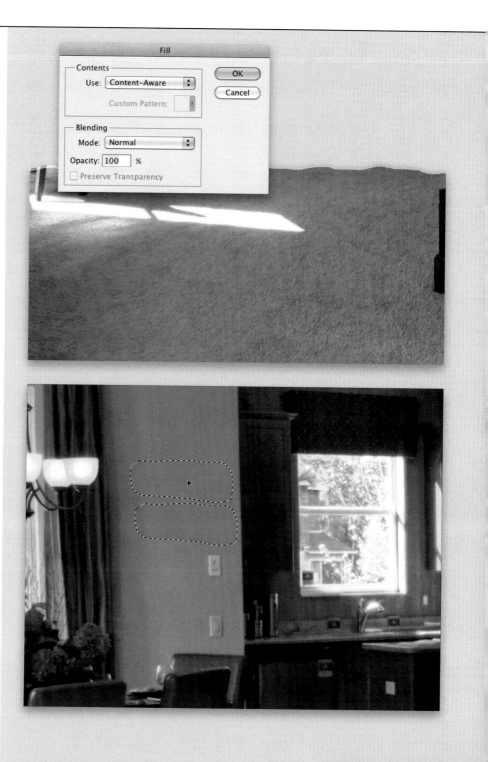

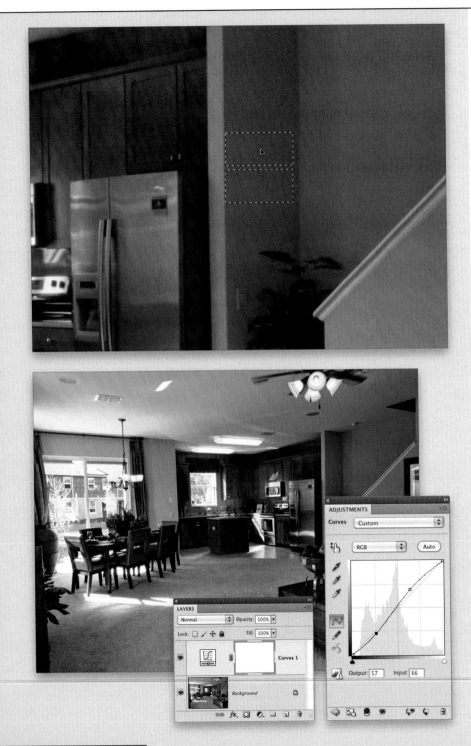

STEP FIVE:

There's another distracting sign on the wall to the right of the refrigerator. But, since this one is very close to the edge of the wall, switch to the Rectangular Marquee tool (M) and create a square selection around it. Now, switch back to the Patch tool and drag upward to get rid of that sign, then deselect.

STEP SIX:

Once the patching is complete, give the image a small contrast bump by creating a Curves adjustment layer (you learned this on page 78) with a slight S-curve.

STEP SEVEN:

While I spent some time at the beginning working on smoothing out the image, this may be a case where the Unsharp Mask filter helps bring back a little bit of contrast. So, merge the layers up to a new layer (like you learned on page 79), then press Command-J (PC: Ctrl-J) to duplicate the merged layer. Next, click on Filter> Sharpen>Unsharp Mask and give it a slight sharpening. If you find that portions of the image don't need sharpening, you can always add a black layer mask (you learned this on page 77) and paint back in the areas that you would like sharpened with a white brush.

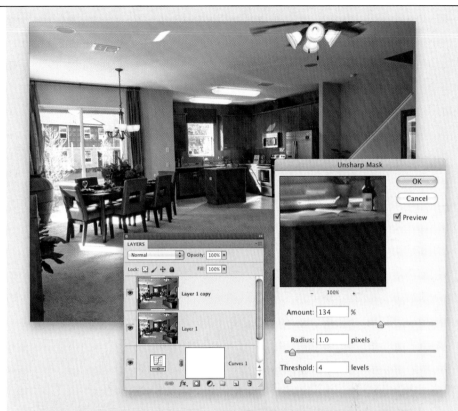

STEP EIGHT:

The tone mapping took care of a great deal in the image, but I really wish that I could see the trees outside the sliding glass door, as well as outside the window over the sink. Rather than rely on the tone mapped file to do this, it's better to just mask back in these areas from one of the original exposures. So, open one of the underexposed images (I chose the −2 exposure).

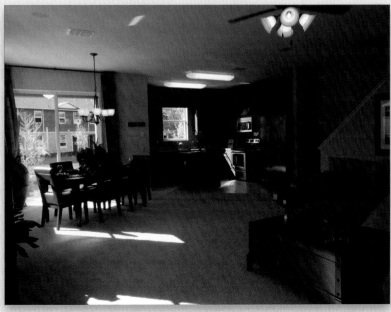

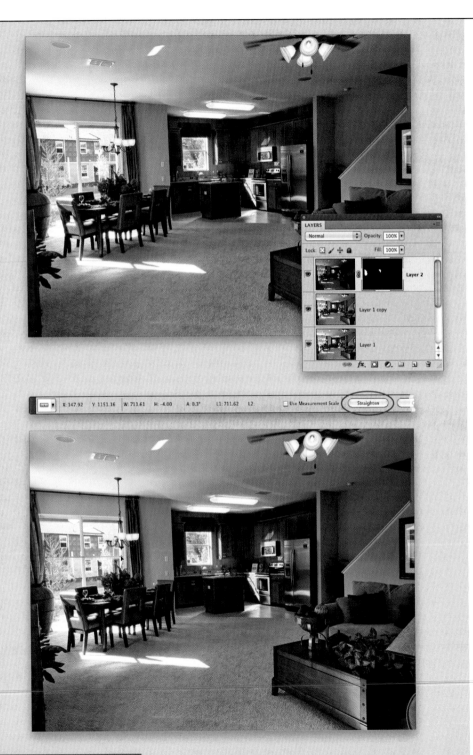

STEP NINE:

Once the image is open, press Command-A (PC: Ctrl-A) to select it, then with the Move tool (V), press-and-hold the Shift key, and drag it on top of the tone mapped image. Now, create a black layer mask and then bring back in the areas you want by painting on the mask with a soft, round, white brush with a low Flow setting.

STEP 10:

Looking at this image, it appears to be a little crooked. So, we'll straighten it just like we did with the image in Chapter 7. Create a new merged layer and then, using the Ruler tool (it's nested under the Eyedropper tool, or press Shift-I until you have it), draw a line along something that should be straight in your image (for landscape images, this is often the horizon). Here, I used the division between the bottom floor and the top floor of the condo under construction outside the sliding glass door (as shown here). Once you've drawn your line, click the Straighten button up top in the Options Bar to straighten out the image.

STEP 11:

Next, we'll add a Glamour Glow effect to the image. So, create a duplicate layer, then click on Filter> Nik Software>Color Efex Pro and select Glamour Glow from the list on the left. Here, I increased the Glow and decreased the Saturation and Glow Temperature settings a bit.

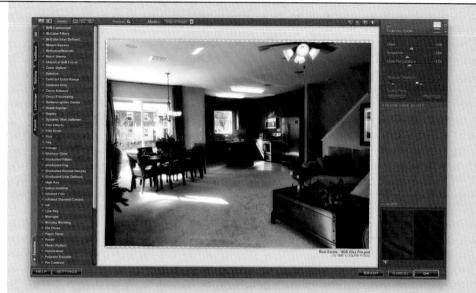

STEP 12:

Finally, let's darken up the edges of the image a bit (like we did to the image in Chapter 7). First, duplicate your Glamour Glow layer, then set that duplicate layer's blend mode to Multiply. Now, press Command-A (PC: Ctrl-A) to put a selection around the entire image, then click on Select> Transform Selection. Press-and-hold the Option (PC: Alt) and Shift keys, click on one of the corner handles and drag it inward (if you need to bring the sides in more than the top and bottom, just release the Shift key, and Option-click on a side handle, then drag inward). Once the selection is resized, press Return (PC: Enter). Then, click on Select>Modify>Feather, enter a large number, and click OK. Option-click (PC: Alt-click) on the Add Layer Mask icon at the bottom of the Layers panel, and now only the edges are darkened. If they look too dark, lower the layer's Opacity a little. See the next page for a before/after.

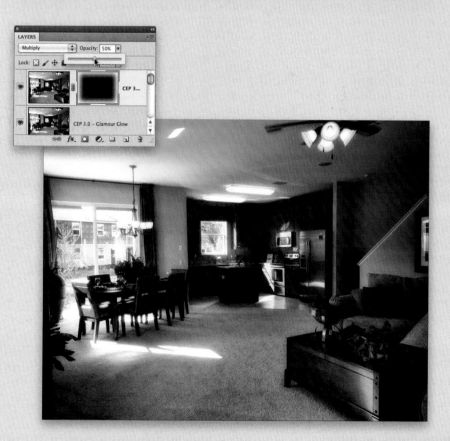

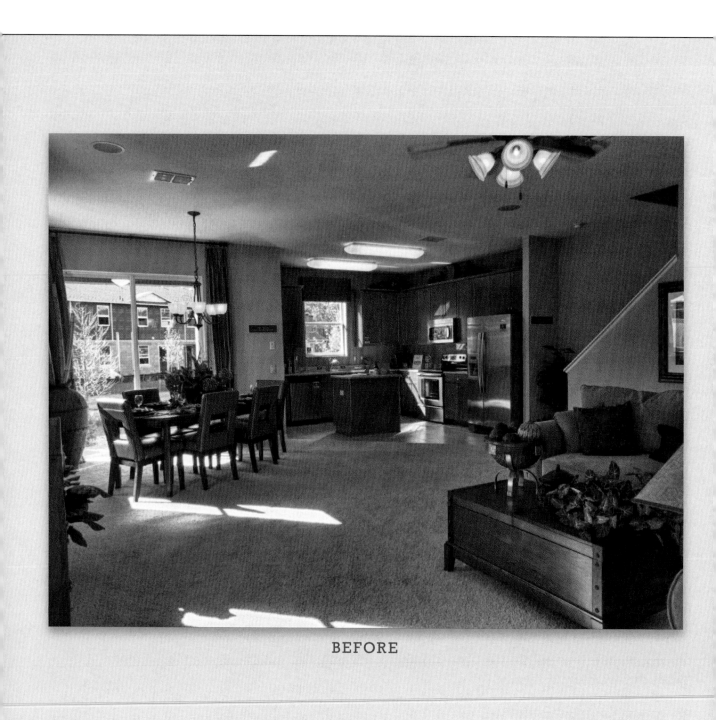

BEFORE

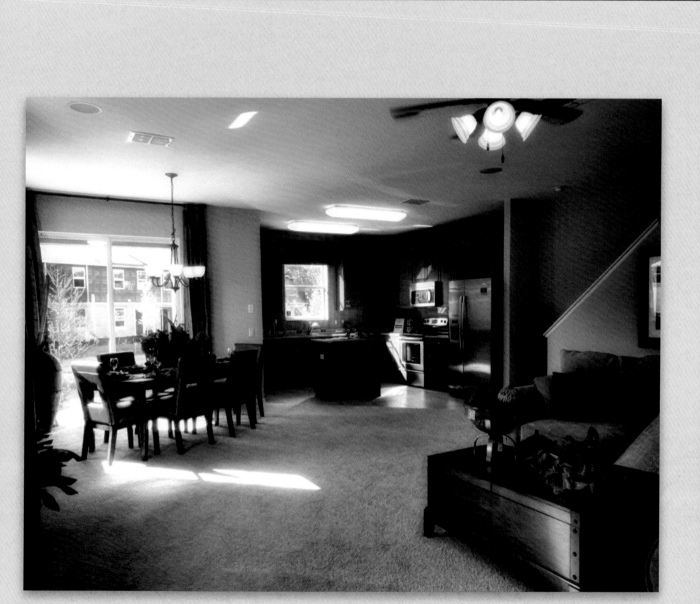

AFTER

HDR Spotlight: Jim Begley

Q. Tell us a little bit about yourself.

I am 59 years old and was born and raised in Corbin, Kentucky. I have worked for CSX Transportation, Inc., for 37 years and I am a Manager of Field Investigations. I have a wonderful wife, Susan, and we have an amazing daughter, Macy, who is a sophomore at Centre College.

I have always enjoyed photography, but my recent experience with HDR has rejuvenated my interest. I love landscape photography and sweeping panoramas. The HDR process just loves old cars and buildings, and makes golf courses look amazing.

Q. What got you into HDR photography?

At our church, I am one of the folks that displays the words and media on the screens for the church service. I was always looking for good backgrounds to use, and every now and then I saw an amazing wallpaper image that made me say, "Wow, how did they do that?" Then someone described the process (HDR), and that was all it took. I did some research and was hooked. I shot my hometown—I shot everything—to see what would work with this process. I purchased better equipment to take care of the hardware side of things, and then devoted massive amounts of time to learning Photoshop (with the help of the fine folks at Kelby Media and their resources) and Photomatix. I also took a two-day workshop in Tampa last year with Trey Ratcliff, and I believe it helped take my work to the next level. Thanks Trey.

Q. How does HDR help you achieve your photographic vision?

During all this, I ran across a quote from a great photographer named Ernst Haas who said, "I am not interested in shooting new things—I am interested to see things new."

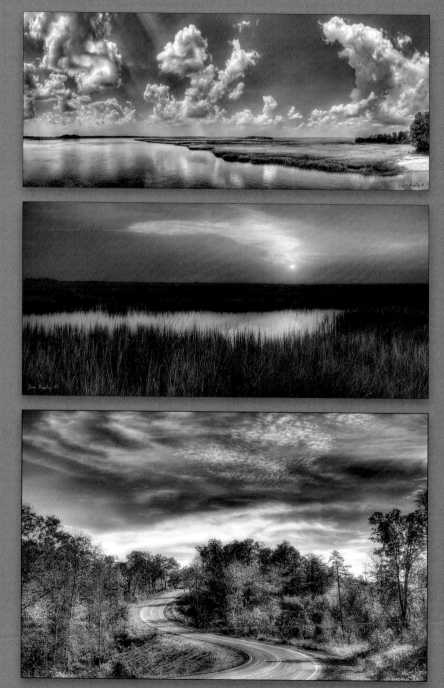

Images Courtesy of Jim Begley

This is exactly what HDR has allowed me to do. We tend to take the things around us for granted (like my hometown) and, by using HDR, I have learned to make it new, vivid, and unique. It seems that the first reaction people have when they see one of my photos is "Wow," hence the name Wow Photos HDR, LLC. It's a hoot when I show them my website or business card with the "Wow" on it.

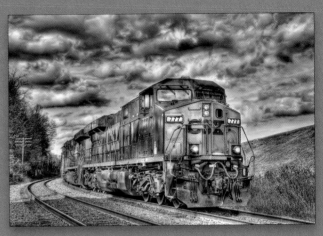

Q. Is there a specific style you find yourself shooting?

I find myself creating a style that is a mix between the detail of a photograph and a painting. People are often surprised when I tell them they are photographs and not paintings. I try not to overdo the HDR process, or oversaturate the image, but keep it clean and simple. I have learned to look for a ton of contrast in a scene, as I just know that HDR will work well in this type of situation.

Q. What kinds of experimentation do you find yourself doing now with HDR?

People seem to be getting caught up in the one-click HDR solutions and think they are done. My experience, and the trial-and-error approach, has shown that the Photoshop finishing work is what really sets people's work apart. I have worked on images for hours in Photoshop to create the work that tone mapping just started. I am always looking for techniques and different workflow patterns to polish my work. I love working with some amazing filters, like Nik, Topaz, and others, but please don't get caught up in using the standard presets—make adjustments and experiment, you will be amazed at what you can do.

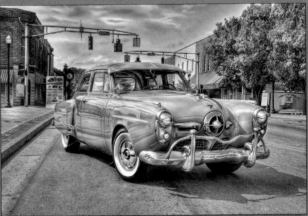

Q. Where can we find out more about you?

My website, www.wowphotoshdr.com, has several galleries that give you a feel for the type of work I create. The local newspaper featured me in an article last year at: www.thenewsjournal.net /details.cfm?id=4264. My good buddy Bill Fortney, who is also a resident of Corbin, and I are starting *The HDR Americana Workshop Series*, with information available shortly.

The best place to learn more about me is to stop in Corbin, and we can walk up to the Moonbow Café, share a mocha together, and talk photography. My email address is: wowphotoshdr@yahoo.com.

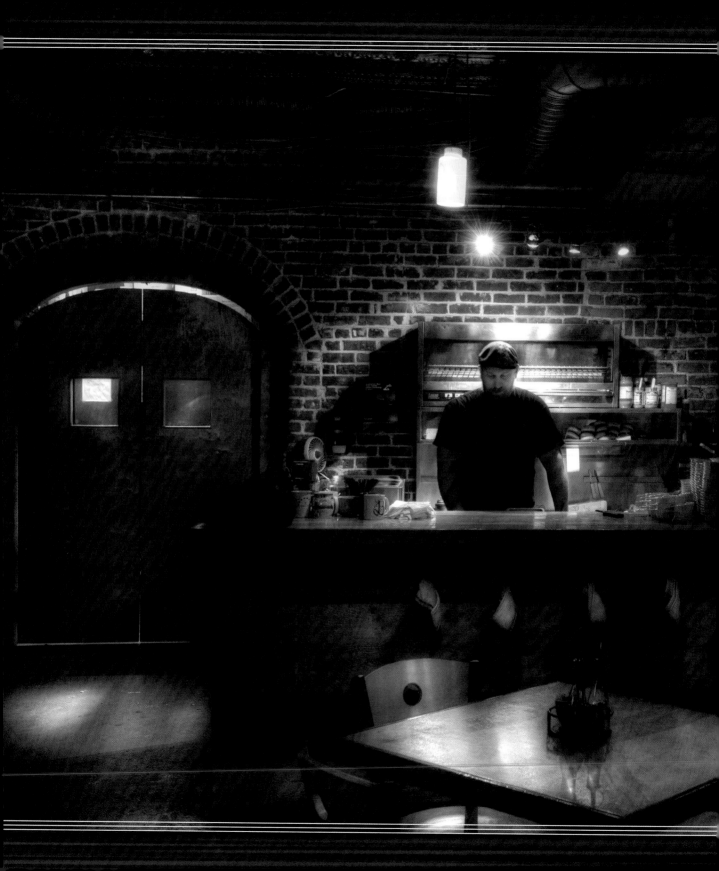

NINE
Project: People

Here in Tampa, Florida, I am the co-organizer of a Meetup.com group for strobist photography (www.meetup.com/photocollective). Every month, about 60 or so photographers and models take to the streets of Ybor City to practice off-camera flash photography. After a couple of hours of shooting, everyone gathers back at a specific location to go over what they shot, chit-chat, and get some dinner.

During the Christmas holiday, we got together at a place called The Bricks in Ybor City. A cool bar/restaurant/coffee shop, the location is adorned with a lot of brick, hip patrons, and Chris Neely—the chef extraordinaire making sandwiches for the masses. As everyone was sitting around eating their dinner, I thought that where Chris was standing—in front of the bricks, and framed by the bar and stockings—would make a great HDR image that would really showcase him and what he does at The Bricks.

After several minutes of nervousness, I threw caution to the wind and asked if I could take the picture. Showing him some samples on my iPad, I explained to him that it would be important for him to try to stand as still as possible while I made the image. Because I anticipated some movement on his part, I increased my ISO to 800 and set the camera to aperture priority at f/5.6. The camera went on the tripod (essential for HDR portraits), and I set it to shoot in Burst mode. After counting to three, I had him hold his breath, and I fired the five shots.

A few short seconds, and I was back at my sandwich, anxiously waiting to get home to work on the picture.

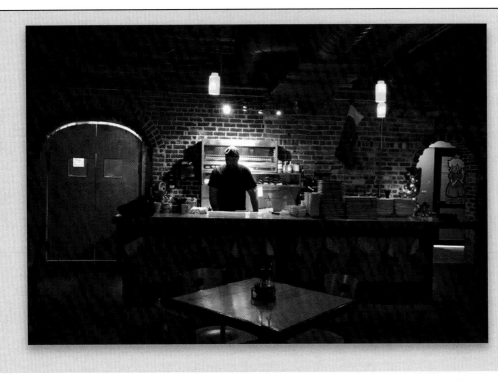

NOTES ON TONE MAPPING

The image seemed flat to me when I opened it. So, I increased the Radius and it seemed to remove a lot of the texture in the image, which I liked. Increasing the Strength gave me more of the contrast and depth I was looking for in the image, and darkening it with Gamma gave me more of the edges that I was looking for. If the image gets too dark, an Exposure increase (as I did here) will offset it. After playing with it for a bit, I decided a moderately steep S-curve in the Curve tab would give me contrast that I could work with, but I really wasn't happy with the image.

⬇ Download this preset at: www.kelbytraining.com/books/hdr.

TONE MAP: PHOTOMATIX PRO

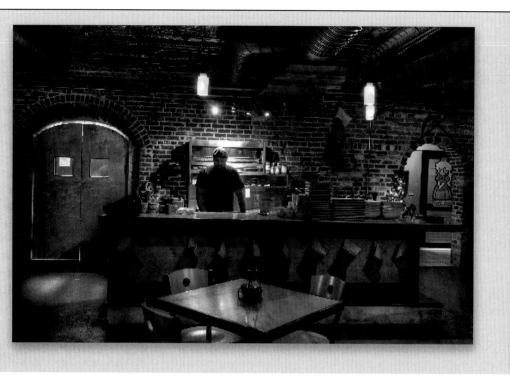

NOTES ON TONE MAPPING

There seemed to be a lot of blue/purple color when processing this image in Photomatix, and the area where Chris is standing looked a little odd. Usually when working with people in an HDR, I will either create a second tone map, or composite one of the original frames, but I want to get as close as I can with the initial tone map. I raised Microcontrast and Strength to create the overall mood of the photo. From there, I turned to Gamma and White Point and made subtle changes to try to bring some of Chris back into the image. I bumped up the Luminosity a little, as well. Bringing the Smoothing slider into the "normal" area on the right side of the slider really cleaned up Chris's area, but I lost the effect on the scene. Because he's in front of bricks and cooking, I wanted to keep that warm feeling in the image, so Color Saturation wasn't changed much, and the Temperature and Saturation Highlights and Shadows settings weren't changed.

⊡ Download this preset at: www.kelbytraining.com/books/hdr.

TONE MAP: HDR EFEX PRO

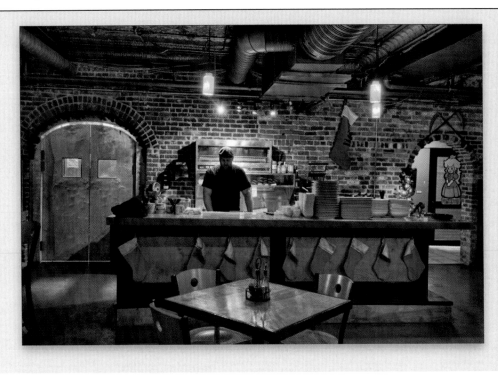

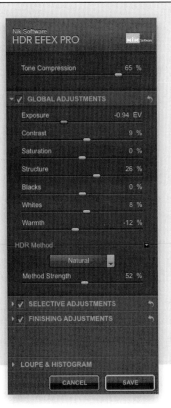

NOTES ON TONE MAPPING

I liked the fact that the image didn't seem as dirty in the processing here, and it didn't take too long to get it to a look that I liked. Increasing the Method Strength brightened the overall scene, and raising the Tone Compression brought the scene back with a cool texture and detail. The problem here, though, was that the image was still overexposed, but dropping the Exposure brought it back into an acceptable range. I added some additional textures with Contrast and Structure, and toned down the overall color in the image with Warmth. A tiny push of the Whites slider rounded out my tone mapping for this image.

⊠ Download this preset at: www.kelbytraining.com/books/hdr.

While both the HDR Efex Pro and the Photomatix versions provided good enough starts for the image, I preferred Photomatix's treatment of the overall scene here. When working with people in images, you will often mask in one of your original images, which we'll do here. We'll also be masking in a different version of the tone-mapped file, creating a double-tone-mapped composite image.

STEP ONE:

Opening the file in Photoshop, I quickly zoom in and out of the image, taking stock of the different things that I will need to correct. For post-processing, the order of corrections is normally dictated by the thing that stands out the most in the image. So, I take care of the glaring problems first, then move my way deeper into the picture, until it's completed.

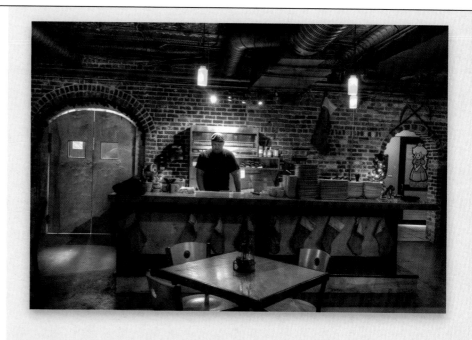

STEP TWO:

In addition to not liking what the tone mapping is doing to Chris's face, I also don't like the introduction of color (you can see those areas circled in red here). I can also see that the image will need to be straightened, and the perspective corrected. Finally, I'll want to apply a Glamour Glow effect (from Color Efex Pro) to give it a warm, fireplace feeling.

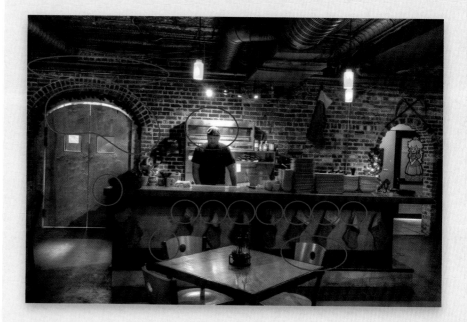

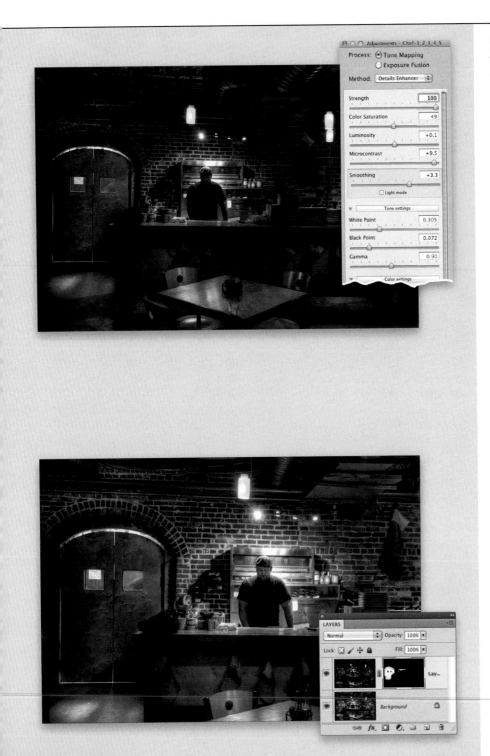

STEP THREE:

There are a lot of times when the tone-mapped image will fall short of its effect. Some areas of a tone-mapped image will look great, while others won't look so good (similar to the problems with exposure that got us to tone map in the first place—ironic, huh?). To be able to fix that, we'll need to go back to our source images and create a second tone map of the image. I tend to call this a tone-mapped composite—two different tone maps blended together into one image.

In this case, I created a second preset for the image that was much darker (by only moving sliders in the top two sections). I like what this dark image does to the chrome above his head, as well as how much color it removes from the doors and stockings. Once this second tone map is created, save it and open it in Photoshop.

STEP FOUR:

Once the second tone-mapped image is open in Photoshop, grab the Move tool (V), press-and-hold the Shift key, and drag it on top of your original tone-mapped image. Then, create a black layer mask to hide the entire image (we covered this in the "Things You'll Do a Lot in Photoshop" before Chapter 4). Get the Brush tool (B), choose a soft, round brush with a low Flow setting, and paint in white on the mask, revealing the portions of the image that you want to include in the original tone-mapped file. In this case, I used this for the area just above his hat and the doors.

STEP FIVE:

To be able to create an effective portrait in HDR, I will pick a middle exposure of the bracketed series and open it in Photoshop. After moving the image onto the tone-mapped image I am working on (the same way we moved the second tone-mapped image onto it), I will add a black layer mask and only paint back in the face and arms. I've hidden the other layers in this image (Option-click [PC: Alt-click] on the Eye icon next to the top layer to do this), so you can see just how much I painted back.

STEP SIX:

If you find that the "real" portions of the image pop out too much against the tone-mapped portions, you can always lower the Opacity of the layer, allowing the "real" parts to blend a little better with the tone-mapped portions.

STEP SEVEN:

To further remove the color from the doors and some of the other items circled in Step Two, create a Hue/Saturation adjustment layer (we did this in the "Things You'll Do a Lot in Photoshop" earlier) and desaturate the image by dragging the Saturation slider all the way to the left. Once it's desaturated, hide the adjustment by pressing Command-I (PC: Ctrl-I) to Invert the layer mask, and paint the desaturation back in on the image.

STEP EIGHT:

Make sure you zoom in and inspect the image for the introduction of any foreign color. In this case, I had to zoom in quite a bit to remove some in the corner of the bar, as well as the edge of the coffee cups and the soap dispenser on the wall.

STEP NINE:

There will be times when you'll pull too much color from the image, and will have to get some specific color back. So, create a merged layer of your work to this point (you learned how to do this on page 79). Then, using the Eyedropper tool (I), click on an area to sample the color you want to reintroduce to the image.

STEP 10:

Click on the Create a New Layer icon at the bottom of the Layers panel to add a new blank layer, and set its blend mode to Color. Then, get the Brush tool again, select a soft, round brush, and paint back in the color you just selected on that blank layer. Because the blend mode of the layer is set to Color, the color will blend with the tonalities of the layer directly underneath it.

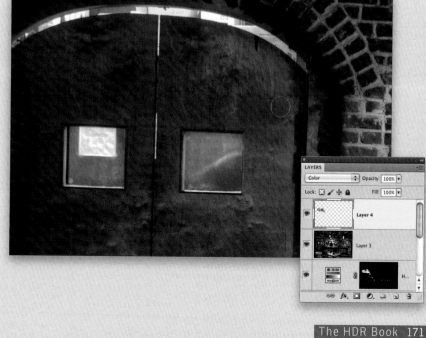

STEP 11:

When painting in a specific color on a new layer, you will at times need to readjust the color. Rather than selecting a new color and repainting the image, create a Hue/Saturation adjustment layer directly above the layer you painted the color on. Then, press-and-hold the Option (PC: Alt) key, hover your cursor between the two layers, and when you see the overlapping circles, click. This creates a clipping mask by grouping the Hue/Saturation adjustment and the painted layer, limiting the color you shift with the adjustment layer to what is on the painted layer.

STEP 12:

A quick change to the Reds in the Adjustments panel shows a better mixing of the color on the doors, and makes it look more authentic. Creating this with an adjustment layer also gives you the option to go back and make changes to the color without having to redo large portions of your edit.

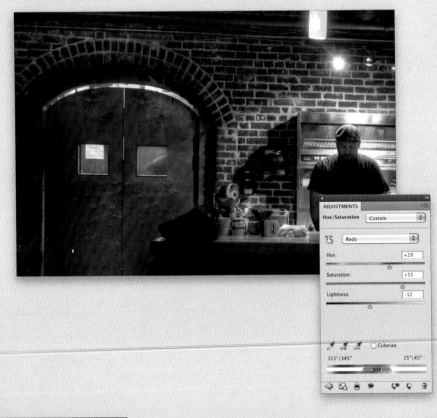

STEP 13:

Repeat these color repainting steps a couple more times to bring back some color to the portions of the image that are desaturated (like the corner of the counter, as you see here). Once you're comfortable with all of the color changes, merge up your layers again, creating a new starting point for the next set of corrections we're going to make. If you take your corrections too far, you can always delete anything that you've done, along with this merged layer, preventing you from having to start from scratch.

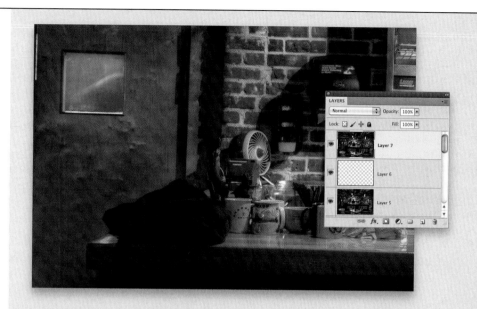

STEP 14:

While the desaturation got rid of a lot of the foreign color, it also dirtied any white areas and made them look less contrasty. To correct this, create a Curves adjustment layer and raise the highlights a little bit, making the entire image brighter. Once that's complete, invert the layer mask, and paint those bright areas in only in the places that need them, like the top of the stockings on the bar. Here, I even painted in a little bit of brightness to Chris's face, as well.

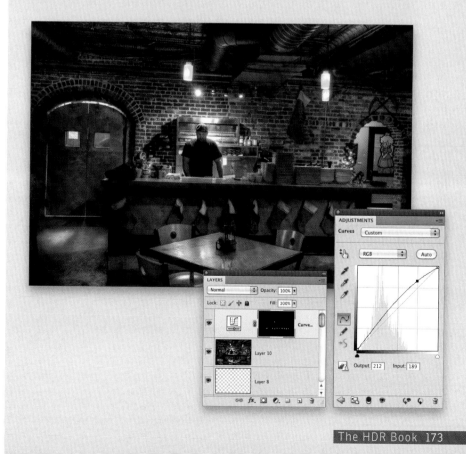

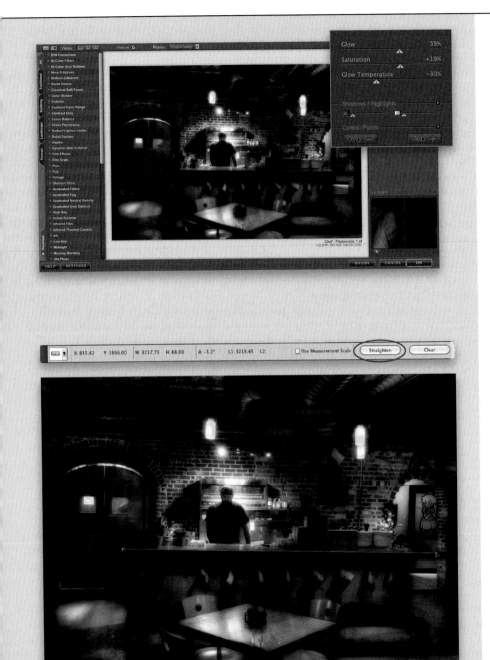

STEP 15:

Once the major changes to the image are completed, create one more merged layer, and if you have it, click on Filter>Nik Software> Color Efex Pro. Select Glamour Glow from the list on the left. Glamour Glow tends to shift all of the colors a little warmer, so I dragged the Glow Temperature to the left, so it didn't make it too yellow. I also nudged the Glow slider up a little, and dragged the Saturation a little higher.

STEP 16:

The final corrections to make in this image are to straighten it and fix the perspective. Using the Ruler tool (it's nested under the Eyedropper tool, or press Shift-I until you have it), draw a line along the edge of the bar (as shown here) and click the Straighten button in the Options Bar. While this straightens out the image, it doesn't deal with the perspective shift toward the right side of the image.

STEP 17:

To fix the perspective, press Command-T (PC: Ctrl-T) to open Free Transform, then press-and-hold the Command (PC: Ctrl) key, click on the top-right corner point, and drag it out slightly. This will adjust the perspective of the image and give you something that looks a little more centered. Once you're done, hit the Return (PC: Enter) key, and your image is complete. You can see a before and after on the next page.

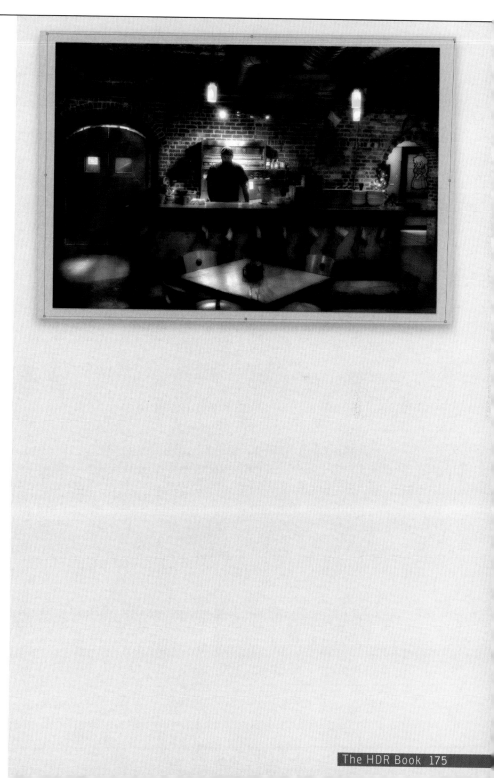

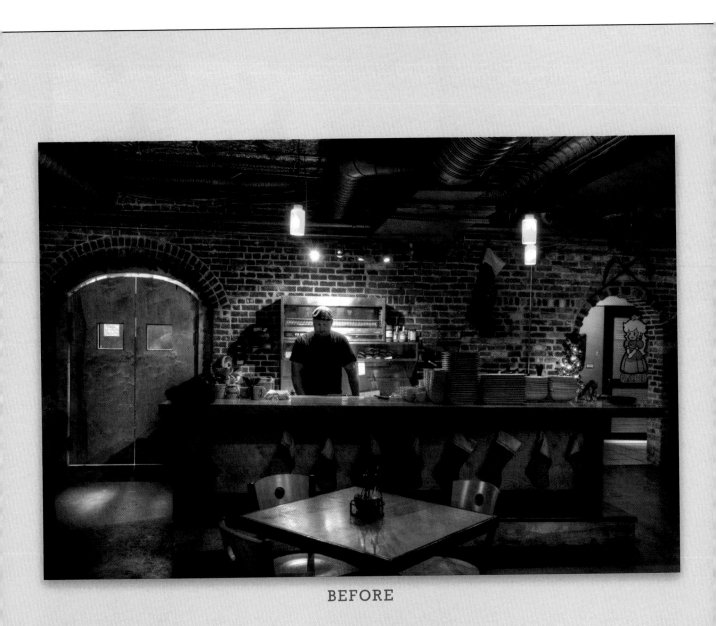

BEFORE

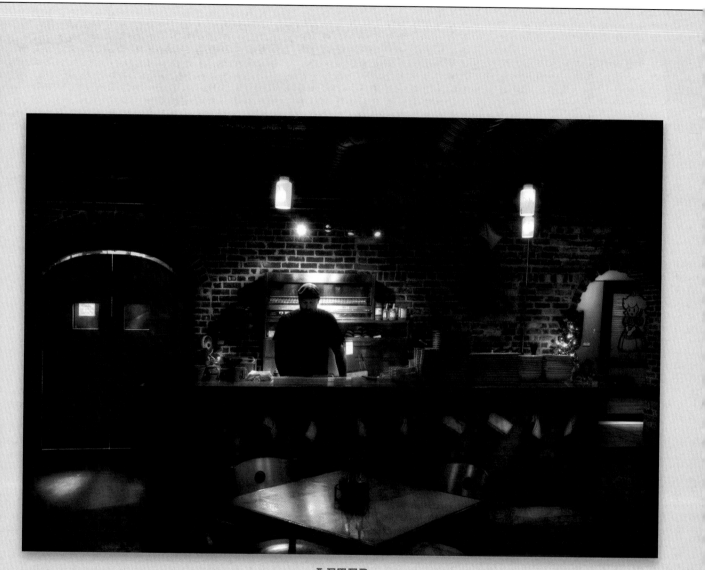

AFTER

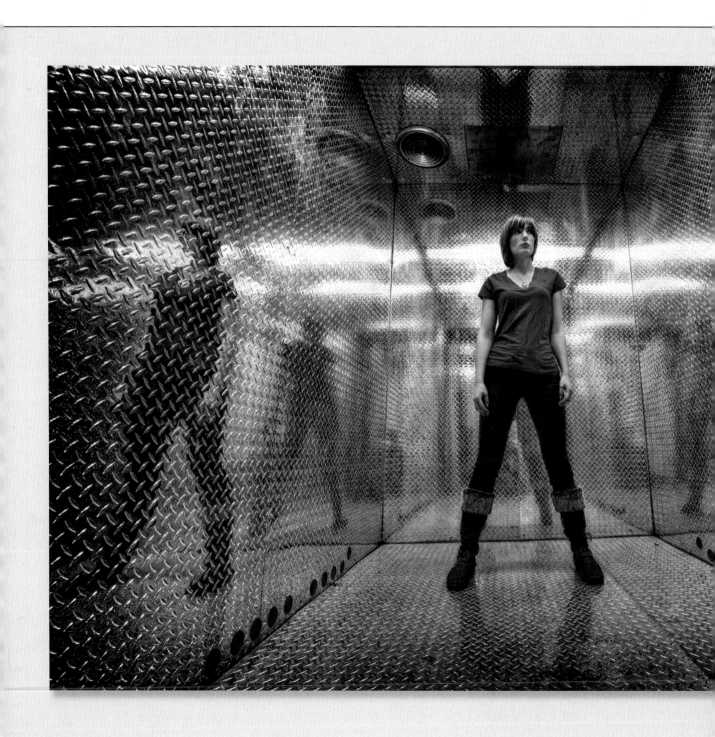

It's Your Turn:
Kena's Portrait

When I was in Chicago this past December, I was able to spend some time with my buddy Kena. She has broken into the sports journalism/media field as an awesome sports photographer/editor in Chicago, serving as a photographer, with Bill Smith, for the Chicago Bears, working as a photo editor/assistant for NBA Photos and a Getty/NHL Images editor for the Chicago Blackhawks, as well as shooting with photographer Rudi Ayasse for the Chicago Rush Arena Football League team.

As we were looking for cool places to shoot HDR images, we came upon an interesting elevator in a music studio. I thought it would be a great place to get a cool, gritty, HDR portrait. The challenge with this was that Kena could easily pass as a model. Gritty isn't something that you'd think with a female model, so we needed to remix one of the original frames to bring back her skin.

After employing some of the techniques we talked about in this chapter, I was able to come up with this. Now, it's your turn. What can you come up with?

▣ Download the bracketed images at: www.kelbytraining.com/books/hdr.

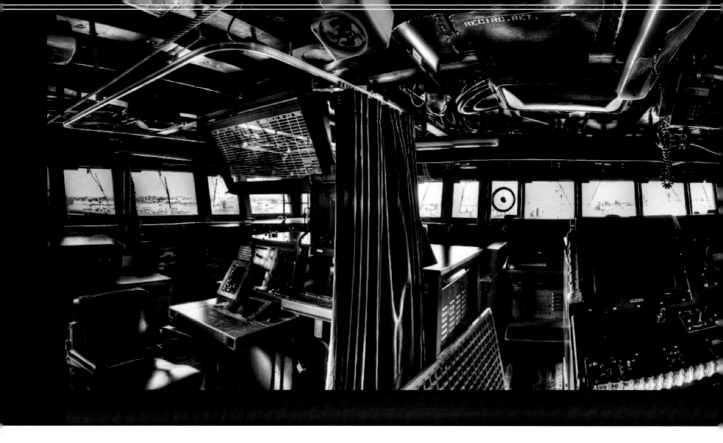

Up and down through the bowels of the ship we went, until we got to the front (fore), where it's steered. I had a Nikon D3s with me and a 14–24 mm lens, and just shooting a shot from the center, covering the entire bridge, would have sufficed. But, there was just so much detail in the image—knobs, switches, gears, etc. There were so many things to sit and inspect, and I didn't think one picture would do it justice. What to do?

The following tips and tricks explain what I did to get a good shot of the interior, and how you can apply those techniques to working with your panoramic images.

Tip: Shoot Panoramas in Portrait

A lot of times when you shoot a pano, you frame the image as a landscape image and pan to the right. The problem with this is that, many times, after it's completed, you have too much missing information at the top and bottom of the image that you inevitably cut out. To counteract this, switch the orientation of the camera to vertical. By placing the camera in portrait orientation, you are able to get more details of the scene in the picture, making it easier to crop it later in Photoshop. Ever since Scott Kelby introduced me to this trick, my panos have come out better.

Tip: Pretend to be a Tripod—Shift Your Feet

Having a tripod when shooting a pano really takes away a lot of the pain when stitching the images together. A tripod's center column can rotate your camera while keeping its legs in place. Problem is, when we try to pretend to be a tripod, we leave our legs in place on the ground and rotate from our hips to make the image. We don't have the same range of motion as a tripod, so you'll end up seeing an arc as you go from left to right that causes merging problems.

Instead of spreading your legs apart, put them together and pretend to be the center column of a tripod. Shoot your first picture and turn your feet (keeping your waist straight), and that will better replicate what your tripod would be doing. The shots will be a lot better, but I'd still shoot from a tripod if possible!

TEN

Project: USS Sterett Panorama

In HDR, Bigger is Better

There are lots of things that are great about working with HDR images. But, the one thing that really stands out to me is the level of detail that you can get with an image.

The day before I was teaching a Photoshop seminar in San Diego, California, I met up with Stephen Zeller, one of our NAPP members, for a special tour of a Navy destroyer—the USS Sterett. As I walked the passageways of the ship, I couldn't get over how incredibly big the ship was, yet how small it felt while in it.

HDR First, Merge Later

There's the chicken or the egg discussion of whether you merge or process first when working with panos. I think you should always process first. There will be times when you're taking really wide brackets of images (on really sunny days, and trying to avoid halos), where your underexposed images may well be in the basement (very low), and you will not see much detail in the image. If you can't see that much detail, you can expect Photoshop to have a bit of a time trying to merge the image.

Consistentency: White Balance & HDR Presets

One of the biggest gotchas when working with HDR panos is your need to make sure that you try to keep as many things as possible consistent. This will include things like exposure, white balance, and using HDR presets.

You can sync your white balance in Photoshop or Lightroom pretty easily (we'll talk about this on the next page), but you can't really guess whether the HDR software will tone map your

images consistently for the set of panos you are working on. To counteract that, process a test file of one of the sets in the pano, preferably one in the middle portion of it. Once you have the HDR toning exactly as you want it, save this as a preset. Now you can go back to the other sets of images and work through the series, using that preset as the basis for all of the processing. This will give you a more consistent look in the image.

Auto and Geometric Distortion Rock

When you're ready to work with the image in Photoshop, you'll be using Photomerge. There are very few instances where Photomerge's Auto setting hasn't worked for me, so save yourself some time and leave it set to Auto. The Geometric Distortion Correction and Blend Images Together settings also work really well.

Now, I'll walk you through how to process the Sterett image, then we'll go outdoors and see how to use the same techniques for "Valley View," a panoramic image I made in Yosemite.

HDR PANO PROCESSING IN PHOTOSHOP

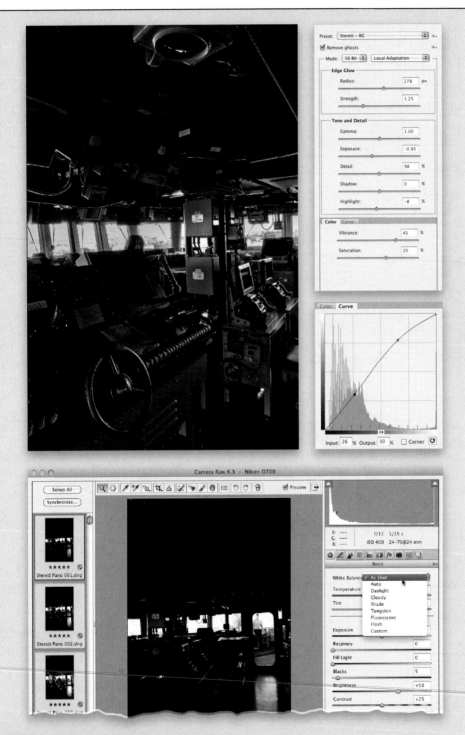

This image posed a bit of a challenge in Photoshop's HDR Pro. I wasn't able to get the cool, grungy look I wanted. I started by really increasing the Strength and Radius sliders to get some dimension. The default Gamma setting of 1.00 gave me a bit of detail in the windows, something I tweaked a bit further using the Exposure and Detail sliders. I also gave Highlight a slight adjustment down. While I thought it would be great to really turn it down to see more detail in the windows, it made them a little dirty. I increased the Vibrance a little, then switched to the Curve tab, added a couple points, and lightened the image a little. Overall, I wasn't really happy with the results.

It's important to keep in mind that Photoshop doesn't do automatic batch tone mapping. To make a panorama, you have to tone map the sets of images first. This is a great place to make a preset (like we did in Chapter 3). Then, you can go to File>Automate>Photomerge and select the tone-mapped files (we'll talk about that in detail later).

TIP: Syncing Your White Balance
In Lightroom's Develop module, set the white balance for the first photo, then select all the other images as well, and click the Sync button at the bottom right. Choose White Balance in the Synchronize Settings dialog, and click Synchronize. In Photoshop or Bridge, open all your images together in Camera Raw, click the Select All button at the top left, and then set your white balance.

One cool thing about Photomatix is its ability to generate multiple HDR files for your pano processing. It has a "set it and forget it" type of functionality, where you tell it where your folder is and what preset you want, and it will take care of the rest. While it may take some time to process, you can at least focus on getting ready for processing in Photoshop.

STEP ONE:

In order to batch process the HDR images, you're going to need to create a preset that you'll base the images on. So, click on the Load Bracketed Photos button in the Workflow Shortcuts panel and then select a series of images from the middle of the pano. This will let you work with tone mapping on the more visible portions of the image.

STEP TWO:

Take a quick scan around the image to make sure you're getting as much as you can for the file. In this case, I think the interior is looking really good, but the outside is looking a bit drab. So for now, I'm going to sacrifice that and just make sure that I'm getting the most bang for the buck on the interior. I've gone for a darker processing by dragging the Gamma over to make it darker, and really relied on the surrealistic Smoothing to bring out the detail in the metal. I also adjusted all of the settings at the top of the panel, the White Point and Black Point, and all of the Color settings.

STEP THREE:

Once you have the image looking the way you want it, create a preset. Click on the Presets pop-up menu at the bottom of the Adjustments panel, choose Save Settings, give your preset a name, click Save, and this preset will be saved in the Presets pop-up menu. Close the file without actually processing it, because we just needed to create that preset here. *Note:* I've provided this preset on the book's companion website (you can find the address in the book's introduction). You can download it, choose Load Settings from the Presets pop-up menu to load it, and then apply it. If you don't create your own preset, be sure to load mine, because you will need one in a bit.

STEP FOUR:

Now, in the Workflow Shortcuts panel, click on the Batch Bracketed Photos button to begin processing your pano. The Batch Processing of Bracketed Photos dialog has a lot of options, but it's pretty straight-forward. I tend to work in this dialog counterclockwise, starting in the upper left.

STEP FIVE:

Turning on the Generate HDR Image checkbox and then clicking on the Settings button to the right brings up another important dialog. Here, turn on the Force Exposure Values Spacing To checkbox and then set the pop-up menu to the right to 1 stop, as this is the max that the newest Nikon cameras use (and what I recommend for Canon shooters anyway). I want Photomatix to reduce ghosting, chromatic aberrations, and noise on images that are underexposed (although I will run Photoshop's Noise Reduction later if I need it), so I will turn on those three checkboxes here, and then click OK.

STEP SIX:

The tone mapping preset we saved for the image was based on the Details Enhancer method, so turn on the Tone Map with Details Enhancer checkbox. Click on the Settings button to the right and, if you didn't create a preset, you can adjust your settings in the dialog that pops up. But since we did create a preset, we'll go down to the bottom of that dialog and select it from the Presets pop-up menu. Make sure that the Save checkbox is turned on, and then click OK.

PROCESS

☑ Generate HDR image (Settings...)

 ☑ Tone map with Details Enhancer (Settings...)

 ☐ Tone map with Tone Compressor (Settings...)

☐ Fuse exposures with H&S – Adjust (Settings...)

☐ Average

☐ Fuse exposures with H&S – Auto

☐ Fuse exposures with H&S – Intensive (Settings...)

◉ Select [5 ⬍] images at a time ○ Advanced

Batch will take 5 of the files listed on the Source (Options...)
frame and process them with the above options.

☑ Align images ☐ Crop aligned images

 ○ By correcting horizontal and vertical shifts

 ◉ By matching features

SOURCE

Selection by ◉ Folder (Select Source Folder...)
 ○ Individual files

Sterett Pano 001.dng
Sterett Pano 002.dng
Sterett Pano 003.dng
Sterett Pano 004.dng
Sterett Pano 005.dng
Sterett Pano 006.dng

(Remove file) Filter by (All ⬍)

 ☐ Process subfolders (sequentially ⬍)

STEP SEVEN:

Moving down, choose to have it Select 5 Images at a Time when processing, and then turn on the Align Images checkbox and click on the By Matching Features radio button.

STEP EIGHT:

The Source section in the bottom left is very important, because it's here that you'll select the folder or files that you'll use to make your pano. I usually put all of the images for my pano in one folder for Photomatix to process—in this case, there are 30 images (six sets of five exposures) for this pano. So, go ahead and click the Select Source Folder button (or the Select Files button if you're selecting individual files) and choose your folder of images (or your files).

TIP: Use Three Digits When Renaming

The most important part in selecting the source images for your pano is making sure that the order of the images is the same as the order of the series you want to process. For example, the capture here is a sure sign of trouble, because when you rename your images with just one digit, it usually places images "10" through "20" immediately after image "1." This will make for a horrible pano. So, when you rename your images for processing, always use a minimum of three digits, as shown in Step Eight.

STEP NINE:

In the Destination section in the bottom right of the dialog, you can specify where you would like the files to be saved. I tend to leave these in the same folder as my source images, so I can keep everything organized. Because we're just going to work with the TIF images that are created from Photomatix, turn on the Remove 32-Bit HDR Image After Tone Mapping checkbox, as those files can be very big and unnecessary for what we'll be doing here. The last thing to do here is to click on the Naming Options button and then make sure to add "HDR" to the end of the filename (as shown here)—this makes it easier to find. (*Note:* Interested in what a Radiance file does and how you can use it? Check out the video I created about this on the book's companion website.)

SOURCE

Selection by ● Folder ○ Individual files — Select Source Folder...

Sterett Pano-1.dng
Sterett Pano-10.dng
Sterett Pano-11.dng
Sterett Pano-12.dng
Sterett Pano-13.dng
Sterett Pano-14.dng

Remove file Filter by All

☐ Process subfolders sequentially

Batch Processing of Bracketed Photos

PROCESS

☑ Generate HDR image
 ☑ Tone map with Details
 ☐ Tone map with Tone C
☐ Fuse exposures with H&S
☐ Average
☐ Fuse exposures with H&S
☐ Fuse exposures with H&S

Naming types
○ Start with processed set
 ☐ Use shortened version ☐ End with sequence number
● Start with filename of first image in the set
Sample output name: IMG_3421_2_3Enhancer.jpg

Suffix (optional)
Append: HDR

OK

Close Run

● Select 5 images a

☑ Align images ☐ Crop aligned images
 ○ By correcting horizontal and vertical shifts
 ● By matching features

SOURCE
Selection by ● Folder ○ Individual files — Select Source Folder...
Sterett Pano 001.dng
Sterett Pano 002.dng
Sterett Pano 003.dng
Sterett Pano 004.dng
Sterett Pano 005.dng
Sterett Pano 006.dng
Remove file Filter by All ☐ Process subfolders

DESTINATION
● Created under Source Folder
○ Customized location Choose...
Save as TIFF 16-bit JPEG Quality: 100
Save 32-bit HDR image as Radiance RGBE (.hdr)
☑ Remove 32-bit HDR image after tone mapping
Naming options...

STEP 10:

Now that all of the options we want have been selected, click on the Run button and go get yourself a good cup of coffee. Depending on how well equipped your computer is, this process can take a bit. On my Macbook Pro, I've processed these 30 files in about 5 minutes—give or take. (Hey, this could be a good time to watch the videos on the book's companion website, or check out the newest *D-Town TV* episode on Kelby TV [www.kelbytv.com/dtowntv]. Don't say I didn't try to keep you busy!) As Photomatix processes your image, you will see the section in the top right of the dialog update, letting you know what's going on. Once the files have been processed, you will see a blue link letting you know that it's done. If you look in the folder where you chose to save your images, you'll see a new folder with the TIF images you created and the tone mapping part is complete.

HDR PANO PROCESSING IN HDR EFEX PRO

The one thing that I wish I were able to do in HDR Efex Pro when it comes to panos is to be able to batch process them. That being said, it only takes me a little bit longer to work on them on a set-by-set basis.

STEP ONE:

I like using Lightroom 3 for processing my images (and I really like being able to make small corrections to the files). So here, we'll use that to process and organize the images that we'll be working on. (If you want to use Bridge CS5, Photoshop CS5, or use HDR Efex Pro as a standalone [though you're not able to open DNG files with the standalone], you learned how to do this back in Chapter 3.)

STEP TWO:

There will be times when I take a look at the original exposure series and wonder if the darkest exposure that I have has enough information. In this case, I was trying to capture some of the outside environment on the darkest exposure, but as much as I tried, I didn't quite nail it. So, to try to help, I'll go into the darkest exposures of each set and drag the Exposure slider to the left to bring back some of that outside detail. Once I've done that to each of the darkest exposures, I'm ready to process the files.

STEP THREE:
Select the first set of images and open them in HDR Efex Pro by Right-clicking on one and choosing Export> HDR Efex Pro.

STEP FOUR:
Spend some time taking a look at the different settings that are available as a starting point. Here, I found that choosing Halo Reduction from the HDR Method pop-up menu gave this image a good starting point. So, set your HDR Method, and then adjust the Method Strength. Once you've dialed that in to a favorable level, use the Tone Compression slider to make special effect adjustments. Lastly, adjust your Global Adjustments as needed. Don't make any Selective Adjustments or Finishing Adjustments here, as you'll be processing a series with this preset.

STEP FIVE:

Click on the Custom tab at the top left of the window, then click on the + (plus sign) button to the right of User Presets, name your preset, click OK, and it'll now appear under your User Presets. If you'd like to use the preset that I created for this file (which you can download from the book's companion website), click on the arrow button to the right of Imported Presets. Navigate to the folder where you saved the file, click on it, and then click Open. The preset will now appear under your Imported Presets.

STEP SIX:

From here, you'll just process each set of images as you normally would, but you'll use this preset. *Remember:* If you have your images in a collection, the tone-mapped files that are created won't be imported into that collection. You'll have to go to All Photographs to see the processed files. Just select all of the tone-mapped images that are going to be part of your pano, and drag them into your collection and you should be good to go.

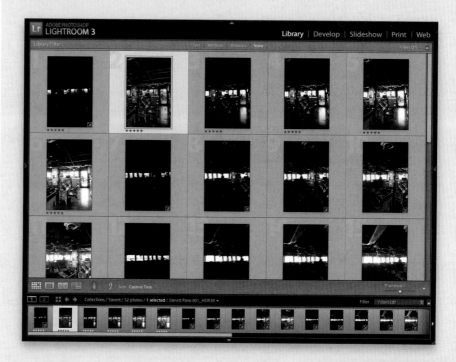

MERGING THE PHOTOS USING PHOTOSHOP CS5'S PHOTOMERGE

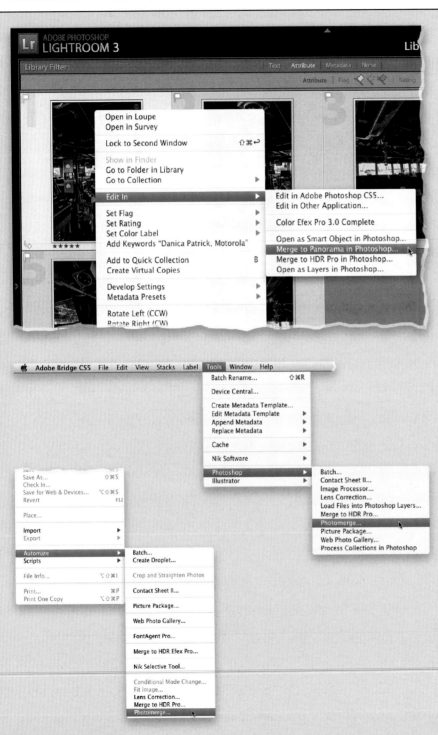

Once you've processed all of your images, you're going to merge those into one panoramic file. In the days of yore (like three years ago), this was a somewhat painful process. Thankfully, Photoshop CS5's Photomerge does a phenomenal job of merging those images and you'll be surprised at how well the Auto setting does.

STEP ONE:

You can access Photomerge a variety of different ways: Lightroom users can just select the series of images to be merged together, then Right-click on one and choose Edit In> Merge to Panorama in Photoshop. If you're a Bridge CS5 user, you can access Photomerge by selecting the files you want to work with and then select Tools>Photoshop>Photomerge. If just want to select the files in Photoshop CS5, click on File>Automate>Photomerge.

STEP TWO:

If you've already selected the images, the files will appear here in the Photomerge dialog. If you still need to select the files, you can click on the Use pop-up menu, select Files or Folder, and then click the Browse button to select the files or folder. The options in the Layout section, on the left, let you specify how you want Photomerge to treat the images when making the pano. There are very few times that I find using anything other than Auto is better, so I usually leave it set there. What's more important here is that you turn on the Blend Images Together and Geometric Distortion Correction checkboxes. These help a lot.

STEP THREE:

Click OK and, after a couple of minutes, you'll see the result of the Photomerge. Photoshop brings in each of the images as its own layer, transforms and skews them, then creates layer masks over the areas that overlap, creating the pano. It's very easy and pretty accurate. From here, choose Flatten Image from the Layers panel's flyout menu and then we can move on to cropping.

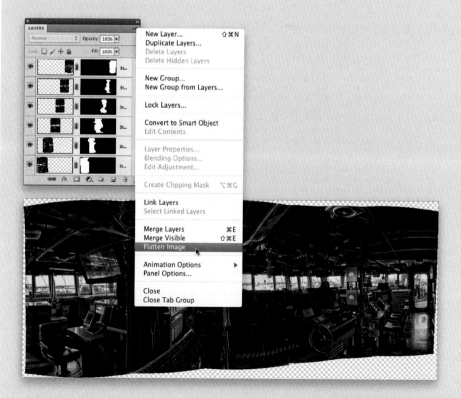

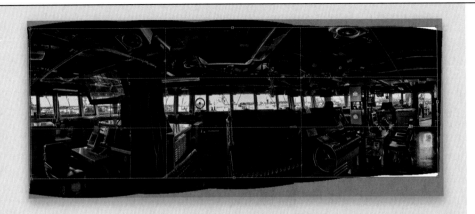

STEP FOUR:
Grab the Crop tool (C) and drag out a cropping border on your image. When cropping an image, try to keep as much of the image as possible. As much as I would have loved to keep more of the lower-right area here, that would've been a little difficult to reconstruct. With this crop, there are only small portions of the image that need to be rebuilt using Content-Aware Fill. Don't worry about whether the panorama conforms to a specific ratio just yet. Here, we're just looking for maximum image. We can always trim it further later.

STEP FIVE:
To fix the corners, we can fill them in with Content-Aware Fill. So, select one of the corners with the Magic Wand tool (press Shift-W until you have it; here, I'm selecting the bottom-right corner). Then, click on Select>Modify>Expand and give it a small pixel expansion—around 3 pixels. This will create a fill that looks a bit more real.

STEP SIX:
Press Shift-Delete (PC: Shift-Backspace) and you'll get the Fill dialog. From the Use pop-up menu, choose Content-Aware, click OK, and the area will fill in. Press Command-D (PC: Ctrl-D) to Deselect. *Note:* Content-Aware Fill randomly fills in a selection. If you notice that the fill doesn't really look that good, just press Command-Z (PC: Ctrl-Z) to Undo and fill the area again. Now, go ahead and do the other corners, as needed.

STEP SEVEN:

Once the corners of the image are fixed, zoom into the image and just quickly pan through it using the Zoom (Z) and Hand (H) tools, checking for inconsistencies. Sometimes the image can look great when you're looking at it from afar. Up close can be an entirely different story. The tonality and detail in this picture is what really makes it sing!

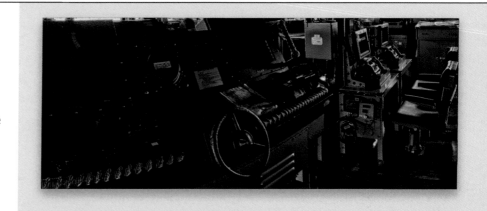

STEP EIGHT:

The final image here is about 38 inches long at 300 dpi. With some tweaking, we should easily be able to print this out at about four feet long and have great detail. Now, you'll notice that the center of the image has a lack of color. This is something that is pretty typical of HDR images. They get you really close to the finished product, but will need some adjustment in Photoshop to make them their best, as we've seen in the other projects. I'm not going to make any adjustments here, though.

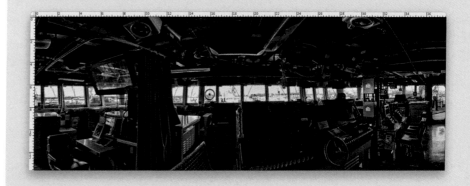

STEP NINE:

Save this file as a TIF in the same folder that your bracketed series is in. This way you have your entire HDR project saved in one spot. Later, you can go back to this image and apply what you've learned in the other projects about post-processing in Photoshop and make it better.

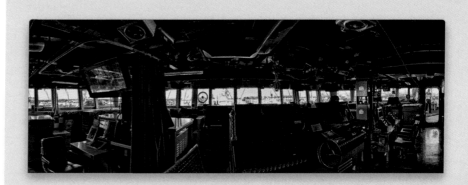

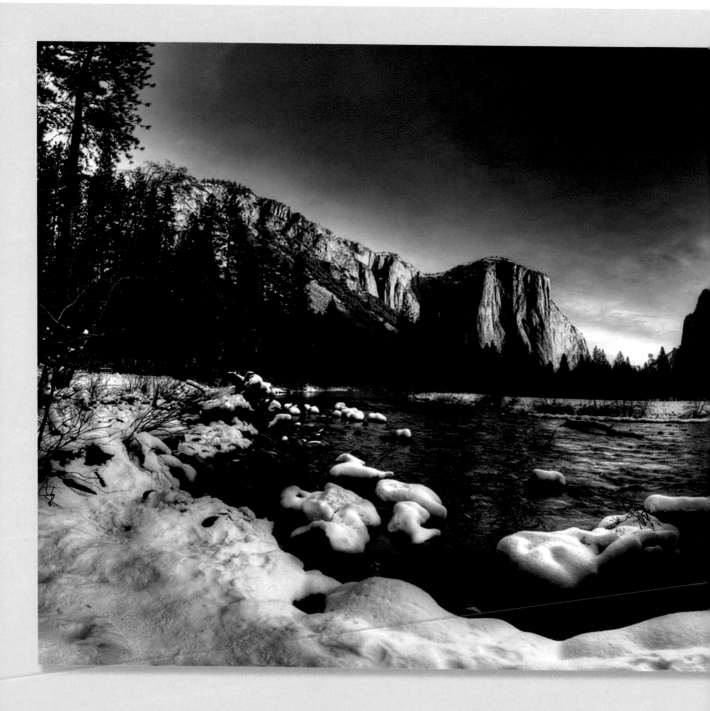

It's Your Turn:
Valley View

Now, it's your turn to take the HDR pano technique out for a spin. On the book's companion website, I've provided you with source files for "Valley View"—an HDR pano I made at Yosemite National Park. Spend some time creating the preset that will best define how this image will look and generate a pano from it. You can see what I got for each of the three tone maps on the next page.

◪ Download the bracketed images at: www.kelbytraining.com/books/hdr.

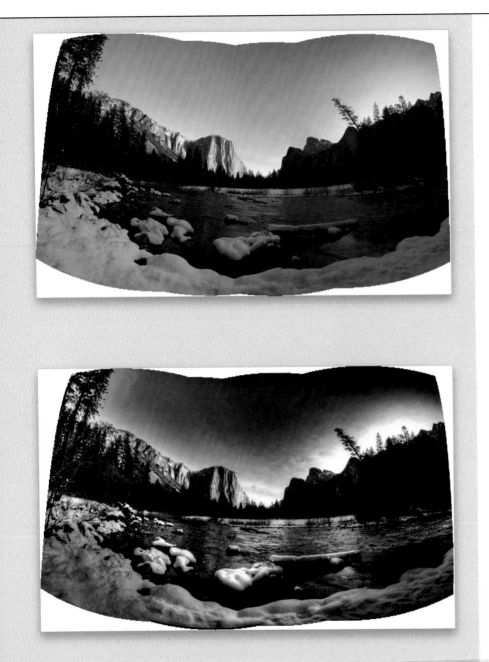

PHOTOSHOP CS5 USERS:

Of the things that I do like about Photoshop's HDR Pro feature is that, on average, the tone maps that come out of Photoshop are very natural looking. Going through the pano will require you to process each of the nine frames (six sets) individually and merge them together afterward, but you'll find that the resulting file will look really good!

PHOTOMATIX USERS:

Once you have created your preset, you can run the batch action to make the source files. You'll notice that you may get some halos in the sky area when working with this image. Ideally, I'd double-tone-map the image to correct for this, but for now, let's just work on getting this one to a decent state. This is what I got from the mix. What about you?

HDR EFEX PRO USERS:

I tend to prefer this mix from HDR Efex Pro to the Photomatix one, as it gave me a lot fewer halos in the sky area. It's not as processed as the Photomatix one. What effect you choose, and where it goes, will all be up to you!

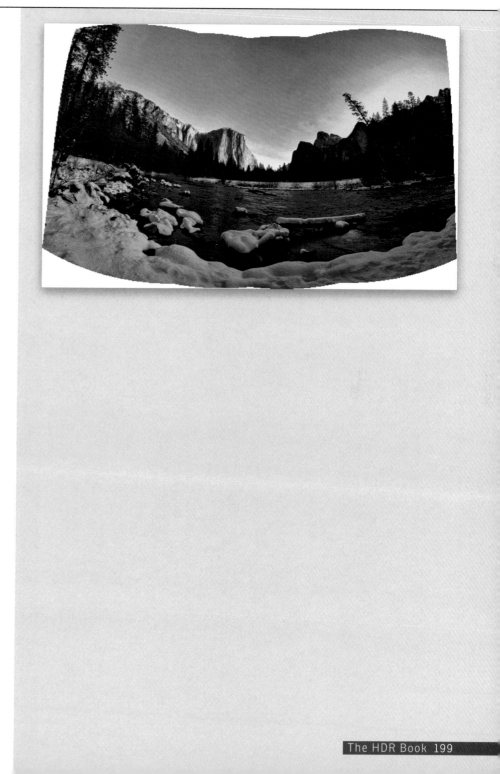

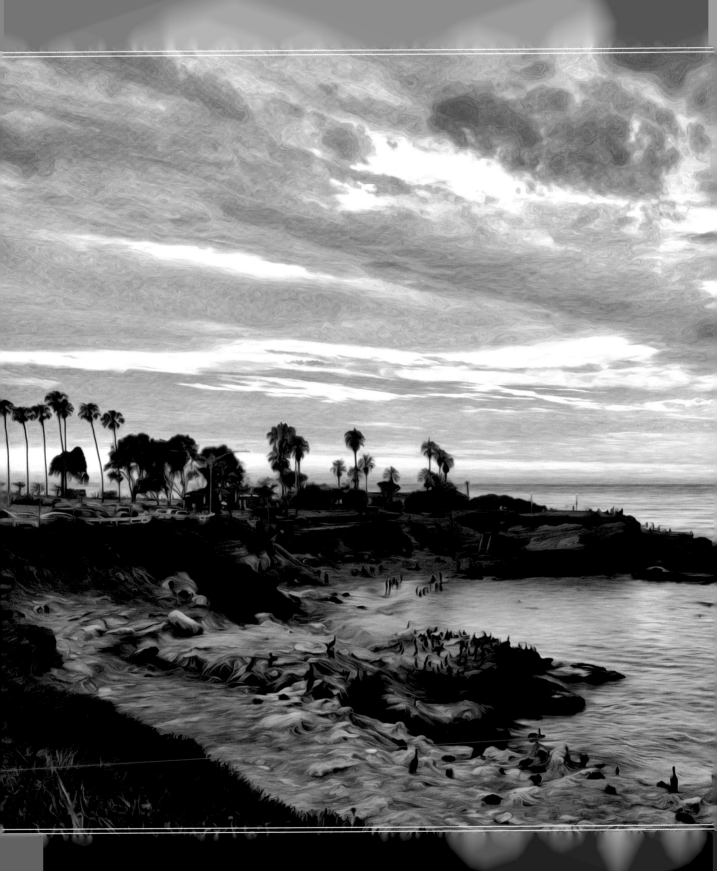

ELEVEN

Project: Sunset at La Jolla

Not too long ago, the folks over at Nik Software called and asked me to come and check out their newest piece of software, HDR Efex Pro. So, I headed to California, and spent a few days kicking the tires of the software and giving my opinion on what I thought it did well, and what I thought it was missing. While I was there, I also spent some time walking around the coastal town of La Jolla. The peace and tranquility of the beachfront was great, and I wanted to be able to take that ethereal experience back with me.

A lot of times, when people talk about HDR photography, they mention that the images tend to look a lot like paintings. In some scenarios, I agree 100% and believe that to be a good thing. The entire "painting" concept has stuck with me, and while I was out there enjoying the beach air, I thought to myself, "What if I used HDR to make the foundation of a painting?"

The only problem? I can't paint to save my life. As much as I wanted to be able to show some artistic gift, I knew that I wouldn't be able to pull that off. That is, until I went back home and downloaded Pixel Bender from the Adobe Gallery. In short, Pixel Bender is a plug-in that allows Photoshop to run some cool filters. One of them is Oil Paint. Combine that with the Mixer Brush in Photoshop CS5, and you have yourself a good foundation for some painting experimentation.

I don't believe something like this could ever replace the hands of an artist, but this, however, gives me a chance. At the end of the day, it's an outlet for creativity, and isn't that what all of this is about?

TONE MAP: PHOTOSHOP CS5 HDR PRO

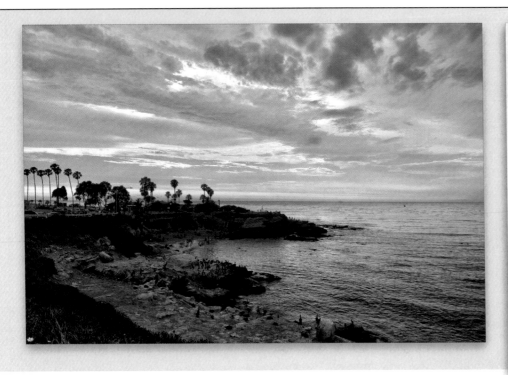

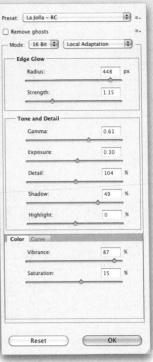

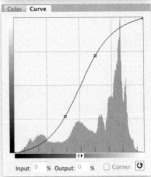

NOTES ON TONE MAPPING

To start, with this image, I changed the Radius to a very high number and the Strength to a relatively low number. In this instance, the higher the Strength went, the more we lost detail in the horizon. The scene looked like it lost a little bit of detail, so an adjustment to the Gamma brought the detail back. I also increased the Exposure and opened up the shadows. Once the overall toning was done, I added some Detail to get more of a textured feel to the image. And then, rounding the image off, I increased the Vibrance and Saturation, and added an S-curve to bring out some contrast.

⊡ Download this preset at: www.kelbytraining.com/books/hdr.

TONE MAP: PHOTOMATIX PRO

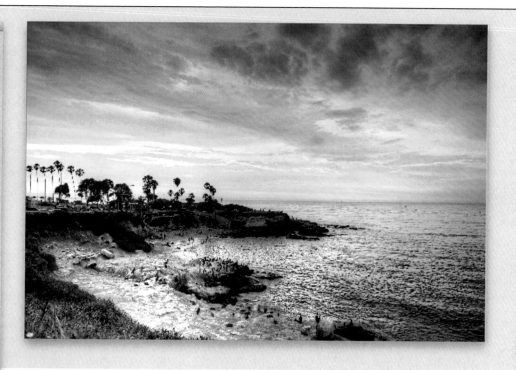

NOTES ON TONE MAPPING

The default file felt a little bit flat to me, so I started by making sure that my Strength and Color Saturation were set high. Once those two were set, I could focus on how much "effect" I wanted in the scene by working on some light Smoothing. The more I got into the surreal side of things, the more the sky darkened, so I kept it very much on the natural side. I also reduced the Luminosity and increased the Microcontrast. I was able to correct any remaining darkness in the image using the White Point and Gamma settings (using White Point first, as the Gamma setting will change the overall exposure). To bring back the sky, I warmed the image with the Temperature setting. Because I ultimately want to create a faux-painting effect with this image, I made sure that the Saturation Highlights and Saturation Shadows were set higher, giving me more color in the image to work with.

✉ Download this preset at: www.kelbytraining.com/books/hdr.

TONE MAP: HDR EFEX PRO

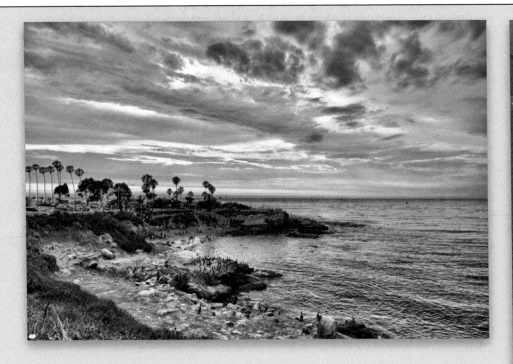

NOTES ON TONE MAPPING

I wish I could give you more insight and make the processing on this one more complex than it was, but it was actually pretty straightforward. I started by increasing the Tone Compression, which usually darkens the image. To compensate for that, I brought up the Exposure a little bit. Once I was comfortable with the overall exposure, it was time to start adding some additional tone and color. Increases in Contrast and Saturation took care of most of it, but I also decreased the Warmth a little bit. I usually save my favorite slider—Structure—for last. This gives the image that "pop" I'm looking for to start the base of my faux-painting effect.

⊞ Download this preset at: www.kelbytraining.com/books/hdr.

POST-PROCESSING IN PHOTOSHOP

Out of all three of the tone map files that I made, I found that Photoshop CS5 gave me the closest image to what I was looking for. With some basic cleanup, some Pixel Bender adjustments, and some color adjustment layers, this image will have a great faux-painting look.

STEP ONE:

Open the file in Photoshop CS5 and make your image window really large. Take a quick scan of the image, zooming in to 100% to look for any dust spots, scratches, or other anomalies that will detract from the image. Keep in mind that just because you don't see them at full-screen size, doesn't mean that they're not there. Use a 100% zoom as a guide to whether or not you should remove a spot.

STEP TWO:

Cleaning up the random spots in the image will be best accomplished by using the Patch tool. Like we've done in previous projects, circle a spot that you want to remove, and then press-and-hold the Shift key and circle any additional spots that you'd like to correct. Once selected, drag the selections to new, clean locations and those spots should be removed.

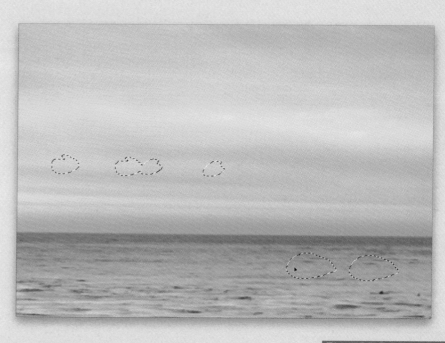

STEP THREE:

The oil painting effect is going to look great with an image that has a good deal of "punchy" color. I want to increase the blues in the sky, here, but don't really want to add green to the trees or the beachfront. So, to do that, I will create a Vibrance adjustment layer and really turn it up. Then, I'll invert the mask to hide the adjustment and only paint it back into the sky area (you learned how to do this back on page 78). When you're done painting, you'll need to flatten your image so the Pixel Bender filter can be applied.

STEP FOUR:

Pixel Bender is a plug-in that doesn't come pre-installed in Photoshop. To download it, go to the Adobe Labs website at http://labs.adobe.com /technologies/pixelbenderplugin. Click on the download link and follow the instructions to download and install the plug-in. Once installed, restart Photoshop, and you'll see Pixel Bender appear under your Filter menu.

TIP: GPU Hardware Limit Warning

Depending on your hardware configuration and how big your file is, you may or may not see this message. Pixel Bender is something that can tax your video card's GPU (Graphic Processing Unit). I find that, in many cases, this has just slowed down the response time of the filter, but hasn't caused anything bad to happen to my machine. If you have a problem with it, you'll see a checkbox in the Pixel Bender dialog that allows you to use the CPU (Central Processing Unit) to process the image. As of now, I haven't had to use this setting, but it's there if you need it.

STEP FIVE:

The default filter in the Pixel Bender Gallery just makes everything look bad, so I wouldn't worry about it if your entire image just looks like one color when the dialog opens. Click on the pop-up menu at the top right and select OilPaint. After a few seconds, you'll see the foundation for your faux-painting, as the image turns into an oil paint piece with a lot of little squiggle lines.

STEP SIX:

I'd like the number of lines on the image to diminish, and I would like an overall smooth effect for this picture. To do that, I'm going to decrease the amount of Stylization and increase the Cleanliness. This will smooth out the painting quite nicely. If needed, you can play with the BrushScale and BrushContrast sliders to adjust the overall effect from here. Remember, these settings should be applied to your taste. If you're trying this on your own image, you may need to experiment with the Cleanliness and BrushScale further. But, you'll find that Stylization is usually used best at a low setting. Click OK when you're done.

STEP SEVEN:

Now, make a duplicate copy of this layer by pressing Command-J (PC: Ctrl-J). Then, select the Mixer Brush tool, located under the Brush tool in the Toolbox (or press Shift-B until you have it). Because we want to blend the colors that are in the image with one another, it's very important that the icon to the left of the blending brush pop-up menu (shown circled here in red) is active. This option will clean your brush after every stroke. I'm going to use a soft brush for this effect, lower the Wet, Load, and Mix percentages, and make sure that the Flow is set to a low percentage to softly paint in the effect I want.

STEP EIGHT:

This is the part that can get really time intensive, but the part I find the most fun. On this new layer, slowly brush through the image in the areas that you would like to have a little softer. This is also a great place for you to experiment with different brush types and sizes, as well as different Flow percentages. What the final result will be here is up to you, but I really like to use this technique to create more of a smoother look to the lines, as if they were painted in.

STEP NINE:

Once the overall smoothness of the image has been set up, go back and hide the layer to check if there are any other spots that stand out. By doing a quick show/hide (by clicking the Eye icon next to the top layer in the Layers panel), you can identify any trouble spots in the image and address them from here. You can also soften the smoothing effect on the image by adjusting the Opacity of the duplicate layer.

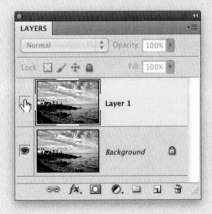

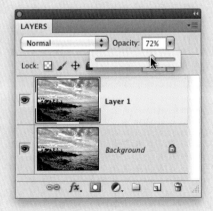

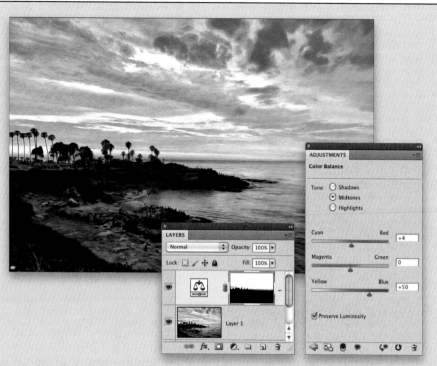

STEP 10:

Once the overall effect is complete, let's go back and adjust the blue in the sky. Add a Color Balance adjustment layer (you learned how to do this back on page 78) and, with the Tone set to Midtones, add blue to the sky by dragging the Yellow/Blue slider to the right. I also dragged the Cyan/Red slider a little to the right, as well. After making the adjustment, invert the layer mask to hide the effect and, with a white brush, paint back in the color change to the sky.

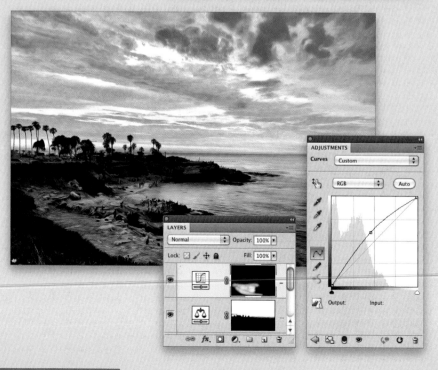

STEP 11:

With all of the processing that we've done to the image, I also noticed that the beach area could be a little bit brighter. To add this, create a Curves adjustment layer. Click on the center of the curve, and drag the point slightly higher, brightening the midtones a little bit. As before, an inverted layer mask hides the effect, and a soft, round, white brush will paint back in that brightness (as seen here).

STEP 12:

Once I save the image, I like to go back to Camera Raw or Lightroom and make some final finishing touches to it. For this image, I wanted to burn the edges in a little bit (but not make them as dark as the technique we've used in previous projects). If you're using Camera Raw, click on the Effects icon (the fourth from the right at the top of the panels), and in the Post Crop Vignetting section, choose your Style from the pop-up menu, and then you can change the Amount, Midpoint, etc. In Lightroom, go to the Develop module's Effects panel and you have the same choices. Keep in mind that if you add too much, you may want to adjust the Feather for the vignette. Just a little bit will do. See the next page for a before and after.

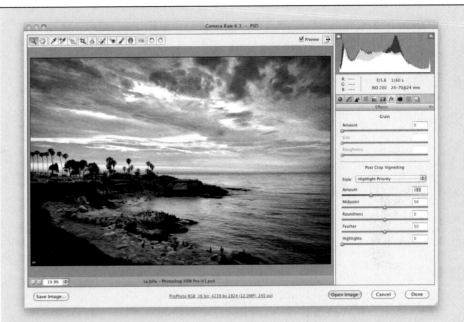

ALTERNATE PROCESSING:

Just to show you how different your processing may be from mine, here is another version of the same image. In this one, I added some red to the plants along the shoreline, brightened the whole beach area, darkened the upper part of the sky, and almost blew out the sky along the waterline.

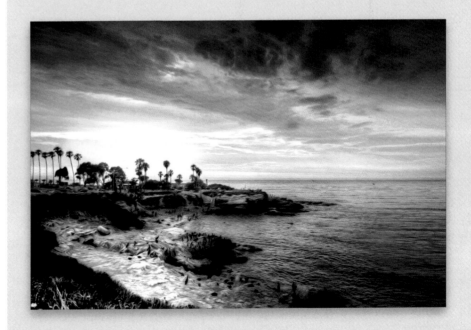

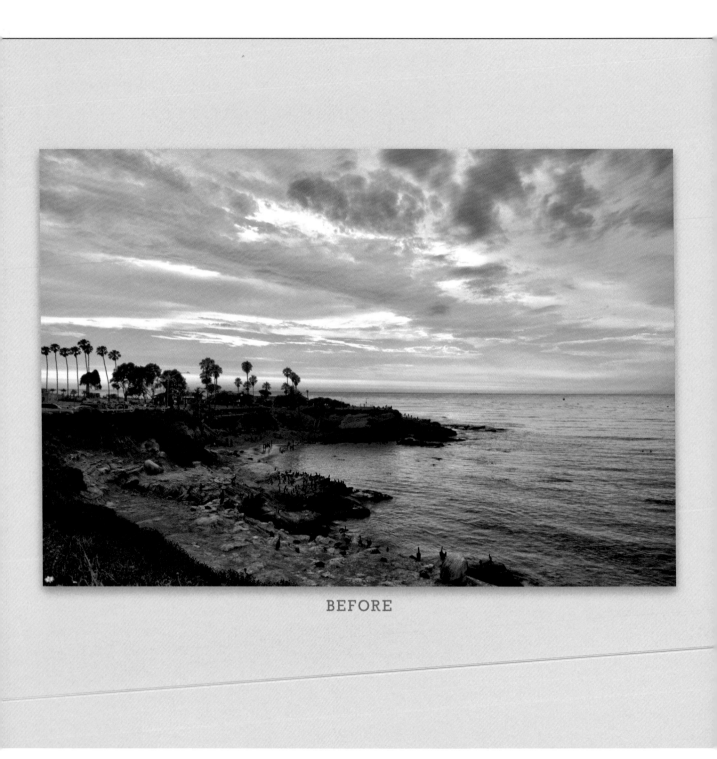

BEFORE

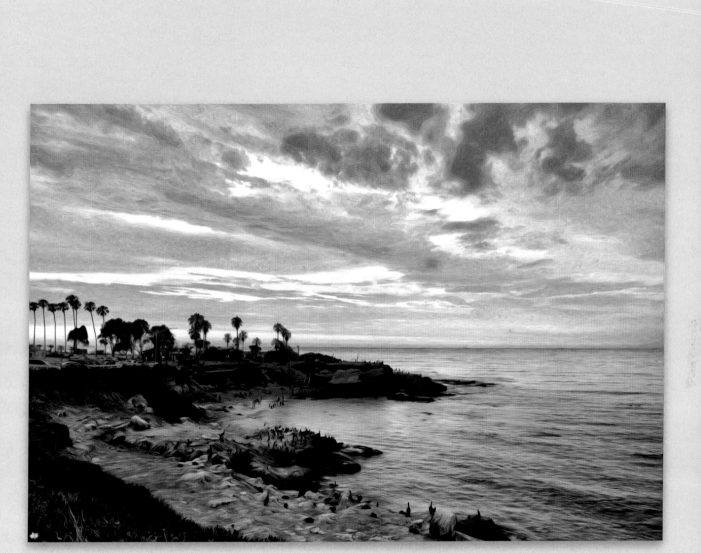

AFTER

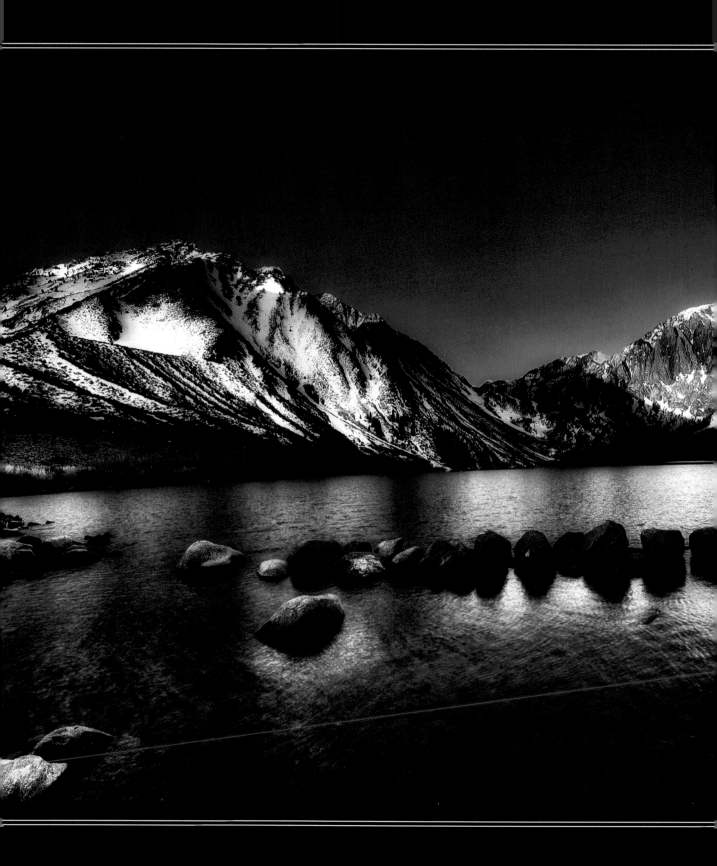

TWELVE

Project: Black & White

If you get a bunch of my photographer friends together to chat about images, the conversation will automatically drift to some of the great masters of photography and how they approached their work. One day, while doing this, one of my friends brought up the name Ansel Adams—someone I hold in very high regard for his black-and-white photography. The conversation drifted in and out of the use of his Zone System for making images, and some mused as to whether Ansel Adams would have been fond of what we are doing in the digital world. Thinking about it, I've often considered that had he seen what we are able to do with HDR photography, he totally would've been into it.

Without getting into an overly technical conversation on the subject, the Zone System basically laid out a roadmap for how to take out specific portions of an image and how each portion (or "zone") has a specific exposure to it. Following that logic, the production of a print has a photographer merging a series of these zones together, creating a composite of many zones. There isn't one exposure, but rather a series of exposures that come together in a final print.

That sounds a lot like what we are doing in tone mapping. When we bracket an image, we are taking different exposures and compressing them into one file. We then use software to take specific portions (zones) of the image that are out of our viewable range of tone, and map them so we can see them (tone mapping). In a roundabout way, one could say that we're merging these zones into a final composite. I wondered, "What if we took a really wacky HDR image that had a surreal compression and turned it into a black-and-white? Would it, too, provide a good black-and-white?" Well, we're about to find out!

TONE MAP: PHOTOSHOP CS5 HDR PRO

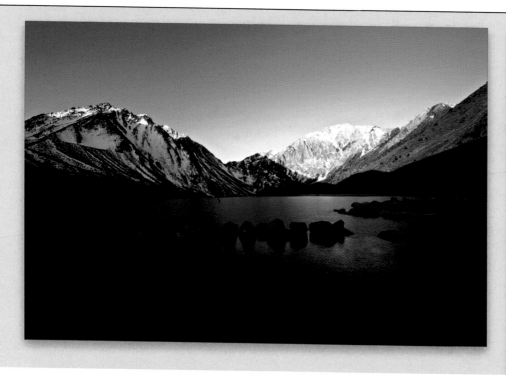

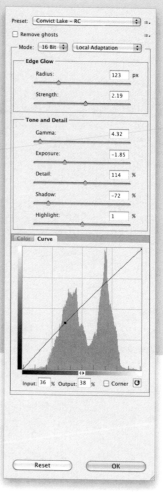

NOTES ON TONE MAPPING

The default setting did a pretty good job of merging all of the exposures in the bracket, and gave a good amount of range for the image—almost too good. In order for this effect to look great, we really want to pop out as many tonal differences in the image as possible. To do this, I dragged the Gamma to the left to make the image darker, and also decreased the Exposure to get some good contrast in the mountains and sky. I kept a low Radius and increased the Strength to get more contrast in the image. Then, I increased the Detail to get even more contrast, decreased the Shadow, and barely increased the Highlight. In the Curve tab, I dragged the midtones slightly higher to increase the tone in the water.

⊞ Download this preset at: www.kelbytraining.com/books/hdr.

TONE MAP: PHOTOMATIX PRO

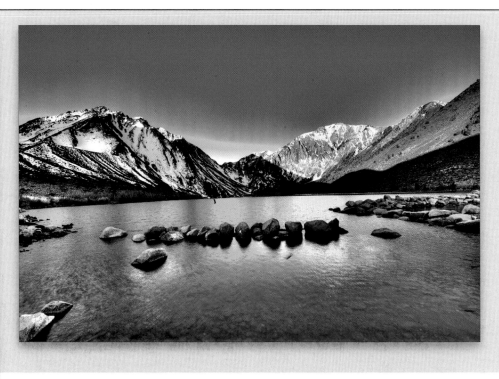

NOTES ON TONE MAPPING

If there's one thing that I think Photomatix can do, it is to take the image to the extremes of tone mapping. These extremes are going to work nicely here. I increased Strength, Color Saturation, and Microcontrast as far as they could go. I also took the Smoothing way to the left, into surreal land—much more than I would on almost any image—and the decreased the Luminosity, as well. Gamma for the image is pretty dark and I did raise the Black Point a little, but I've included a high amount of White Point to really get some cool textures in the water. Yes, this looks horrible, but it's going to be perfect for black and white.

▣ Download this preset at: www.kelbytraining.com/books/hdr.

TONE MAP: HDR EFEX PRO

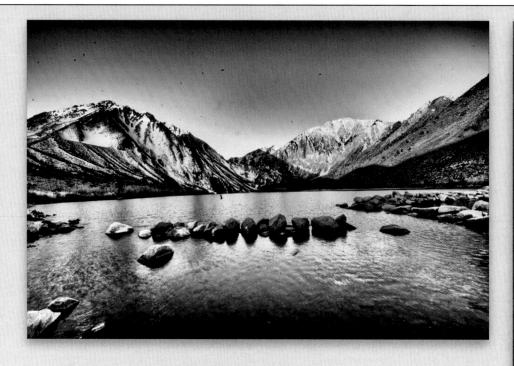

NOTES ON TONE MAPPING

Whenever I work with Nik, I tend to work the specific tone map in a step-by-step fashion. This case really called for something out of the box. Because of that, I thought it was a good idea for me to explore with presets that were available to give me a starting point for where I wanted to go. In the Surreal category, there is a really cool preset called Granny's Attic, so I used that one. From there, I added some Structure, decreased Exposure, and moved the Tone Compression and Method Strength up a bit. I also bumped up the Contrast and Blacks a little. When it started to look like something I wouldn't normally show someone because of so many contrasting tones, that's when I stopped.

⊟ Download this preset at: www.kelbytraining.com/books/hdr.

POST-PROCESSING IN PHOTOSHOP

I selected the most out-there image (the one from Photomatix) from the series of tone maps because I wanted to make sure that we have very distinct changes in the overall picture. Keep in mind that the color of the image is going to need to move to either black or white. The more color, the more interesting the shot. Sounds crazy? Crazy like a fox! Watch!

STEP ONE:

Once you open the tone-mapped image, I suggest that you zoom in to 100% and take a look at the entire image to make sure that all of the fine details look good before you start converting it to a black and white.

Zooming in to the image, you'll notice that there are a lot of spots on it, and they'll need to be cleaned up. Here's the problem: The sky has a lot of haloing going on, so we'll need to change out the sky in this image with one of the skies in the original bracketed series that doesn't have that haloing in it. We're looking for color and continuity, so one of the middle exposures in the series will look good for this.

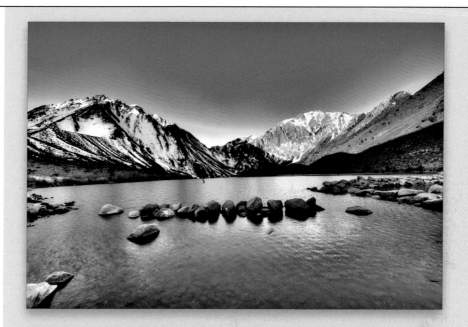

STEP TWO:

Open that middle exposure in Photoshop, press Command-A (PC: Ctrl-A) to Select All, get the Move tool (V), press-and-hold the Shift key, and drag it onto the tone-mapped image. Then, use the Patch tool (press Shift-J until you have it) to get rid of any of the random spots that appear in the image. You'll notice that there are a lot fewer spots than in the tone-mapped image. The spots were really magnified due to the tone mapping, but it's no problem here.

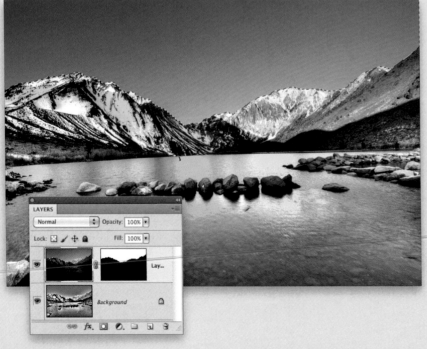

STEP THREE:

After cleaning the image up, make a selection around the sky using the Quick Selection tool (W). If it selects part of the mountains, just press-and-hold the Option (PC: Alt) key and paint over any areas to remove them from the selection. Once you have the sky selected, create a layer mask by clicking on the Add Layer Mask icon at the bottom of the Layers panel. This will create a composite image with the tone-mapped mountains and lake and a smooth sky.

STEP FOUR:

Click on the Create New Adjustment Layer icon at the bottom of the Layers panel and choose Black & White from the menu. You'll notice that the image is immediately better. You'll also notice that there are a series of sliders in the Adjustments panel under the preset pop-up menu that allow you to make adjustments to your black-and-white image based on a specific color. There is a much better way to do this, however.

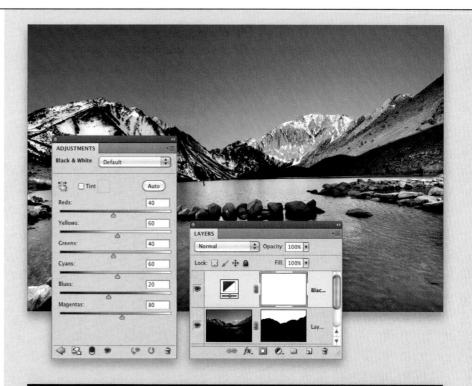

STEP FIVE:

If you click on the Targeted Adjustment tool (TAT) near the top left of the panel, you can click-and-drag on your image right on the area that you want to adjust. If you drag to the right, it becomes brighter. If you drag to the left, you make it darker. By simply clicking-and-dragging to the left on the sky, the image takes on a completely different look.

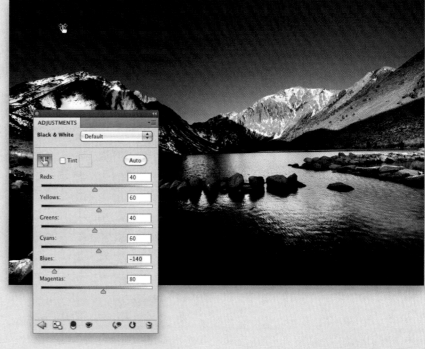

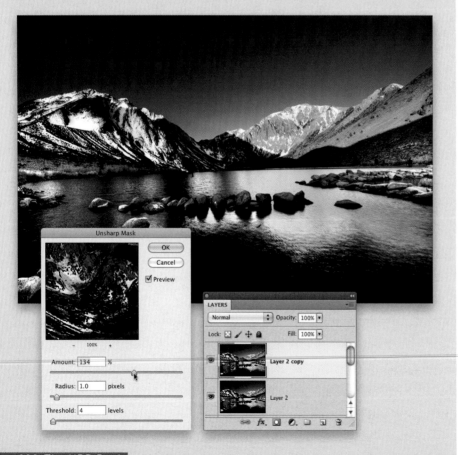

STEP SIX:
Another great option here is tinting. Turning on the Tint checkbox allows you to tint the images. I like using a slightly gray color to give the image a nice feel.

STEP SEVEN:
Once the image is adjusted, we should spend some time sharpening the rocks. So, merge your layers up (you learned this back on page 79), press Command-J (PC: Ctrl-J) to duplicate that layer, and go to Filter>Sharpen>Unsharp Mask. Because it's a mountain, I'm going to really exaggerate the sharpness here.

STEP EIGHT:

Now, add a black layer mask here (we talked about how to do this on page 77) to hide the sharpening, get the Brush tool (B), and with a soft, round brush with a low Flow setting, paint in white over the mountains and rocks to make sure that only they get sharpened, not the water or the sky.

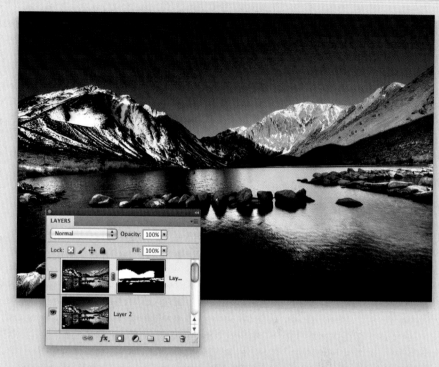

STEP NINE:

If you want to give the image a little final touch, you can merge your layers up again, and set the blend mode for the new layer to Multiply (we did this back in Chapter 7). Then, you can Feather the selection and create a layer mask to hide all but the darker edges of the image (that way you can paint in the bright and dark areas as you'd like them). The great part about it is that, if the effect seems too strong, you can always dial it down by changing the opacity of the layer (I lowered mine to 44% here).

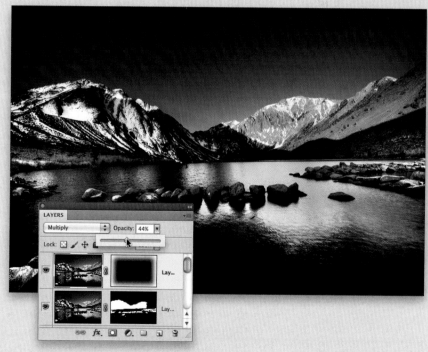

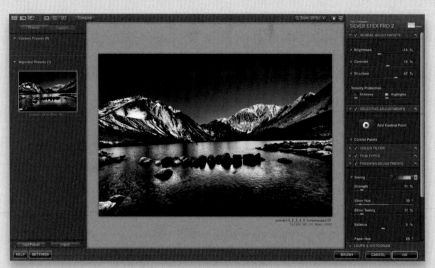

Silver Efex Pro

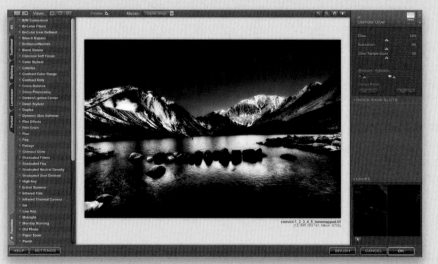

Color Efex Pro

NIK SOFTWARE SUITE USERS:

If you happen to own the entire Nik Software Complete Collection, you can just use three products to give you this post-processing. Once you have tone mapped the image and made the clean sky layer, merge your layers up and click on Filter> Nik Software>Silver Efex Pro. This will bring up a window like HDR Efex Pro, with presets and controls for you to tone map the image.

Without getting into a big tutorial on it, I have a preset that I've made for this image, and you can download it at: www.kelbytraining.com /books/hdr.

What I like about Silver Efex Pro is that if you're used to using HDR Efex Pro, the jump to this is pretty easy. For this image, just click the Import button at the bottom of the Presets panel, navigate to my preset, and click Open. When it appears in your Imported Presets area, click on it, then click OK in the bottom right of the window.

Once your image is completed from a black-and-white perspective, open the image in Color Efex Pro and apply the Glamour Glow preset to it. This gives it a soft, ethereal look.

Once the Glamour Glow is complete, the last thing that I added was some sharpening by clicking on Filter>Nik Software>Sharpener Pro Output Sharpener. How much you sharpen will largely be up to you, but I tend to use the default Display preset in the Output Sharpening preset pop-up menu.

Once it's complete, click the Brush button at the bottom right of the window to return to Photoshop and add a black layer mask (just like we did with the Glamour Glow in Chapter 6). Click the Paint button in the Selective tool, then paint over the mountains and rocks to make sure that the sharpening only appears on them, not on the sky or on the water.

And you're done! From crazy HDR to amazing black-and-white. With very few clicks. You can see the before and after on the next page.

Sharpener Pro

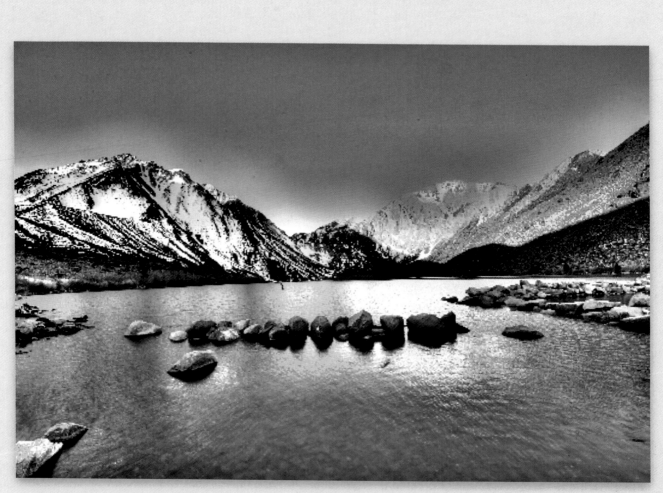

BEFORE

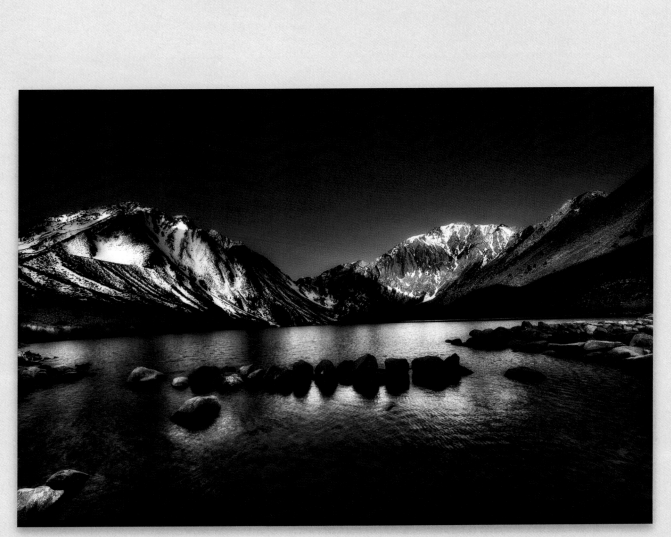

AFTER

HDR Spotlight: Roger Laudy, Owner, Image Wizards

Q. Tell us a little bit about yourself.

People ask me how I came up with imaging on aluminum. I would first like to tell you where I've been, which leads you to where I am today. I started in printing at the age of 14 as a part-time job to make some money. That led me into an apprenticeship at the age of 16, working on a 40" 4-color Harris printing press. At the same time, I started a small printing business in my parents' basement. My dad was a photographer who went to the Fred Archer School of Photography and helped me develop the negatives to make my printing plates. He also was a really good salesman who liked to hug women a lot. With that said, the business grew. At the age of 19, I moved the business into my first commercial space.

An ink salesman named Al Robbins, from Sinclair & Valentine, introduced me to a new type of printing ink for offset presses called sublimation. It was first developed, by the French company Sublastic, as an electrostatic toner for strike-offs for imaging polyester fabrics. I thought it might work for cotton t-shirts and, man, my brain started working. I saw myself living at the beach, making transfers on my offset printing press, and applying them to t-shirts. Well, that didn't work out, since the sublimation dyes would not go into cotton.

I started working with coatings that would accept the dyes with the help of Battelle Memorial Institute. The results were pretty impressive! Now, what do I apply these coatings to? I came up with the idea of applying them to ceramics, and created a machine to image onto coffee mugs. If you ever saw a coffee mug with someone's picture on it, that was me. I then created a way to produce sublimation offset transfers, apply them to a mug, and print in a very big heat tunnel. This turned out to be the highest-quality imaging onto ceramics in the world.

I forgot to mention that I sold the business and took a consulting agreement for three years. After my three years, we were producing 50,000 mugs a day. I then started a new business and created the rage of full-color mouse pads. After four years, that business grew to almost 10 million in sales, and I owned three 4-color Heidelberg presses that I bought new and had almost 100 employees. Well, what goes up must come down, and did it ever! Six of my top customers went bankrupt, and China was nipping at my heels with cheap prices and terrible quality. I closed the business down, went through a divorce, and my father died.

I knew I could not produce anything in any great quantity, since China would take it away, so I took the next three years doing R&D

on inkjet sublimation, applying coatings to new substrates, and building a new million-dollar super press in Denmark. My father always said "Do what you know how to do best." Well, to make a long story short, that is how I ended up creating imaging onto aluminum, ready to hang on a wall out of the box. This is the best business I have ever had. The quality of work we do is bringing us the most talented photographers from all over the world, not to mention the nicest group of people I have ever met!

Q. What is different about your printing?

What makes imaging onto aluminum so much better than paper is the reflective surface of the aluminum and the coatings that are applied to the surface. I am in constant communication with my coating supplier. I worked with them on the four different finishes that are available today. They are applied on a $3-million finishing line. You might notice other companies (photo labs) out there offering metal prints, and that's okay. This has created a much bigger demand for metal prints, and my coating supplier is putting a lot more time and money into this product, which is how we have brought it to the level it is at today. There are some new finishes we are working on that are going to blow people away!

Q. How does printing on metal work for HDR?

Imaging onto metal (aluminum) creates an almost HDR feel. Some of this is from the finishes we apply, and a lot of this is from our 35 years experience in dye sublimation. When you print an image on the lightly brushed aluminum, the aluminum actually reflects some light behind the image, almost backlighting it, giving it a 3-D feel. Our White Aluminum High Gloss finish really pops, but doesn't reflect the light behind the image. When I go to shows, I never use any kind of extra lighting. The sizes we image range from a 12x20" up to 48x96". Unlike the photo labs offering metal prints, we provide a proof at size for the customer to approve before going into production. We maximize the image for the finish the customer chooses. We also include a wooden shipping crate for sizes over 24x36".

The level of detail is unsurpassed. The black that we produce is unparalleled by any other imaging technology. Other image processes have a deficiency in the ¾-tone and above, which normally goes solid black and has a loss of detail. We are able to maintain various levels of the color spectrum, which are lost in other processes.

We have done many very unique images. One of my favorites has to be David Jeffries' "Bike Shop" (shown here). It has fantastic lighting and great detail; plus it is just an unusual shot taken by a very keen eye.

Q. Where can we find out more about you and Image Wizards?

To find out more about my company, you can visit us at www.imagewizards.net, or you can contact me personally at rkl@imagewizards.net.

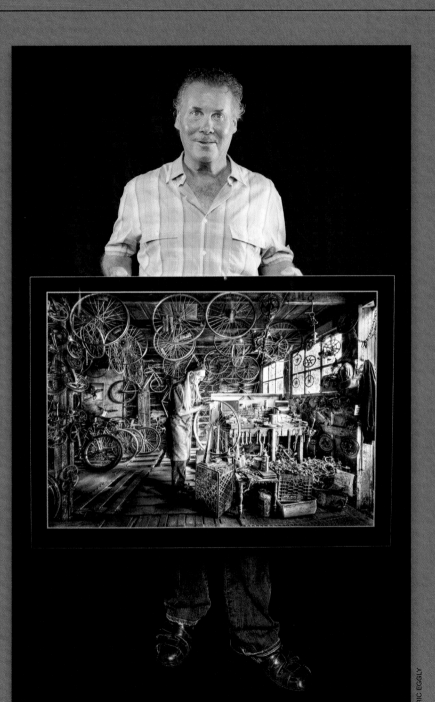

ERIC EGGLY

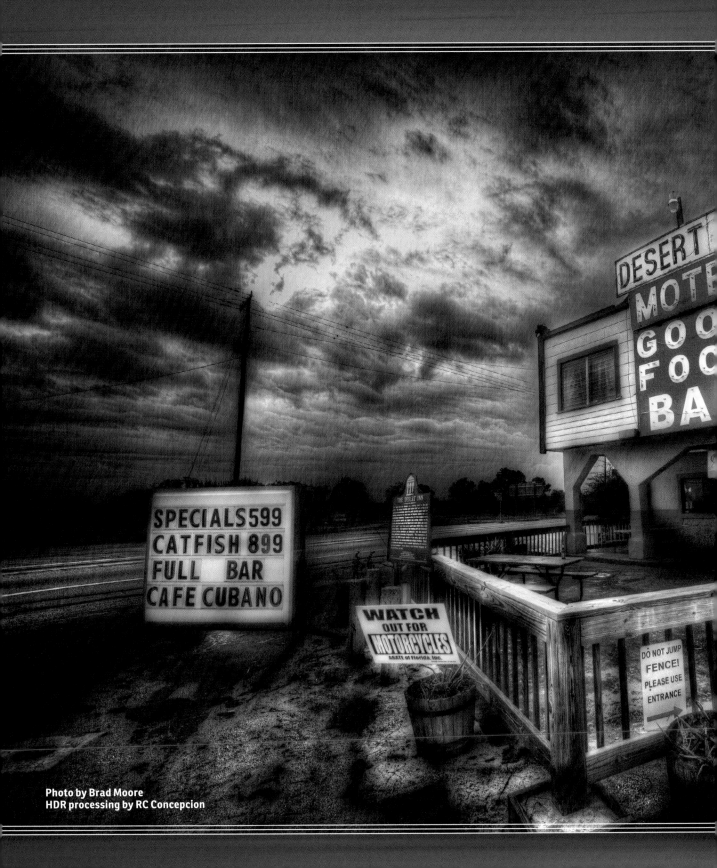

SPECIALS 599
CATFISH 899
FULL BAR
CAFE CUBANO

THE DESERT INN

WATCH
OUT FOR
MOTORCYCLES
ABATE of Florida, Inc.

DESERT
MOTE
GOO
FOC
BA

DO NOT JUMP
FENCE!
PLEASE USE
ENTRANCE

Photo by Brad Moore
HDR processing by RC Concepcion

THIRTEEN

Project: Single-Image HDR

I was sitting in my office working on some HDR projects when I got an email from our Studio Manager (and amazing photographer) Brad Moore. Brad recently took a trip across Florida and, as he was driving, he passed a place called the Desert Inn at Yeehaw Junction. The Desert Inn is on the National Register of Historic Places, and it's a great place to stop if you are passing through. The email had only once sentence in it: "Do you think you can do anything with this?"

It appeared that Brad, passing through the area, uncharacteristically took a single shot of the Desert Inn and went on his merry way. Coming back to the image, he saw that compositionally it was cool, but it didn't have anything else going for it. He thought there was a possibility of there being something more, so he passed it along to me. Thankfully, he shot the image in RAW, which minimizes the amount of junk you can get in single-image HDR processing, but it's not a cure-all.

The problem that I find with HDR images is that the tone mapping usually solves only one part of the problem in the image. More often than not, you find yourself creating tone map composite images of two or three tone-mapped files to get the data that you want. It is possible, however.

While we'll be processing a landscape image, it's important to note that single-image HDRs are very effective in a variety of scenarios. You'll find yourself making them more with portraits or subjects that are not prone to sitting still. With a little bit of tone map compositing, some texture effects, and some adjustments in Photoshop, we should be able to make a good tribute to this place.

TONE MAP: PHOTOSHOP CS5 HDR PRO

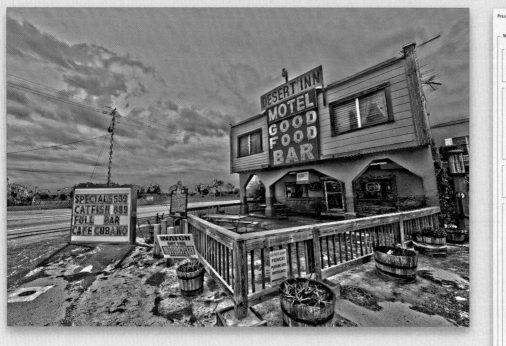

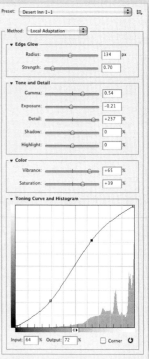

NOTES ON TONE MAPPING

Photoshop's HDR Pro won't work on a single image, so instead, open the image, then go to Image>Adjustments>HDR Toning. Out of all three programs, I found Photoshop the least for-giving. I think the limited number of corrections that you can do with the image is due to the limited amount of information that the file has. That said, I was able to get a base image by in-creasing the Radius until I started seeing details in the clouds, increasing the Strength a little, and dragging the Detail almost all the way to the right to get as much contrast in the building and clouds as possible. Once those are set, adjust the Gamma and Exposure settings to darken the image and create a scene. Vibrance and Saturation will bring back some of the color in the image, but most of this will need to be toned down and corrected in Photoshop. I also added a slight S-curve to add more contrast.

⊠ Download this preset at: www.kelbytraining.com/books/hdr.

TONE MAP: PHOTOMATIX PRO

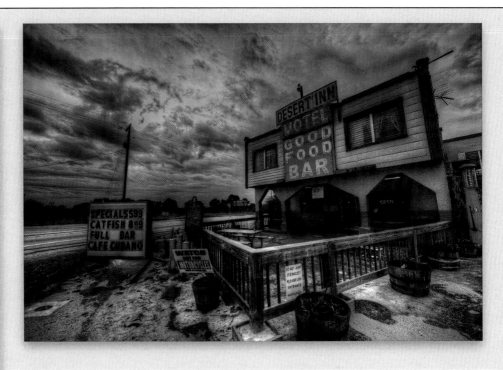

NOTES ON TONE MAPPING: FIRST IMAGE

This image will require several tone maps to get it where it will look good. I focused the initial tone map on making sure the sky and background looked as good as possible. To that end, I started from the Default, and dragged the first four sliders all the way to the right. From here, I adjusted the Smoothing until I got some good cloud detail. I was able to add more drama to the image by adjusting the Gamma and White Point, making the image darker. While this affected the face of the hotel and the signs, a second tone map of the file can take care of that (see the next page). I dropped the Temperature a little to get more blue in the sky and increased the Saturation Highlights and Shadows. By default, Photomatix applies a bit of Micro-Smoothing to each image. I didn't want this, as I wanted to eke out as much drama from the sky as possible, so I set it to 0.

⬇ Download this preset at: www.kelbytraining.com/books/hdr.

TONE MAP: PHOTOMATIX PRO

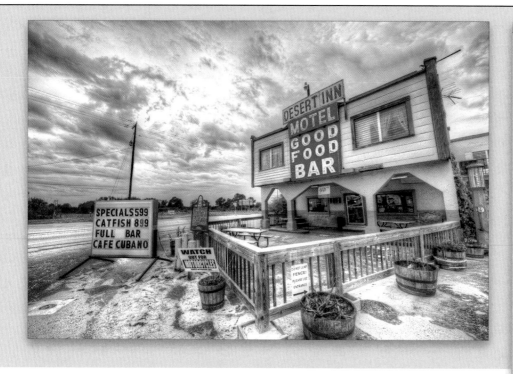

NOTES ON TONE MAPPING: SECOND IMAGE

We spent a lot of time working on the original file to adjust for the sky and background. Because of this, the image suffered on the face of the hotel, the fence, and the signs in the front. So, for the second image, I changed the Presets pop-up menu at the bottom of the Adjustments panel to Previous. Then, I simply adjusted the White Point and Gamma to lighten the building and signs, and desaturated the image by reducing the Saturation Highlights and Shadows to bring out as much detail as possible in these parts of the image.

⬇ Download this preset at: www.kelbytraining.com/books/hdr.

TONE MAP: HDR EFEX PRO

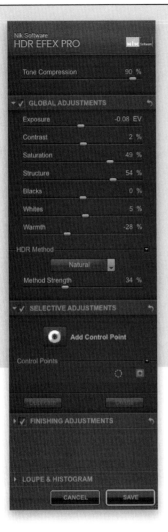

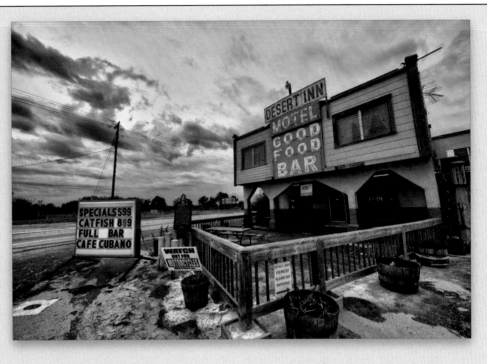

NOTES ON TONEMAPPING

The main goal in working with this single-image HDR is to process twice: once for the sky and background, and a second time for the face of the building. To get the sky and background I'm looking for, I moved the Method Strength slider to 34% and adjusted the Tone Compression to a high setting. I stopped adjusting it when I saw enough detail in the cloud area. Additional drama was added by increasing the Structure, and tweaking the Contrast. I then decreased the Warmth in the image and added Saturation to get a good blue color for a starting point in the image (although this could be adjusted later in Photoshop). I also slightly decreased the Exposure and increased the Whites a little bit. Since I'm not really crazy about the way the sky and background are looking here, I'm not going to even bother processing it a second time for the face of the building.

⬆ Download this preset at: www.kelbytraining.com/books/hdr.

POST-PROCESSING IN PHOTOSHOP

I selected the Photomatix tone-mapped files to work with as the foundation for the edit here, because of the added drama that I was able to get in the sky. We'll be using both tone-mapped files and merging them together in Photoshop to create the base image. Once completed, we will then perform our post-production edits.

STEP ONE:

We'll need to open both of the tone-mapped images in Photoshop and start working on merging them with layer masks. Lightroom users can Command-click (PC: Ctrl-click) on both of the images in their catalog to select them, and then Right-click on one of them. In the pop-up menu, select Edit In>Open as Layers in Photoshop.

If you are using Bridge CS5, select both of the images you want to open and click on Tools>Photoshop>Load Files into Photoshop Layers.

If you'd like to open up both of the images right from within Photoshop, click on File>Scripts>Load Files into Stack. This will give you a dialog that lets you Browse for the two files you want to load. Once you've selected them, you can click OK and both files will open with one placed on top of the other. (*Note:* Because both files are exactly the same, there's no need for us to turn on the Attempt to Automatically Align Source Images checkbox at the bottom of the dialog.)

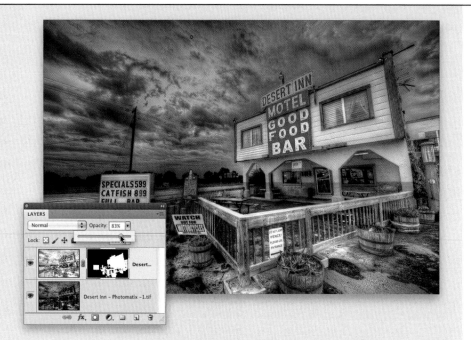

STEP TWO:

Place the image that has been corrected for the hotel, the second tone map, at the top of the layer stack and hide it with a black layer mask (you learned how to do this back on page 77). We're hiding this one because there is less detail here to reveal, so that means there's less to brush. Get the Brush tool (B), and with a soft, round brush set to a low Flow setting and your Foreground color set to white, paint back in the areas that you would like to reveal on this layer. If you'd like to tone down the layer after working on it, you can drop the Opacity of this layer a little and let it blend with the layer beneath it (as shown here).

STEP THREE:

Because of the amount of saturation adjustment we did for the sky, the image took on a lot of blue cast in areas that we would not expect to see blue—signs, fences, the historical marker, and the concrete in the parking lot. To remove these, create a Hue/Saturation adjustment layer (we covered this on page 78), and then in the Adjustments panel, change the pop-up menu above the sliders to Blues, and drop the saturation to –100. Once that's complete, press Command-I (PC: Ctrl-I) to Invert the layer mask and hide the effect, then paint in the desaturation in these problem areas only (using the same Brush settings as in the last step).

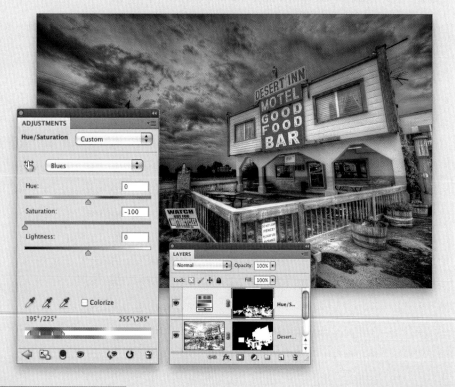

STEP FOUR:

While the sign on the front of the hotel seems bright, it doesn't seem to have the amount of contrast that I would like. So, create a Curves adjustment layer, and add an S-curve to add a small amount of contrast. As before, I will hide the effect with a layer mask and paint it back on the sign.

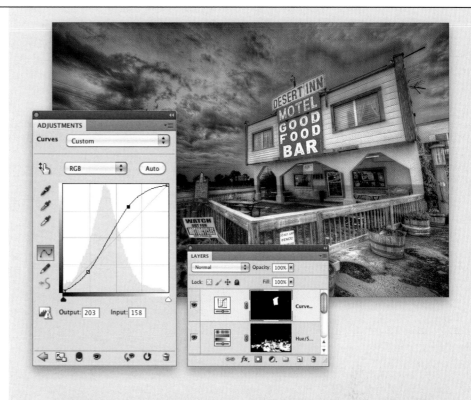

STEP FIVE:

Dropping the Flow setting on my soft, round brush to a really low number (think 5%) can let me add some contrast into the sky very softly by using the same layer mask that I used for the sign. Notice in the Layers panel here that the paint that is going on the mask is darker than the white spot where we revealed the sign. This lets us tackle two spots with one mask.

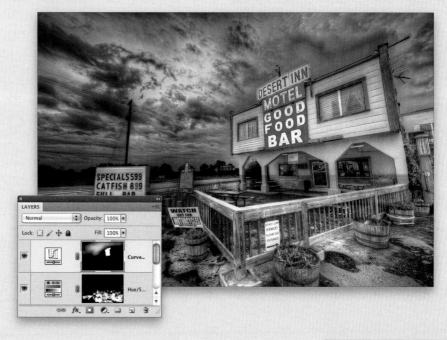

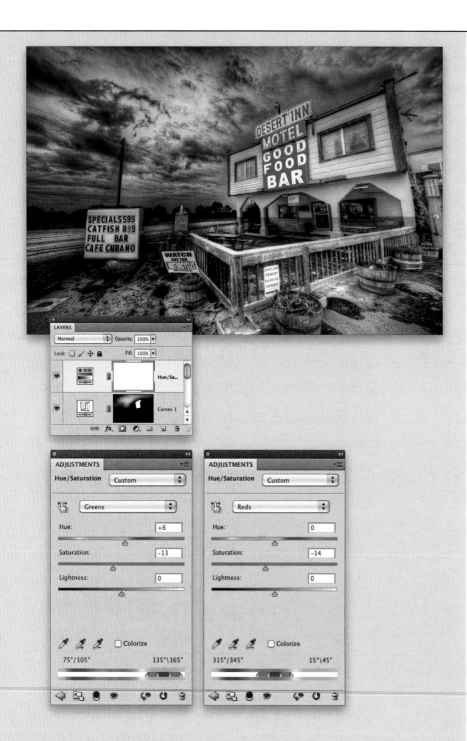

STEP SIX:

Once the localized color changes are complete, add a Hue/Saturation adjustment layer to make a global color adjustment to the image. In this case, I wanted to shift the greens in the image and make them a little more desaturated. Keep in mind that the Hue/Saturation adjustment layer does not have to be used for just one color. In this case, I used the same adjustment layer for changing the reds in the image, as well. Click on the pop-up menu above the sliders, and change it from Greens to Reds. Then, drop the Saturation for this color a little.

STEP SEVEN:

Once all of the color changes are complete, merge your layers up (as you learned back on page 79), giving you a new base image with all the changes so far. That way, at any point, if you need to go back to the color adjustments, you can delete this layer and any changes you've made above it.

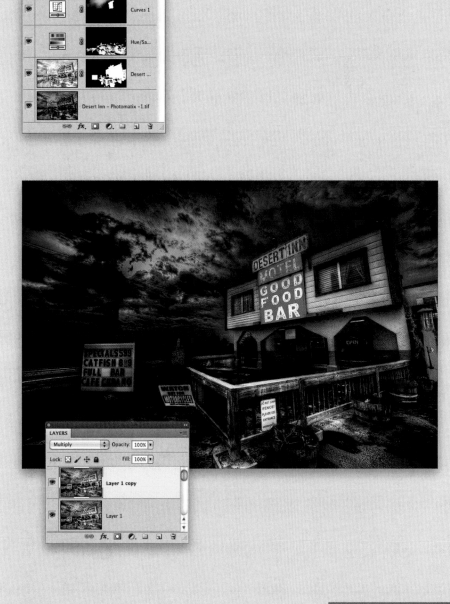

STEP EIGHT:

Let's darken the edges of the image to give it more of a pinspot effect. To do this, press Command-J (PC: Ctrl-J) to make a copy of the merged layer and set the blend mode of the copy to Multiply.

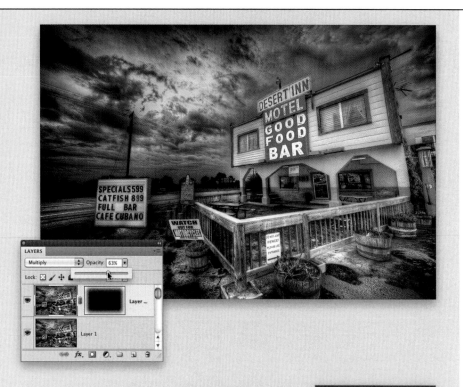

STEP NINE:

As we did in Chapter 7, make a selection, transform it, feather it, and create a layer mask that will hide the center portion of the image where the feather occurred. If it looks too dark to you, lower the Opacity of the layer, as I did here.

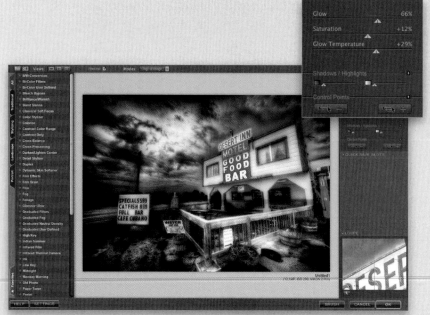

STEP 10:

Now that the majority of the image has been completed, we can merge our layers up again, and go to Filter>Nik Software>Color Efex Pro, where we can apply a Glamour Glow effect. Here, I increased the Glow to 66%, added a little Saturation, and increased the Glow Temperature to warm the image a little.

STEP 11:

After clicking OK, I noticed that the signs on the face of the hotel are still a bit bright. When masking them in the original step, I thought they were very bright, but I went ahead with the processing. Why? If we had toned down the image back in the original step and found that we needed them to be brighter, there's always more of a possibility that we'd introduce noise or color shifts as we increased values. Small S-curves are okay, but I'd rather have to darken a bright image than to brighten and introduce other elements.

STEP 12:

Here, we're going to add a Curves adjustment layer, add a point near the center, and drag it down a little to darken the image. Invert the layer mask, and with a very low Flow setting for your Brush tool, paint the darkening in over the signs.

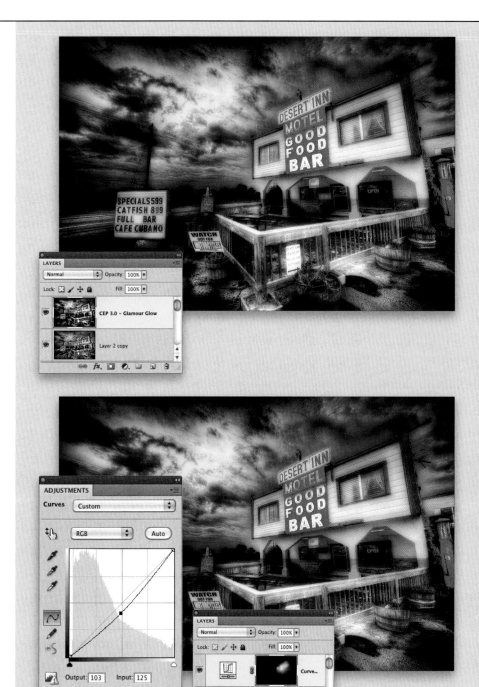

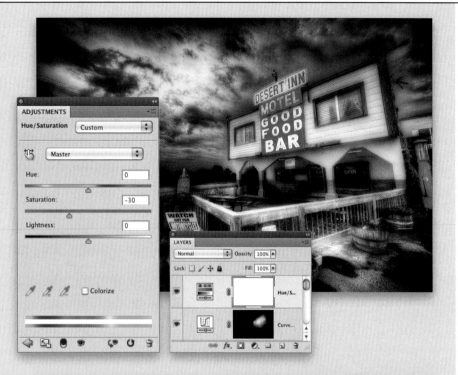

STEP 13:

The Glamour Glow made the image look good, but even with changing the temperature, the image took on a little bit of color. A quick Hue/Saturation adjustment can correct for this.

STEP 14:

We'll start working on creating the texture for the image now, so it's a good time for us to merge our layers up to give us a good save point. Then, to create the texture that we'll run over the image, click on the Create a New Layer icon at the bottom of the Layers panel to create a new blank layer. In order to run this effect, you'll need to have something on the layer. Most of the time, I just fill the layer with 50% gray, so go to Edit>Fill and, in the Fill dialog, choose 50% Gray from the Use pop-up menu, then click OK. At this point, it's also a good idea to have the default colors of black and white selected in your Toolbar by pressing the letter D.

STEP 15:

Click on Filter>Render>Fibers to get the Fibers dialog. Keeping a low Variance and a high Strength, you'll get thin strips of black and white that will look great as a pattern overlay for the image. Click OK when you have the texture you're looking for.

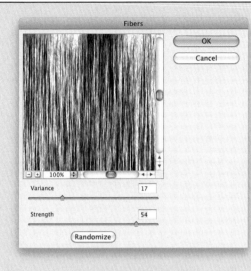

STEP 16:

Once you have your texture, switch the blend mode of this layer to Soft Light and drop the Opacity, and you'll notice the texture blends into the image nicely.

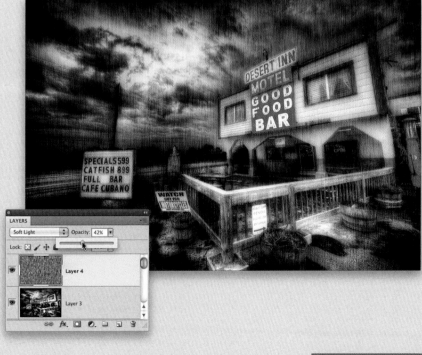

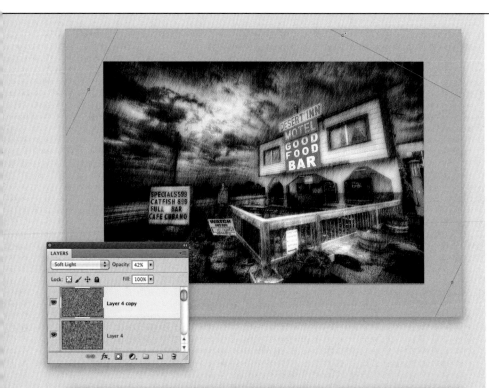

STEP 17:

To spice it up a little further, make a copy of this texture layer, press Command-T (PC: Ctrl-T) to open Free Transform, and scale it outward, as well as rotate it slightly, so it interacts with the texture below. We're not really afraid of pixelation at this point, so really make it big. This is just a pattern, so if it loses quality because of the scaling, it's not that big of an issue.

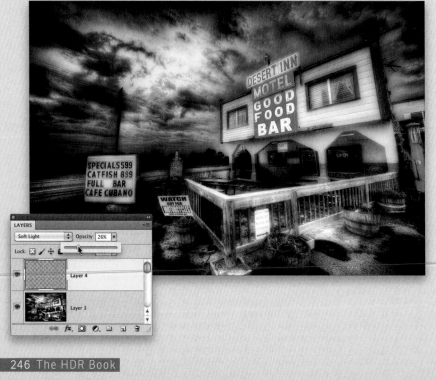

STEP 18:

Once you have both of the elements where you need them, make sure the top layer is selected and press Command-E (PC: Ctrl-E) to merge the two textured layers. Then, make sure the new layer is still set to Soft Light, and drop the Opacity a bit.

STEP 19:

There's a good chance that you won't want the effect to run over the front of the hotel, or at least not that much. To fix that, add a regular (white) layer mask to the texture layer. This will reveal all of the effect on the layer. From here, get a soft, round brush with a low Flow setting, and paint in black over the portions of the mask where you do not want the texture to be applied.

Once that's complete, save your file and you're done! You can see a before and after on the next page.

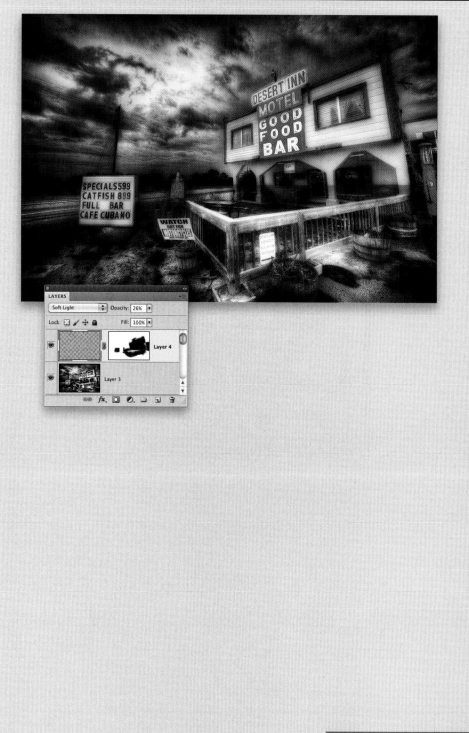

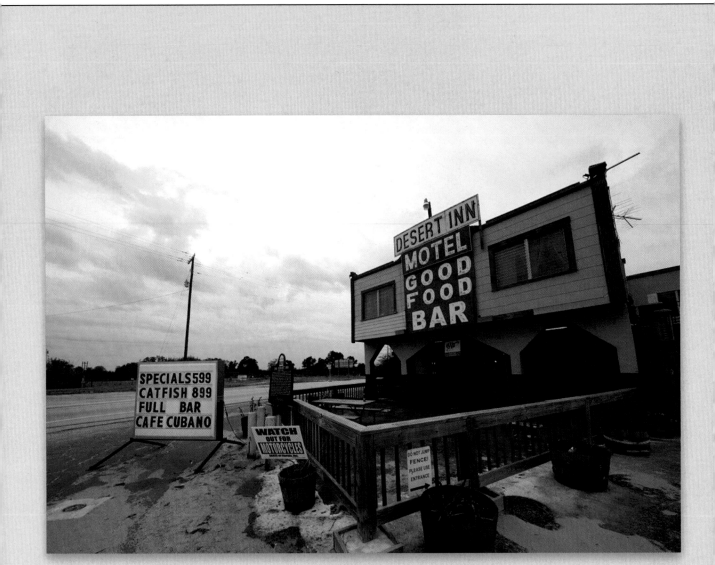

BEFORE

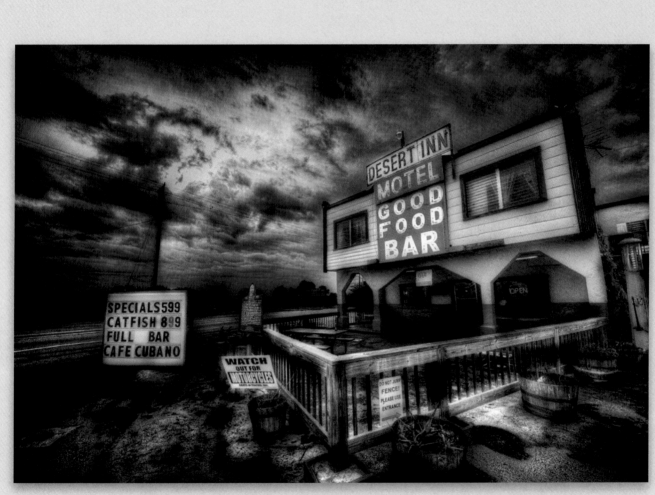

AFTER

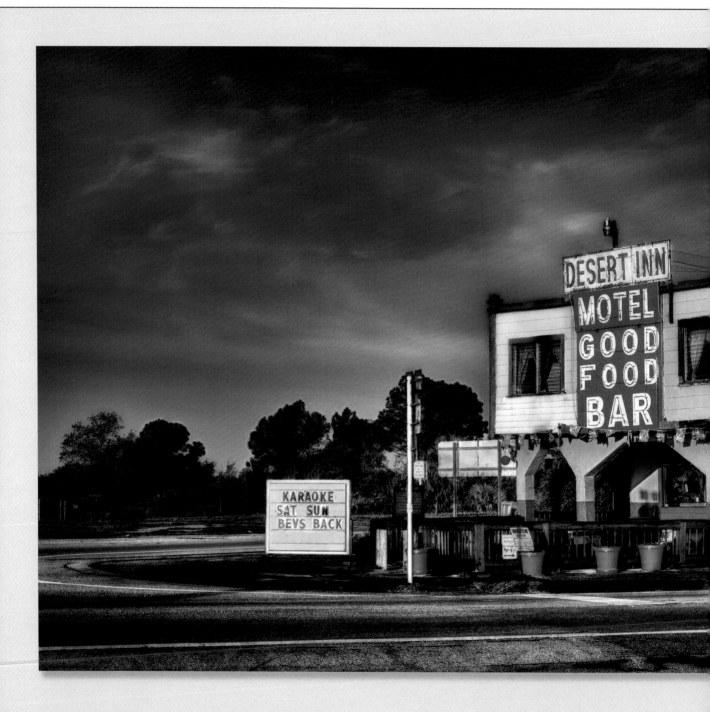

It's Your Turn:
Desert Inn 2

Here in the book, we've covered everything from point-and-shoot camera images all the way up to high-end DSLR camera images as source files. A couple of months ago, the folks over at Leica AG were nice enough to let me play around with one of the S2 camera systems, a 37-megapixel medium-format camera. I knew the level of detail would be phenomenal, but the burning question that I had was, "How well will this camera do with an HDR sequence?" As I was driving to West Palm Beach, I was able to stop by the Desert Inn over in Yeehaw Junction. As the sun was beginning to rise, I set the tripod down and made a couple of five-shot brackets with the camera. Using all of the techniques that we covered here in the book, I was able to produce the image that you see here.

That's not all that important, though. What's more important here is you. See what kinds of images *you* are able to make with them. I hope you enjoy working with them as much as I did.

⊞ Download this preset at: www.kelbytraining.com/books/hdr.